YARN
BOMBING

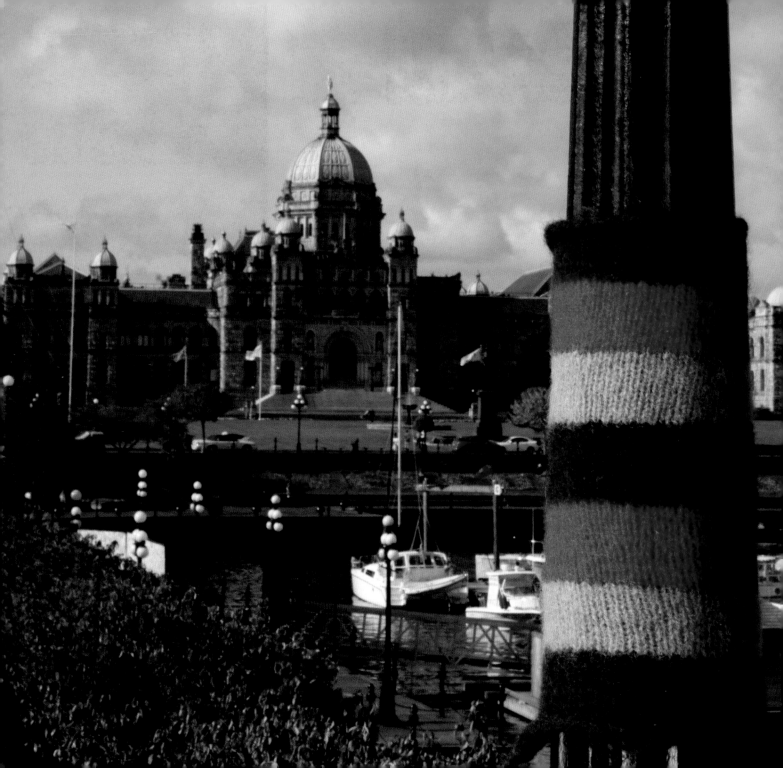

YARN BOMBING

The Art of Crochet and Knit Graffiti

Mandy Moore and Leanne Prain

ARSENAL
PULP PRESS

VANCOUVER

YARN BOMBING

Copyright © 2009 by Mandy Moore and Leanne Prain

ARSENAL PULP PRESS
Suite 200, 341 Water Street
Vancouver, BC
Canada V6B 1B8
arsenalpulp.com

The publisher gratefully acknowledges the support of the Government of Canada through the Book Publishing Industry Development Program and the Government of British Columbia through the Book Publishing Tax Credit Program for its publishing activities.

Efforts have been made to locate copyright holders of source material wherever possible. The publisher welcomes hearing from any copyright holders of material used in this book who have not been contacted.

Book design by Electra Design Group
Technical editing by Mandy Moore
Editing by Susan Safyan
All photographs by Jeff Christenson unless otherwise noted

PRINTED AND BOUND IN CHINA

Library and Archives Canada Cataloguing in Publication

Moore, Mandy, 1975–

Yarn bombing : the art of crochet and knit graffiti / Mandy Moore and Leanne Prain.

ISBN 978-1-55152-255-5

1. Knitting—Political aspects. 2. Graffiti. 3. Art and society.

I. Prain, Leanne, 1976– II. Title.

GT3912.M65 2009 746.43 C2009-900809-2

Please go to yarnbombing.com to report an error or find errata.

Table of Contents

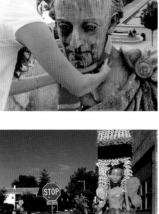

 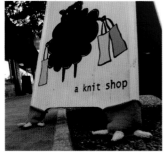 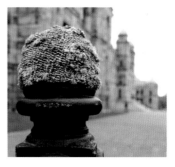

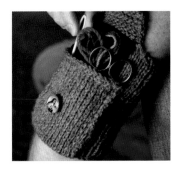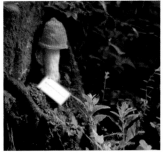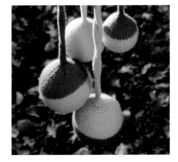

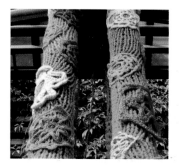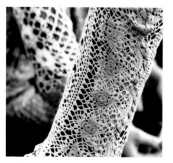

Foreword

AMY R. SINGER, EDITOR OF KNITTY.COM

My husband and I kayak. We're not the white-water rapids types—at least I'm not—but give us a bit of flat water and we can handle ourselves. We've paddled a strange assortment of places: a drought-season river in Vermont; a silent lake in the middle of Algonquin Park, quietly chasing the loons; an afternoon's jaunt along a quiet Cape Cod river that opened into the Atlantic Ocean, teaching us that we needed to do more research on tides before we ever tried that again; and the Don River on the one-day-a-year Save the Don eco-paddle and portage-fest. Our main launch point for a quiet afternoon's paddle is Cherry Beach, where we get to explore a tiny corner of Lake Ontario and then head over to Toronto Island for a popsicle.

Most of the things we've come across during our various paddles have been what you'd expect. We've seen huge carp, first noticed by the large splash they leave behind when they try to chase us out of their territory. Loons. Kelp. Things tossed overboard from pleasure craft that shouldn't have been. Seagull-poo-covered meeting places.

But the most notable sight on any of our trips was found close to home. We landed on the beach at Ward's Island, parked our kayaks, and on our way to grab our usual popsicle, we were stopped dead in our tracks by a crocheted tree. A linden tree, covered in intricate, delicate, perfect crochet.

It was as if the tree had slipped on an elastic lace bodysuit, the fit was so perfect. Except that the lace was done in fine, notoriously unstretchy cotton yarn, which meant the skintight fit of the piece was due to painstaking, careful work. The design was symmetrical and not, reminiscent of nature in sections, and nothing that could naturally evolve on its own in other places. I had no idea who had created this work of art, but I had great respect for the artist.

In much the same way, I stumbled into one of the co-authors of this book the first time through her work. Mandy Moore was introduced to me as a powerfully good knitter and designer, and brilliant at math. These are the essential characteristics of a successful technical editor (someone who makes sure knitting patterns are correct and knittable before publishing). So, based on a glowing recommendation, and without having met her first, I hired Mandy to be the Technical Editor for my magazine, Knitty. She's everything she was advertised to be and more, and we've worked together now from opposite sides of the country for more than four years. I'm thrilled and honored to be a tiny part of her first book. I haven't yet met Leanne, but any friend of Mandy's…

As I was writing this foreword, a quick web search provided pictures of the exact lace piece I'd found on Ward's Island, as well as the artist's name: Janet Morton (see **flickr.com/photos/karmakazi_/135134485**). Of course, she's one of the artists profiled in this book—Mandy and Leanne have written a rather deliciously comprehensive volume on this new subject.

I can't wait to see the final version of the book when it's released to the public. I've got a special popsicle set aside just for the occasion.

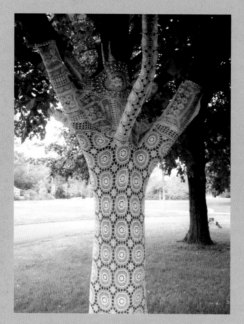

Linden in Lace, Janet Morton, 2003. Photo: Andrew Harris

Acknowledgments

This book would not be possible without the support of friends and strangers. Our sincerest gratitude goes to:

Our partners, Zak and Jeff, for their support at every stage of this project. We can't thank you enough for your love and patience, the advice on sound equipment, the home-cooked meals, and for providing a never-ending supply of chocolate.

The faculty, guest lecturers, and students of the Masters of Publishing Program (2007 cohort) at Simon Fraser University for offering their feedback and enthusiasm. Special thanks to Mary Schendlinger, Don Sedgwick, Mary Alice Elcock, Julia Monks, Laura Byspalko, Pearly Ma, and Alexis Roumanis for their invaluable advice and guidance.

Thanks to Diane Farnsworth, Susie Gardner, Christa Giles, Jessie Paterson, Susannah M. Smith, Jeff Christenson, Angie Ready, and Zak Greant for providing helpful suggestions on our proposals, patterns, and early drafts.

A heartfelt shout-out to Rachael Ashe, Jeff Christenson, Mary Alice Elcock, Gillian Gunson, Pippa Lattey, Nicole Lillo, Kassi Lloyd, Jason Prain, Angie Ready, Kat Siddle, Susannah M. Smith, Pearly Ma, and Tara Williston for modeling for us. We're glad that some of our favorite people are in this book. Thanks to Three Bags Full and Subeez Café of Vancouver, BC, for letting us shoot projects inside your doors. We can't thank Francesca Pagliotti enough for her ongoing encouragement, and for the discounts!

Our sincere gratitude to Robert Ballantyne for seeing merit in this project and for bringing it to Arsenal Pulp Press. We're thrilled to be published by such a cool company. Thanks to Brian Lam, Shyla Seller, Janice Beley, Richard Swain, and Bethanne Grabham for your support along the way. Our thanks to our editor Susan Safyan for all of her hard work and to Diane Yee and Lisa Eng-Lodge of Electra Design Group for thoughtfully involving us in the design process.

This book would not exist without the participation of interviewees and contributing artists. We thank the following for contributing and inspiring us: KnitGirl; Lina & Maria of Masquerade; Jan Ter Heide and Evelien Verkerk of Knitted Landscape; Magda Sayeg of Knitta; Edie of The Ladies' Fancywork Society; Daniel Fergus, Andrew Harris; Carol Hummel; Gelitin; Dropztitch; K.1.P.1., Beatknit and Knit Nurse of Incogknito; Janet Morton; Danielle Lowry; Kristen of the Micro-Fiber Militia; Mike Richardson; Erika Barcott; Theresa Honeywell; Aliza Sollins; Debora Oese-Lloyd; Lee Juvan; Debbie Stoller; Robyn Love; Chelsea Gunn; Stefanie Japel; Stephanie Lau; Kendra Biddle; MK Carroll; Pene Durston; Julia Hopson; Lauren Marsden; Kim Tame of Feed the Children; David Cole; Corrine Bayraktaroglu and Nancy Mellon of JafaGirls; Marianne Jørgensen; Amy Singer of **Knitty.com**; Sarah Hardacre, Rachael Elwell, and Louise Woodcock of ArtYarn; Brittany Wilson; Rebecca Cantebury; Elvis Robertson; Elina of knit sea; Stickkontakt; Bjami Ketilsson and Rasto Meliska.

A very special thanks to photographer Jeff Christenson who captured every project at a moment's notice. We could not have completed this project without his hard work and creativity.

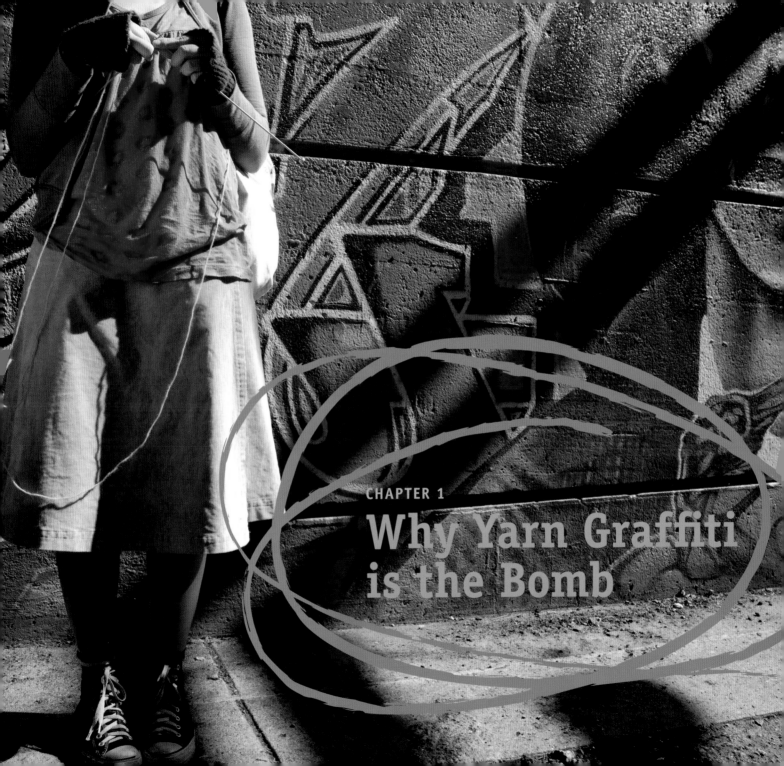

CHAPTER 1
Why Yarn Graffiti
is the Bomb

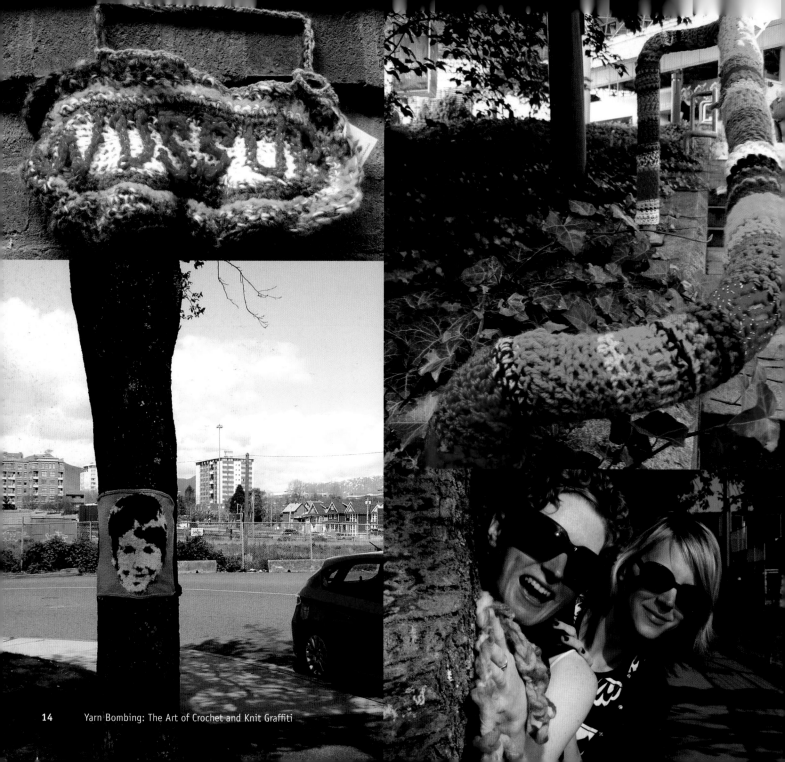

> People have responded. They see this obviously hand-knitted piece that has been wrapped around something that is completely inanimate, and it turns alive. In fact, it not only turns alive, there is something comforting and loving about it. You don't look at the pieces we wrap and get angry or mad. You are happy.
>
> —MAGDA SAYEG, FOUNDER OF KNITTA

PREVIOUS PAGE CLOCKWISE FROM BOTTOM: Vancouver artist KnitGirl created this intarsia likeness based on a childhood photo of street artist Redrum that he often uses in his own work. Photo: Knitgirl. Wassup sign in Stockholm, Sweden, by Stickkontakt. Photo: Malin Larsson. A colorful hit by Stckkontakt in Stockholm, Sweden. Photo: Malin Larsson. Two yarn bombers scout their territory. Photo: Jeff Christenson. THIS PAGE, ABOVE: Yarn bombing in the downtown core of Vancouver, Canada.

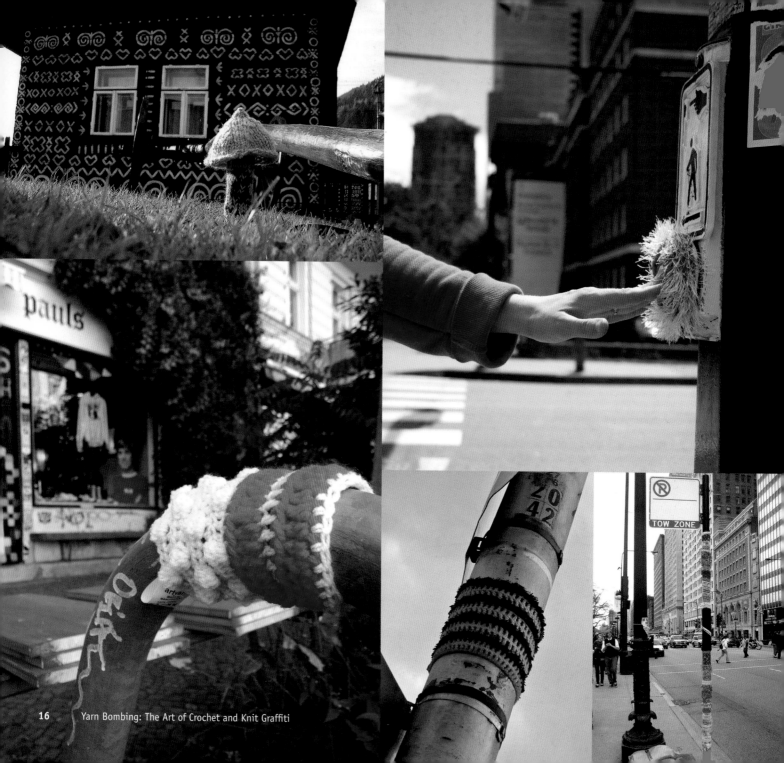

Yarn Bombing: The Art of Crochet and Knit Graffiti

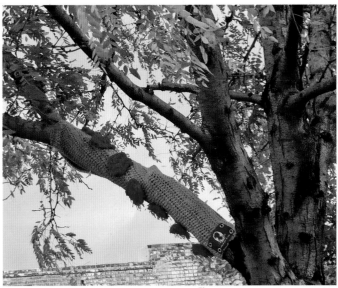

ON CITY STREET CORNERS ALL OVER THE WORLD, yarn graffiti artists snake their work around telephone poles, wrap it through barbed wire, and flip cozies onto car antennas. Originally started in Houston, Texas, by a crew named Knitta Please (a.k.a. Knitta), there is now an international guerrilla knitting movement embraced by artists of all ages and nationalities. Knit and crochet graffiti has been seen in countries from Canada to Chile to China. This book has been written to inspire you to take up the needles (or hooks) and join us in world yarn domination!

Merging the disciplines of installation art, needlework, and street art, yarn bombing takes many forms. It generally involves the act of attaching a handmade item to a street fixture or leaving it in the

PREVIOUS PAGE, TOP TO BOTTOM, LEFT TO RIGHT: Knitted Landscape leaves a mushroom in Slovakia. Photo: Rasto Meliska. Crochet work by Micro-Fiber Militia member Timeline, in Chicago. Photo: Micro-Fiber Militia. ArtYarn wraps a pole in crochet. Photo: Sarah Hardacre. A striped crochet pole cozy. Photo: The Ladies Fancywork Society. THIS PAGE LEFT TO RIGHT: Sparkly JafaGirl art, Yellow Springs, Colorado. Photo: Corrine Bayraktaroglu. A blossoming fancywork by The Ladies Fancywork Society, Denver, Colorado. Photo: The Ladies Fancywork Society

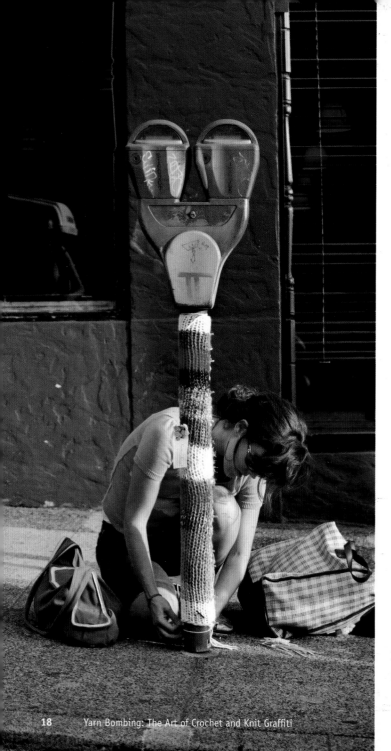

landscape; however, this varies from artist to artist. Yarn graffiti can be as complex as a sweater that has been created to cover a statue or as simple as a crocheted rectangle wrapped around a lamp post. Some artists tag items as tiny as door handles, others create works large enough to cover a public monument. Some yarn bombing works are elaborate, consisting of sophisticated stitch patterns; other artists create flat pieces in one type of stitch. Some people choose to tag their favorite hangouts, other people tag on a whim. Some knit graffiti is brightly colored and in-your-face, other pieces are placed in obscure locations with the hope that a sharp-eyed observer will spot them.

The first thing I did was a little black and pink, diagonal striped cozy for a snow gate. I was kind of on a mission because I wanted to start hitting my neighborhood pretty hard, and so I kept track of all the pieces I did. I know pretty much all of the early ones—I obsessively kept track of them. —KNITGIRL (VANCOUVER, CANADA)

People have various motivations to partake in yarn bombing. The juxtaposition of yarn and graffiti is humorous to some artists, while others see it as a more serious act that builds on a long-standing practice of renegade street art. Others do it to escape the boredom of tedious day jobs. Some want to liberate the needle arts from their long-held association with utilitarian purposes. Yarn bombing can be political, it can be heart-warming, and it can be funny. Most of all, yarn graffiti is unexpected, and it resonates with almost everyone who encounters it, crafters and non-crafters alike.

THIS PAGE: Magda Sayeg, founder of Knitta, attaches a tag in Seattle. Photo: William Anthony
NEXT PAGE: KnitGirl bombs Strathcona in Vancouver, Canada. Photo: KnitGirl

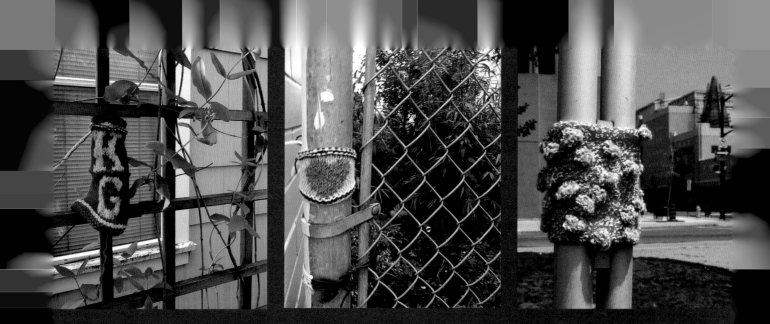

I wanted to show my appreciation [for other street artists]... I felt connected to them. I had never met them, but they all felt like kindred spirits somehow. It was a way of finding some inclusion into what I was seeing around me. —KNITGIRL

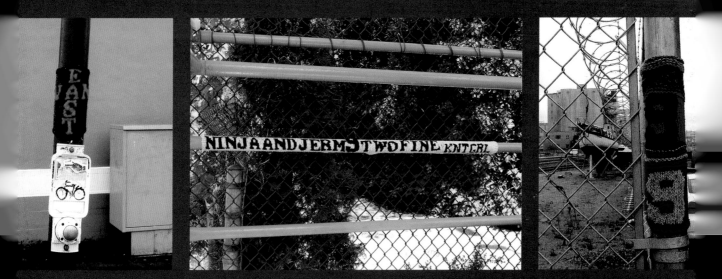

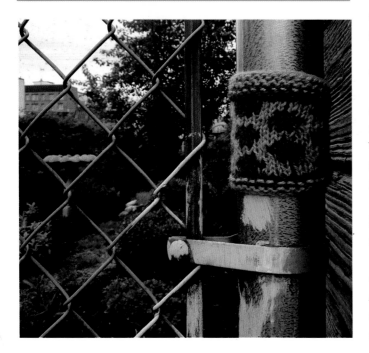

In the beginning . . .

In 2005, Magda Sayeg and her friend (soon to be known as PolyCotN and AKrylik) knit a rectangular strip out of blue and pink acrylic yarn, which they sewed to the handle of a door in Houston, Texas. Sayeg now refers to this door handle cozy as the "alpha piece," as it was the first piece in what has become not only a large and exciting body of work, but also a new form of expression. Sayeg described that first piece: "I started so simply. I sat in my clothing shop and I looked through the glass. I was just tired of it, and I needed something bright. I knitted the door handle for the front of my store. I got such a strong reaction that I knew that I wanted to do more. People came inside and said 'What is this? What artist did this?' So I called my friend and said, 'This sounds kind of weird, but follow me through—I'd like to tag the stop-sign pole down the street.'

"I would see people park their car and take pictures out of it and scratch their heads. That's when the idea was born. Let's take this out on the street, graffiti style; let's tag everything we can think of," she recalls.

PolyCotN and AKrylik became the inaugural members of Knitta, the first yarn graffiti crew.

In just a few years, yarn graffiti has become a widespread phenomenon, with crews in North America and Europe planting tags wherever they travel. One member of Knitta even tagged a stone in the Great Wall of China. The crew has tagged France, Germany, Sweden, El Salvador, and Canada. They've left tags in New York taxicabs and have hit the Golden Gate Bridge in San Francisco.

Their signature piece has become the car-antenna cozy, which can be knit up quickly and slipped onto a parked car as a lovely fuzzy surprise for the car's owner.

"There were things in my life I thought would be my fifteen minutes of fame," says Sayeg. "I have a clothing shop, and I design clothes. And I thought that that was going to be my thing. But this simple, silly idea of making something pretty in my own world has taken me international and given me more than anything else in my life has."

The work of Knitta and other knit-graffiti artists has inspired a global revolution. We asked a variety of yarn bombers, who work in both crochet and knitting, to tell us how they got started:

I've got to say that Knitta totally inspired me. I don't even recall where I saw them first, but when I saw the Knitta group and the whole hip-hop connotation it really opened my mind, and I was totally blown away and started thinking outside the box, and started doing what I thought about. —KNITGIRL (VANCOUVER, BC, CANADA)

*I saw a comic strip that Kaisa Leka (**kaisaleka.blogspot.com**) did when she saw a knit graffiti in Norway. It sounded fun, and I Googled it. I loved the idea right away! I work alone; I think I'm the only active tagger in Finland.* —KNIT SEA (TAMPERE, FINLAND)

We discovered textile graffiti a few years ago when we saw some work by Knitta Please. Then, when I joined a knitting club a year ago, the conversation surrounding the phenomenon of textile graffiti just arose naturally with a bunch of like-minded, yarn-centric people. —ARTYARN (MANCHESTER, UK)

I found out about knit graffiti after my brother sent me a link to the knit cozy by Masquerade on the dock in Sweden. I thought, 'That looks amazing! I want to do that!' I loved how the bright stripes and fuzzy textures of the cozy made the world look a little brighter and more fun. I did some research (on Google) and found out about similar groups who were doing the same thing, from Paris to China. So I rummaged in my closet and found pieces of a hot pink sweater that I was never going to finish. I sewed one of the finished sleeves to an old signpost, and I have never looked back! —ALIZA OF BALTIMOREDIY (BALTIMORE, MARYLAND, USA)

BaltimoreDIY gets up. Photo: Aliza Sollins

★ What does yarn bombing look like?

Just like traditional graffiti, yarn bombing can take any number of forms. Here are some of the most popular tags we've seen:

- car antenna cozies
- doorknob covers
- street sign pole cozies
- organic forms, such as flowers, mushrooms, and rocks
- intarsia messages (intarsia is a technique for knitted colorwork)
- sweaters for trees

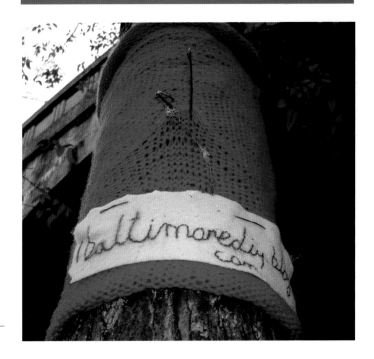

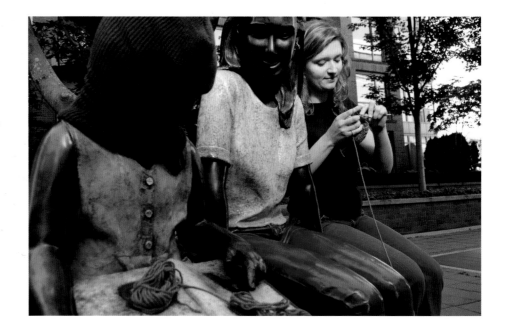

Art and activism

While many may have never have considered yarn and anarchy to be congruous terms, yarn craft and activism have a long history together. Some crafters see knitting and crocheting as ways to change the world. Many people see the act of creating something stitch by stitch with their own hands as a stand against mass-produced goods and corporate values. Crafting as an artistic act, rather than a feminine hobby, is seen in certain circles as subversive. Acts such as knitting and crochet, which traditionally have been devalued by society as domestic work, are now considered by many to be political statements. BETSY GREER, who keeps the website **craftivism.com**, has said: "Each time you participate in crafting you are making a difference, whether it's fighting against useless materialism or making items for charity or something betwixt and between."

While all yarn-graffiti artists have different reasons for tagging, knitters and crocheters have a long history of rabble-rousing. From groups such as Calgary's Revolutionary Knitting Circle, who protested the World Petroleum Congress in 2002 by knitting a web to stop a military convoy, to Microrevolt Projects, who exist to "investigate the dawn of sweatshops in early industrial capitalism to inform the current crisis of global expansion and the feminization of labor," knitting and crochet can be political, artistic, and yes, renegade.

Artist LISA ANNE AUERBACH may be the quintessential political knitter. She uses her knitting machine to knit bold sweaters covered in timely political statements, which she both wears and exhibits in galleries. You can check out her work at her website (**lisaanneauerbach.com**).

The unexpected nature of "abandoned" knitting or crochet can be considered a defiant act in our ordered society. In this age of manufactured goods, handcrafted items are often considered cherished objects. By leaving pieces on the street, yarn bombing becomes a wonderful and unexpected form of anarchy. As soft, touchable graffiti, yarn bombing gives a nod to street art but also comes from a long history of textile installation. At the same time, most yarn bombing artists claim that,

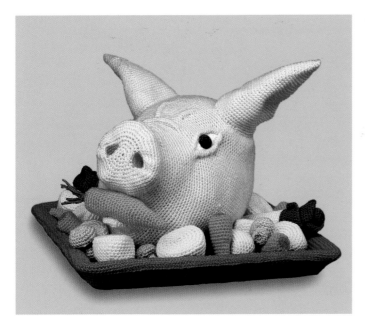

on a basic level, they simply enjoy making things by hand and sharing them with strangers.

There is something inherently empathetic about wool, about knitting. It doesn't present the same barrier to the viewer as other mediums.
—JANET MORTON (TORONTO, ONTARIO)

Because knitted and crocheted objects are intrinsically homey, using yarn craft in unconventional ways can have a special kind of resonance. A number of artists use these media in their studio practices, playing on the many strong associations they carry. Many of us have a lifetime of memories of sweaters and afghans that are warm, comforting, soft, and useful. They were likely made by women, and though a good deal of skill and time was used to make them, that skill and time has often been undervalued. All of these factors make yarncraft a potent means for artistic expression. Here are just a few artists who are changing the ways we see knitting and crochet.

FREDDIE ROBINS uses knitting to exciting unsettling effect in her work, which includes pieces like a knitted human skin (*Skin—A Good Thing to Live In*, 2002), and knitted replicas of the homes of female murderers or the places where they killed (*Knitted Homes of Crime*, 2002). In her artist's statement, she talks about subverting cultural preconceptions about knitting and "disrupt[ing] the notion of the medium being passive and benign." Check out her website to see a wide selection of her work and to read the rest of her artist's statement (**freddierobins.com**).

PATRICIA WALLER's crocheted sculptures, which are often violent or surreal, are both more shocking and more comical because of her chosen medium. A rabbit, impaled by a large carrot, hangs from a wall, dripping blood (*Rabbit 3*, 2003). A perky, wide-eyed pink pig's head sits in the center of a platter of vegetables with a carrot in its mouth (*Sucking Pig*, 2000). The rabbit, carrot, blood, pig, vegetables, and platter are all crocheted. The touchable, toy-like crocheted texture intensifies the emotional impact of the cartoonish pieces, while the

THIS PAGE: *Territorial Knittings*, Lauren Marsden, 2006; wool. Photos: Lauren Marsden

time implicit in the thousands of tiny, well-executed stitches gives weight to the subject matter. Waller's website (**patriciawaller.com**) has many examples of her work.

JANET MORTON has been creating knitted installation pieces since the early 1990s. In 1992, she created "Memorial," a giant knitted workman's grey wool sock, complete with a red and white striped border. The finished piece measured eighteen feet long and four feet wide, and was draped over various structures in downtown Toronto. Morton has created many large-scale works, including an eighteen-foot cardigan for a giraffe and a fifteen-by-four-foot mitten called *Big Big Mitt* (1994). One of her most memorable pieces was *Cozy* (1999), for which she used over 800 recycled sweaters to knit a covering for a small house on Ward Island in Toronto, Ontario.

Morton has also knit in performance. For thirty days in 1995, she occupied a storefront on Queens' Street West in Toronto to create the installation "Newsflash: Madame Defarge Eat your Heart Out." During this installation, she knit the headline of each day's newspaper, along with some personal information, into a giant piece of stranded colorwork. You can see more of her work at **ccca.ca/artists/artist_work .html?languagePref=en&link_id=5793**

LAUREN MARSDEN (**laurenmarsden.com**) has created an installation project called *Territorial Knittings* (2006). Choosing to replicate street signs on roads she's lived on, Marsden knitted five different cozies for streets in Victoria, British Columbia. Each of the cozies are installed without show and left to their fate. The remarkable aspect of Marsden's work is that she replicates every detail of the street signs' appearance. Her rendering is so exact that passersby may have to look twice to notice the covers are there.

CAROL HUMMEL uses crochet, among other materials, to make very personal statements. She says, "I realized that I could…take the ideas from my life and turn them into artwork that could possibly connect

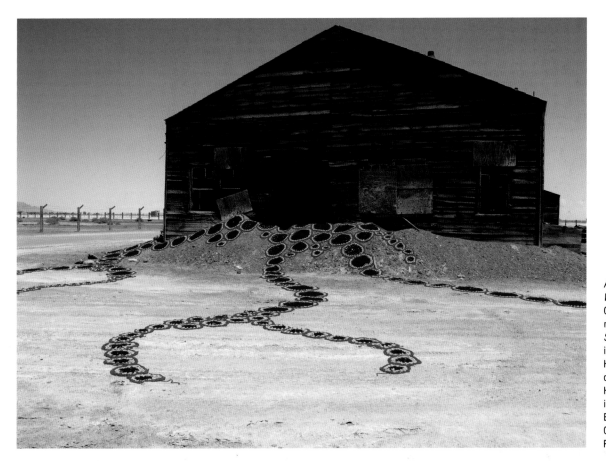

Abandoned Barracks, Wendover Air Force Base, Carol Hummel, 2007, macramé cord, barracks. *Silver Island Mountain* in Wendover, Utah, Carol Hummel, 2007, macramé cord, mountain. Photo: Carol Hummel. Carol Hummel installing *Tree Cozy*. Photo: Emily Hummel. *Tree Cozy*, Carol Hummel, 2005, yarn. Photo: Carol Hummel

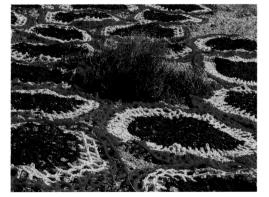

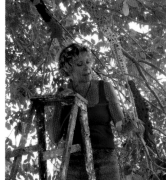

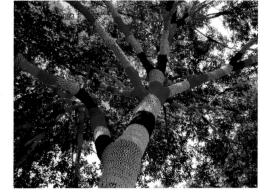

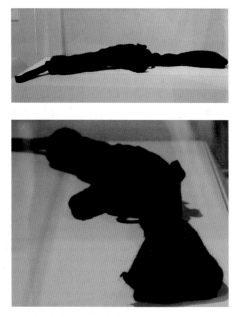

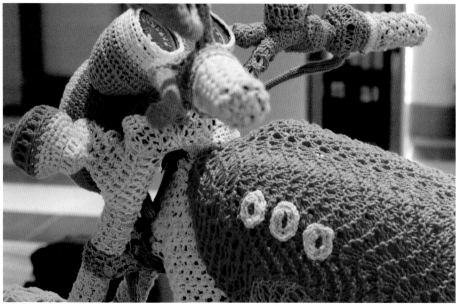

Hand Knit Machine Gun, Theresa Honeywell, 2006; wool, **www.knitmotorcycle.etsy.com.** Photo: Theresa Honeywell. *Everything Nice*, Theresa Honeywell, 2006, acrylic yarn over motorcycle. Photo: Theresa Honeywell

with other people's lives." Often contrasting the elements of comfort and confinement, Hummel uses yarn and yarncraft in her work to explore issues relating to gender, relationships, personal growth, and nostalgia. She writes of imbuing objects with nostalgia, "evoking memories of bygone times and places when life was good." You can see and read about her work at **carolhummel.com.**

XENOBIA BAILEY crochets unique, beautiful, and memorable pieces, with the stated intent of developing a strong and distinct African American aesthetic. She has built the most elaborate, exuberant, and architectural hats you can imagine, and enormous, layered mandala compositions of stunning intensity. Bailey blogs at **xenba.blogspot.com.**

THERESA HONEYWELL juxtaposes the soft nature and feminine associations of knitting with masculine objects like power tools and motorcycles. Her best-known piece is a motorcycle (*Everything Nice*, 2006), all parts of which she covered with pink knitted and crocheted covers. She has also knit a floppy woolen machine gun and a cuddly jackhammer. You can see her work at **theresahoneywell.com.**

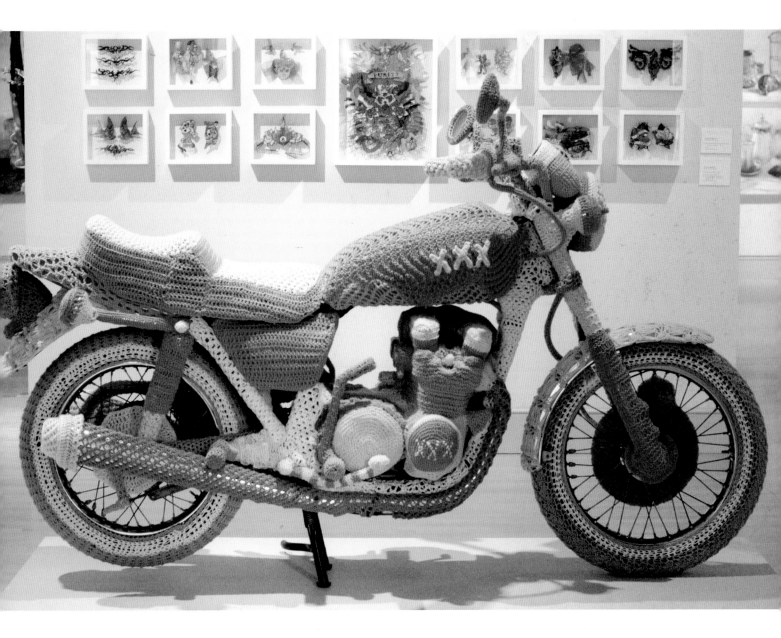

⭐ An informal timeline of yarn bombing

CIRCA 4TH CENTURY, CE—No one knows the exact origins of knitting, but an early form has been found in Egyptian tombs dating from the 4th and 5th centuries. Others say it came from the Arabian Peninsula and spread throughout the Mediterranean region to other parts of the world.

EARLY 19TH CENTURY—Crochet sweeps Europe, providing a low-cost way to replicate expensive needle and bobbin laces.

1939 TO 1945—World War II "Knitting for Victory" campaign. To support the war, the US Army and Navy issued patterns that people could use to knit garments for soldiers to wear during the winter. Patterns included balaclavas, socks, and gloves.

1970s—Crocheters start using chunkier yarns to create bold, colorful pieces, emphasizing the hand-crafted folk-art aspect of their work.

1970s—Graffiti artists go all-city. At the end of the decade signatures began to appear in Philadelphia and New York. Artists such as TAKI 183, Stay High 149, PHASE 2, Stitch 1, Joe 182, Junior 161, Barbara 62, Eva 162, and Tracy 168 added their street names to their graffiti on subway cars, which would travel throughout the city spreading their names.

1980s—Graffiti artists in New York City "bomb" the subway system, and City Hall wages an all-out war on graffiti artists in order to drive them from the city.

1985—Rhode Island School of Design student Shepard Fairey creates "André the Giant Has a Posse" sticker and posts it wherever he can. This campaign later develops into the "Obey Giant" campaign, with half a million stickers distributed worldwide.

1992—Janice Morton knits *Memorial*, a giant sock, which is left on the Trans-Canada Highway.

2000—British spray-paint and stencil artist Banksy's work becomes noticeable around Bristol and London, UK. The line between street graffiti and high art blurs.

2002—**Knitty.com**, the first truly alternative knitting magazine, launches online. Knitty will change the face of knitting projects forever by publishing patterns such as MK Carroll's knitted womb and Dawn Payne's edible thong made of licorice rope.

2004—Crochetme launches as a website and then as an online magazine, offering hip garment patterns for crocheters.

2005—The women of Knitta tag a doorknob with the "alpha piece" in Houston, Texas, and start a knit-graffiti revolution.

2005—Seattleite Erika Barcott creates a one-armed turtleneck sweater for a tree (*Treesweater*), posts a photo of it to her blog, and becomes an instant Internet sensation. See page 167 for a pattern.

2006—Swedish group Masquerade places their first tag in Stockholm and officially begins their world tour of tags. Their motto is *Nemo attexet sobrius* (nobody knits sober).

2008—Online social website **Ravelry.com**, devoted exclusively to knitting and crochet, launches. Over 200,000 knitters join to chat, while hundreds of others are wait-listed to join the site. Yarn bombing groups meet via forums to show off their work, chat about technique, and plan group projects.

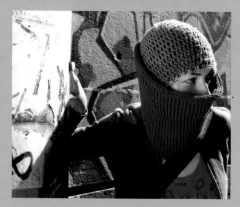

Knitted Womb, MK Carroll, 2002, yarn. Photo: MK Carroll. Erika Barcott's *Treesweater* on the cover of Seattle's independent newspaper *The Stranger*, art director, Corianton Hale. Photo: *The Stranger*. Masquerade shows their love of statues by creating a balaclava for one. Photo: Masquerade. Today, crafty yarn bombers can be found in cities around the world. Photo: Jeff Christenson

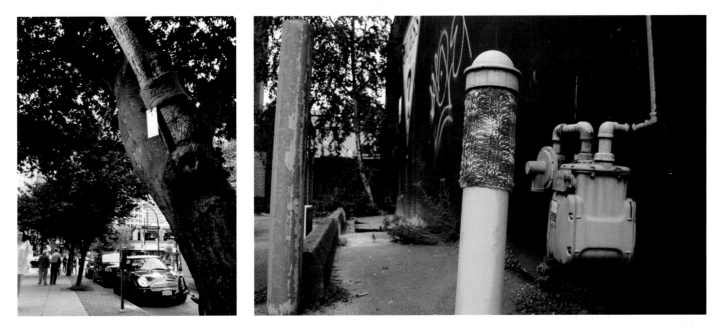

But is it art?

The artistic merit of graffiti and street art can be dated back to a conference held by the Scandinavian Institute of Comparative Vandalism in 1961. While no hard-and-fast ruling has been made, certain areas of the world, such as Stockholm and New York City (where several knit graffiti artists live), have stringent anti-graffiti laws.

Some believe graffiti is a method of reclaiming public space. Others feel that it is an unwanted nuisance and a crime. Since most street art is created by individuals, and not sponsored by government or commercial entities, it tends to have an illicit feeling. Often political in nature, "street art" is a label adopted by artists who wish to keep their work unaffiliated.

Artists often enjoy the risks and challenges of taking work to the street. Knit graffiti allows what can be a very solitary medium to become a very public one.

But doesn't graffiti have a bad rap?

Yarn graffiti's impermanence and benign nature allow you to produce exciting, eye-catching street art without damaging property or, arguably, breaking the law. Yarn graffiti is easy to remove and should not damage the surfaces it is applied to. This impermanence is one of the most important differences between this and other forms of graffiti. However, like traditional graffiti, yarn bombing can be considered a political and subversive medium of communication.

We get our inspiration for tags in seeing somewhere we want to hit, somewhere we want to get up. So this could be a particular piece of street furniture or a public sculpture, something that looks like a real challenge, and most specifically a particular place we want our tag to be seen, like our favorite art galleries, clubs, or shops, always places for which we have respect. —ARTYARN

NEXT SPREAD: ArtYarn bombs Berlin, 2008. Photos: Sarah Hardacre

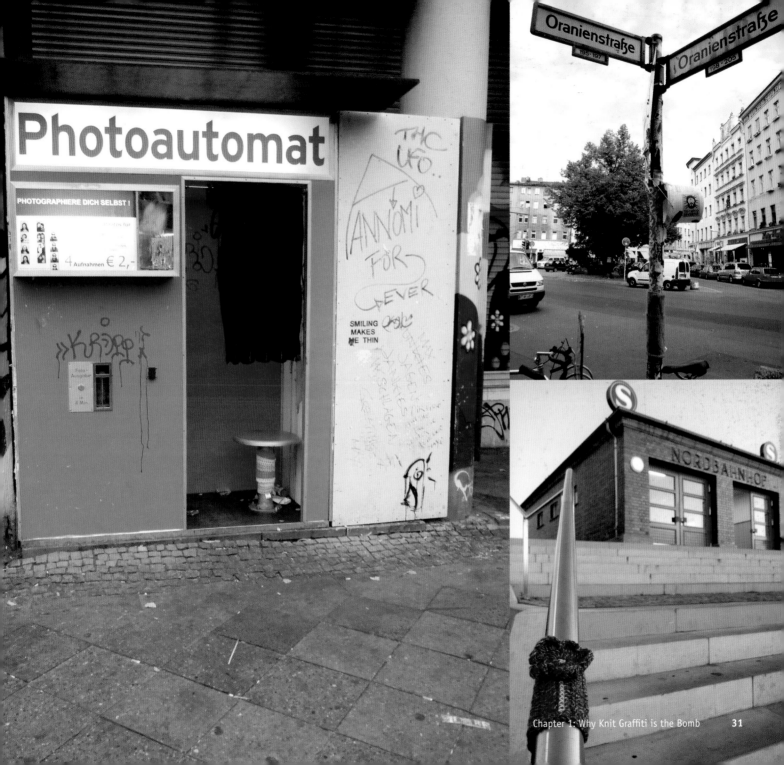

Graffiti and street art

Graffiti is a complex art form. It can be many things, from simple scratch marks on a surface to an elaborately painted wall. The term graffiti was first used to describe etchings found on the walls of ancient cities (see Timeline, page 28). The eruption of Mount Vesuvius in Pompeii preserved graffiti such as political slogans, literary quotes, curses, and magic spells.

Painted graffiti appeared on railroad boxcars in North America in the 1920s. During World War II, American troops left graffiti throughout Europe, including the famous "Kilroy was here" illustration.

In the late 1960s, graffiti began to evolve into the art form we now recognize. It was used by both political activists and street gangs. Graffiti went through many changes between the late sixties and the mid-seventies. The art form morphed as artists experimented with different color palates, shading techniques, and lettering.

It was also at this time that artists began to move from the street to subway yards. In these more deserted places they could create pieces that were more complex. This is how the act of bombing was said to have been established. In the 1970s, tags began to look more calligraphic. Due to the large number of people creating graffiti, artists needed to develop their own styles. Many artists began to increase the size of their tags, trying out different letter types and line thicknesses. Artists began to make marks such as polka dots, crosshatches, and checkers. Outlining tags also became popular. Stencil graffiti became associated with punk rock as followers of anti-establishment bands such as Black Flag and Crass sprayed their names and logos onto club walls and hangouts.

In the late 1980s, New York City, which had been the hub of graffiti throughout the '70s, attempted to remove all subway cars with graffiti on them from the transit system, and artists had to resort to new ways to express themselves. Many began displaying their work in galleries—among them renowned artists Jean-Michel Basquiat and Keith Haring. Today, the word "graffiti" has evolved to constitute a wide range of graphics applied to surfaces. Most commonly created with spray paint and markers, graffiti can also take other forms such as stenciling, stickers, paste-ups, and, of course, yarn.

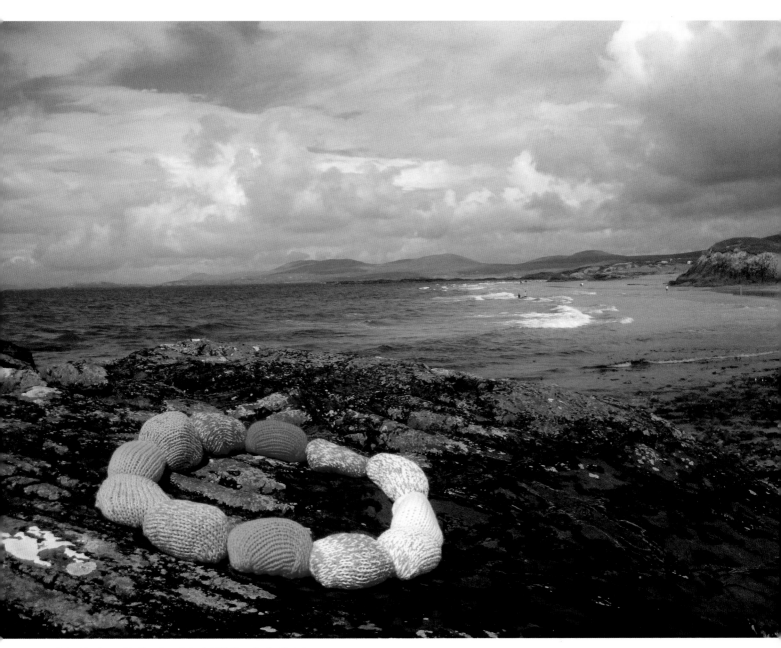

Knitted Landscape hits Glassillaun, Ireland, 2007. Photo: Evelien Verkerk

★ The language of graffiti

TAG—the basic writing of an artist's name, usually with spray paint or a marker. Sometimes tags will have an artist's initials or nickname, or they may contain cryptic messages. We use the word "tag" to refer to any piece of knitting or crochet used as a graffiti object.

PIECE—a more complex piece of graffiti that usually includes the artist's name. Often pieces have more then three colors, and use stylized letters. Typically, these pieces take longer to create, increasing the artist's likelihood of getting caught.

BLOCKBUSTER—a piece created to cover a large area. With territorial artists, blockbusters can be created with the purpose of blocking other writers from creating work on the same surface. A person who creates a blockbuster with this intent is known as a "roller."

WILDSTYLE—an inspiring style of graffiti involving arrows, interlinked letters, and connected points. Letters often seem indecipherable to the untrained eye. Wildstyle pieces mean a great investment of time—they can often take days to create.

GET-UP—the act of putting graffiti on a surface.

GETTING UP—having as many tags and bombs in as many places as possible.

ALL-CITY—graffiti artists living in NYC in the 1970s and 1980s wanted to be seen in all five boroughs of the city; the term is now used to mean bombing in a variety of places to get your work out there.

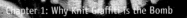

AN INTERVIEW WITH
Masquerade

Two Swedish women, Lina and Maria, formed the well-known knit and crochet group Masquerade in 2006. Based in Stockholm, Sweden, Masquerade has hit places as far apart as Indiana and Latvia. Masquerade's tags use both knitting and crochet techniques, frequently on the same piece. Admired by many other artists, their tags are often embroidered with words or decorated with a delicate stitch pattern. They've covered swan statues with balaclavas, deer statues with legwarmers, and created a variety of artistic cozies for street poles around the world.

Masquerade is part of a larger street art group in Stockholm called Los Fulanos (roughly translated as the so-and-so's). The two women are the only ones in the crew who do yarn-related graffiti. Masquerade documents the development of their world tour on their blog at **maskerade.blogsome.com**.

Q: Can you tell us a bit about yourselves?
A: We both live in Stockholm, where we grew up. We are both twenty-two and are students at the university.

Q: It seems that you travel a lot. Is it on school breaks that you do your world tour?
A: Yes, school breaks and weekends and any time we can get away. We travel whenever we can.

Q: Can you tell us how the two of you got started?
A: We started out in the fall of 2006. Lina crochets and I knit, and we've been doing that for a long time. Both of us are into street art, and this was the perfect combination for us.

Q: Did you see other knitting or crochet graffiti first, or was it an idea you came up with on your own?
A: No, we'd heard of Knitta. But we'd never seen anything in Stockholm. I was living in Paris, and we'd never seen it there. Now we see it everywhere.

Q: We've been interviewing people who say that they saw Knitta as the first group. I'm now finding people who say, "I saw Masquerade." I think there are a lot of people mimicking your work now.
A: That's cool. I think we're probably the most well-known in Sweden, at least.

Q: How did you both learn how to knit or crochet? Did you teach yourselves?
A: Lina's mom taught both of us.

Q: When you make the pieces that are partially knit or partially crocheted, is that both of you using both techniques, or do you each do a bit?
A: We do a bit of both. I knit better than Lina. She crochets better than me. We try and work together, and sometimes we try and trade. One knits and the other crochets so we can try and get better. But usually it's faster if she just does the crochet stuff. And it looks way better.

Q: Where do you create your tags?
A: We do it everywhere—usually on a train to Stockholm, on a bus, in school, in class. Everywhere where we have a few minutes. We will have a beer in a bar and knit.

Q: What are your favorite objects to tag?
A: Statues. Any kind of statues—animal statues or statues of kings. Big statues! [laughs]. At a festival at Stockholm, we put a tie on a king. It was really, really high. I don't think the pictures do justice to how scary it was.

Q: There is a picture of you balancing on a railing while wearing high heels. I was impressed.
A: For some reason we had a climbing thing that day; we had to go as high as possible.

Q: If you are tagging at festivals, or in a place where people can see you doing it, do you try to go unseen, or do you let passersby see you?

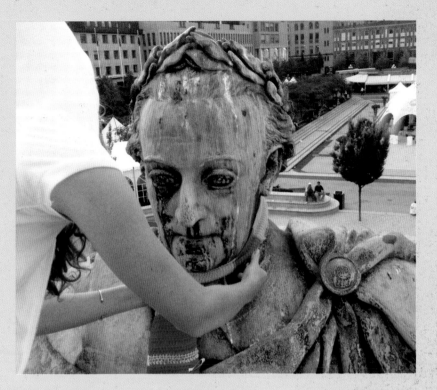

With the help of a crane operator, Masquerade ties one on during a festival. Photos: Masquerade

A: We try and go as unseen as possible, but we don't hide. We go [tagging] at night when there are not too many people around. We don't want to talk to them or tell everyone what we are doing. We don't want to be recognized. We want to do it in peace. But when people see us, it's not like we're afraid. It's not like anyone is going to call the police or anything. We just don't want the attention.

Q: What do you tell people when they ask you what you are doing?
A: It doesn't happen very often. People just pass by or they just say hi and wave. They don't really stop and ask us. Or if they do, we try to wave them off.

Q: What about when you are knitting in your classes?
A: I think by now most people know, but we haven't really told them—it sort of gets out somehow. I used to always tell people I was making cozies, camera cozies, and mittens. They'd ask what happened to that "hat" I was knitting, and I'd say, "Oh, it didn't turn out that well—I let someone else have it." Now, I don't even bother to lie about it.

Q: I noticed that there is a huge variety in your tags in terms of color and shape. Where do you get your inspiration?
A: I think we get a lot of inspiration from street art and also from old craft books from our grandmothers or great-grandmothers—from anything that catches our eye. The place inspires us to create the tag.

Q: It sounds like a lot of the time you'll be making your tags for a particular place.
A: Sometimes we just make them. It depends. We find a spot and say, we are going to tag this place; mostly [we tag] traffic poles and streetlights in the city so we know what size to make it so it will fit.

Q: Can you tell us in which countries you've tagged?
A: Sweden, of course, Denmark, Germany, France, Spain, Italy, Switzerland, Latvia, and all over the US—New York, California, Chicago, and the countryside of Indiana.

Q: Wow! So, what's next on your list?
A: South America. We want to go to Eastern Europe. Anywhere we haven't been. We want to go everywhere!

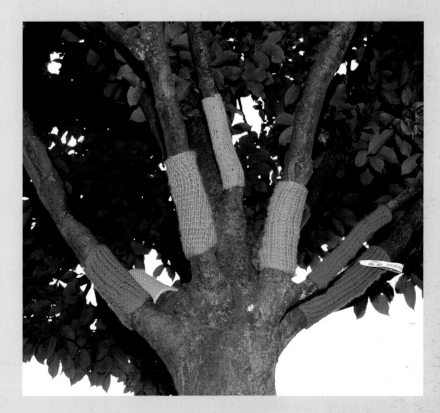

Q: When you go on these trips, are you taking tags with you or making them as you go?
A: If it is a long trip, we try to bring them and make some more. Last time we were in Barcelona, we made everything there, but it's not as much of a vacation when you feel you have to knit tags.

Q: I see that you were in an exhibition in Stickspår at the Sörmlands Museum. Was that all your work, or were there other people in it?
A: We've been in two to three exhibitions. We did one first with street artists; we were the only knitters. And then we had one that was a knitting exhibition where we were the only street artists.

Q: Do you find, when you are mixing with other street artists, that you are getting equal respect from them?
A: Yeah, the ones who talk to us. I'm sure there are some people that might think otherwise. It's not as hardcore as actually painting a wall, but people have been nothing but nice to us.

Note: See Masquerade's pattern for an embroidered tag on page 83 and their manifesto on page 69.

How to Build Your Arsenal

Yarn Bombing: The Art of Crochet and Knit Graffiti

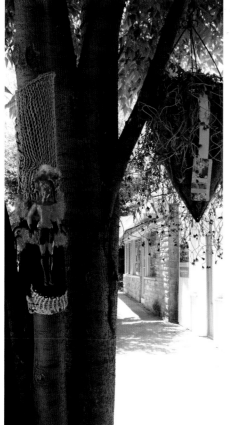

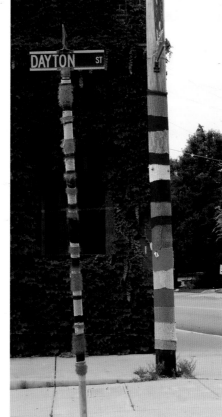

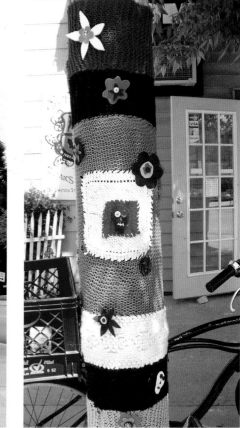

IF YOU HAVE NEVER KNIT OR CROCHETED BEFORE and want to try your hand at yarn graffiti, here's some good news: you can make really good-looking graffiti tags using the most basic stitches. The very first thing you knit or crochet may be an awkward little square of work, full of holes and errors, but you can still sew it around a signpost to bring an unexpected bit of color and delight to someone's day.

We both just knit—basic stitches and bands of colors and textures. We love trees and poles and specifically wanted to fill a whole street.
—JAFAGIRLS (YELLOW SPRINGS, COLORADO)

The JafaGirls are Nancy Mellon and Corrinne Bayraktaroglu, who bomb the streets of Yellow Springs, Colorado. One of their best-known works is the *Knit-Knot Tree*, which was developed for an art stroll in 2007. After installation the tree received additions from the public. The JafaGirls have also used Barbie dolls in their work—now recognizable as part of their signature style. Photos: Corrinne Bayraktaroglu

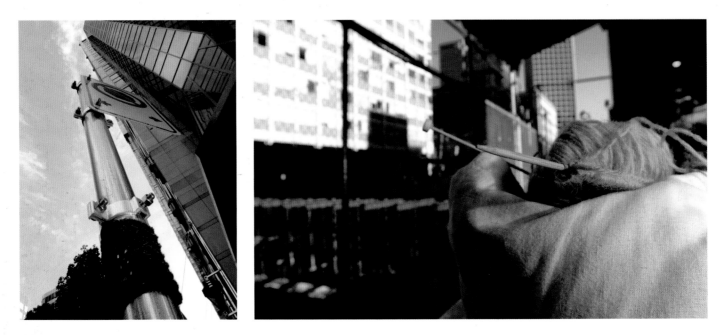

Where to begin

Many people are taught to knit or crochet by a friend or relative. If someone in your life is an avid yarn-wrangler, they will likely jump at the chance to share their passion with you. One caveat about this, though: mad crafting skills are not always accompanied by mad teaching skills. An experienced knitter or crocheter may have forgotten a lot about what it's like to learn the stitches, how awkward and counterintuitive the movements can be when you've never done them before. You may also find that someone you are compatible with in other respects is not a person you get along with in a teacher-student dynamic, so don't be afraid to find a new source of instruction if you need to.

Knitting and crochet classes are another great way to learn and are generally easy to find. Your local yarn shop is a great place to start looking for classes; they will most likely offer them at the shop and will know of other places that do, too. Some craft shops and community centers also offer classes. As with learning from a friend or relative, be sure to find a teacher with whom you are compatible. You may think we're belaboring this point, but it's a very important one; knitting and crochet can be difficult and uncomfortable at the beginning, and bad learning experiences can really turn people off of these wonderful crafts.

Don't be discouraged if it takes a while to become comfortable with your new craft. We've often heard people say "I tried knitting once, and I can't do it!" It's a skill like any other; practice is essential.

I knit at home, usually when I'm watching TV. Mostly I use wool or something wool-like, but I have used some acrylic too. I have used buttons and beads to decorate. —KNIT SEA

If you are the sort of person who learns effectively from books, there are many excellent ones on the market that can help you learn to knit and crochet. Spend some time browsing in a book store, looking at the directions in different manuals. In the same way that you need to take

care when finding a teacher, it is important to find a book that explains things in a way that makes sense to you.

I've always been kind of a solitary knitter. A couple of times I was invited to a stitch 'n bitch and knew they were some kind of punk rock girls knitting in my neighborhood. Maybe it's my day job, but nighttime is really not my time, I do solitary knitting. —KNITGIRL

Here are a few book recommendations. These are only a tiny sample of what's out there.

KNITTING:
Stitch 'n Bitch: The Knitter's Handbook by Debbie Stoller (Workman, 2004).

The Knitting Experience, Book 1: The Knit Stitch and *Book 2: The Purl Stitch* by Sally Melville (XRX Books, 2002, 2003).

Knitting for Dummies by Pam Allen et al. (Wiley, 2002).

CROCHET:
Teach Yourself Visually Crocheting by Kim Werker and Cecily Keim (Visual, 2006).

Stitch 'n Bitch Crochet: The Happy Hooker by Debbie Stoller (Workman, 2006).

Not Your Mama's Crochet by Amy Swenson (Wiley, 2006).

My favorite materials are yarn, felt, and embroidery thread. The materials are cheap, just fuzzy enough without being too fluffy, and come in so many delicious colors! I generally use acrylic yarn since it's cheap, but I'd love to start experimenting with some natural fibers to see how they feel around an object over time. —ALIZA OF BALTIMOREDIY

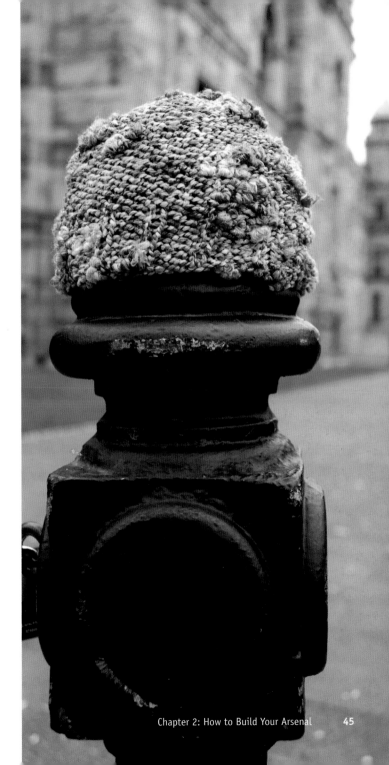

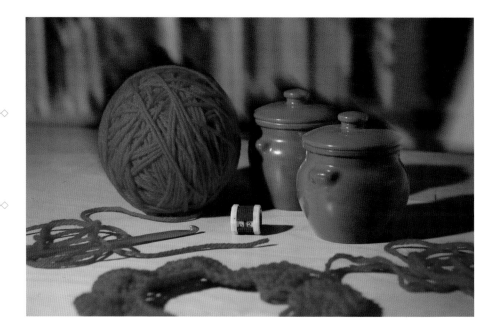

Choose the tools that
appeal to you, and don't
spend too much.

Equipment

Here's more good news: to begin your yarn crafting life, you need very little in the way of equipment. Really, you need only yarn and knitting needles or a crochet hook. We recommend going to a yarn shop to buy these things, for reasons which will soon become clear. However, if a thrift shop or craft store is the best source available to you, keep the following things in mind when stocking up.

YARN: The most important quality your first ball of yarn should have is smoothness. It doesn't need to be soft, it just needs to have a simple, cylindrical shape and an uncomplicated surface texture. There are yarns of this type available at every level, from cheap balls of acrylic at discount department stores to the most luscious and costly cashmere.

It's important that the yarn is not nubbly or furry, or you will have a really hard time seeing how your stitches are formed. For the same reason, choose a yarn that is not thread-thin, and that is light in color.

Huge, chunky yarn is also not a good idea; you'll be able to see what's going on, but it can be unwieldy to work with really bulky yarn at first.

Yarn weights have names, and we recommend using a worsted or light chunky weight yarn (see why yarn shops are a good idea?). The label on a ball of yarn will list a recommended gauge (see page 63). The gauge is expressed in different ways by different yarn companies, and not all the ways are very clear for new crafters. Also, almost all labels give a gauge for knitting but not crochet. Crocheters can use the knitting gauges listed to help them figure out the yarn weight, though. A yarn in the range from worsted to light chunky will have a recommended gauge ranging from fourteen to twenty stitches to four inches (ten cm). It can be hard to find this information on ball bands until you are used to reading them; if possible, ask a yarn shop salesperson for help.

For most of the projects in this book, we have used a widely available, fairly inexpensive wool yarn called Cascade 220, which is an example of a good learning yarn; it's a basic, worsted weight wool yarn with a smooth texture.

Almost all of us agree about using the crappiest acrylic yarns that we can. They stay brighter longer. —EDIE OF THE LADIES FANCYWORK SOCIETY (DENVER, COLORADO AND AMSTERDAM, THE NETHERLANDS)

We work mainly with wool, whatever we can get our hands on. Color is important to us; the brighter the better, and cost is the most important factor. Cheap as chips leads to cheery knitting, so charity shops, second-hand shops, and flea markets are our favorite places to buy materials. We also work with found fibers, string, wire, and plastic carrier bags. —ARTYARN

HOOKS AND NEEDLES: Once you've chosen your yarn, it's time to choose your tools. The ball band on your yarn will list a recommended knitting needle size; again, you may want help finding this information. To begin with, if you are knitting, try the needle size listed on the ball band; if you're a crocheter, choose a hook one or two sizes larger than the recommended knitting needle size. Note that these sizes are only starting points. Once you get going, if you find that your work is very tight, buy a larger hook or set of needles; if your tension is quite loose, invest in smaller tools.

Tools come in different materials: metal, plastic, and wood are the most common. Choose the tools that appeal to you, and don't spend too much. Not only might you need to change tool size, but you may find that you prefer another material. All materials have their advantages and disadvantages—and their devotees. As well, not all metals, woods, or plastics are created equal; for example, rosewood needles are smoother than bamboo, and less inclined to split at the tip (they're also a lot more expensive). Don't hesitate to try out different tool types as you build your arsenal.

ONE MORE THING: A blunt needle with a large eye is the final tool you should purchase if you want to use your first piece as a yarn graffiti tag. These are called yarn needles, darning needles, or tapestry needles. Metal and plastic yarn needles can be bought very cheaply at any craft shop.

★ The stash basket

I put an ad on Craigslist that said, if you have yarn you are just getting rid of, I'd love to have it for some art projects. I got calls from all kinds of people, and I went over to old ladies' houses and picked up trash bags full of old acrylic yarn. —EDIE OF THE LADIES FANCYWORK SOCIETY

The Ladies Fancywork Society knew that they would be getting together to crochet, so they created a three-foot-wide stash basket. Whenever the group met, each member dipped into the stash and created her own piece. The shared yarn also created an occasion for group members with very different aesthetics and color collections to coordinate with each other.

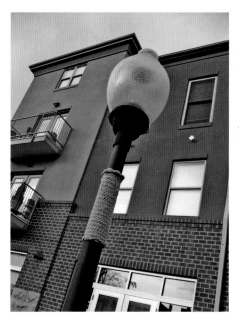

Plan your attack on the streets

As you create your first tag, you'll want to plan how you are going to go about your first act of yarn bombing. Some graffitiers knit tags with a specific place in mind. Others prefer to simply make their tag and then find a place to leave it.

> *Often, in our morning walks, we play with ideas, or inspire each other. I would say also the colors and the textures of yarn are very yummy and inspiring, and we want to play with the yarn and get knitting. Sometimes, a sad or ugly pole inspires us, or a need to spread a little joy.* —JAFAGIRLS (YELLOW SPRINGS, OHIO)

If you are the type who plans ahead, ask yourself where you want to bomb. A first tag is important—you may want to put it in a place that has a special meaning to you, or perhaps you'd prefer to brighten a dingy corner.

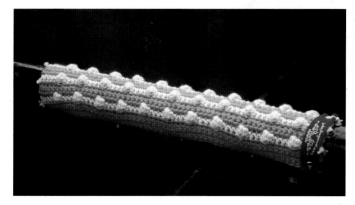

Photos: The Ladies Fancywork Society

Once I tried to sew a piece near a Metro Station (the light rail in Baltimore) in the middle of the day. No one was around, so I went for it. Then, right as I was in the middle of sewing on the cozy, a train pulled up, and all these people got out! My face was red, but I just kept my head down and didn't look at anyone.
—ALIZA OF BALTIMOREDIY

Some places are the bomb

Yarn bombing is an art to be celebrated! Tag in places where people will appreciate your work. We recommend placing your tags where others will welcome the quirkiness of yarn graffiti. A yarn or craft store should love your work. Likewise, your favorite coffee shop, a community garden, a daycare, a library, or a food co-op will likely be receptive to the madness that is textile graffiti. By tagging places you love, you can show your appreciation for the sort of work that indie businesses and organizations do. Your work is likely to bring a smile to the faces of others who appreciate offbeat art.

I think I've become more relaxed doing it. I used to be really scared. My heart would start pounding hard. As if anyone cares what you're doing. Especially in our neighborhood, where there are lots of people doing lots of things. I mostly just started doing it in my 'hood where I lived, and I started by gifting people antenna cozies. I made about fifteen or twenty of those and then just started putting them on cars around the neighborhood, and didn't tell anyone about it. —KNITGIRL

Once you've decided on a fixture to tag, it may be worth doing a quick walk or drive by before you attach your tag. If you are a tagger who likes to plan ahead and go undetected, it is worth determining what the best time of day is to go unseen—this may mean after business hours or before sunrise.

I like early morning as a good time to tag. It's nice because no one is out on the streets yet, and it's a nice way to start the day. Also, I feel like it's less suspicious to be sewing something to a tree in the morning hours instead of in the dark of night. —ALIZA OF BALTIMOREDIY

Determine how you are going to attach your piece to its target. Will you be able to stand around long enough to stitch up a long seam? If it's a busy corner, perhaps adding buttons, Velcro, or snaps to your tag will allow you to attach it quickly. Consider the object that you are going to tag—will your tag be visible to a lot of people, or will it go undetected by everyone except those at a child's height?

Keep in mind that when you tag, you really can't predict how long a piece will stay where you place it. That's the fun of textile graffiti—you have no control over the end result. Be prepared to see your target bare again the next time you pass by it, but don't forget that the piece may have been taken home by a new fan of your work.

We tag very early in the morning—4:30 a.m.—and generally on the weekend. We then top up the work every so often, as things do get taken away. —INCOGKNITO

How to measure up

Not sure if your tag will fit? Measure the spot you are going to hit. If you want to be exact and you don't mind curious stares, a measuring tape is the best way to go. If you think whipping out a workman's tape in the middle of the day is a little bit too conspicuous, there are other ways to determine what size of tag to make.

If the object is small enough, you can always measure it with parts of your body. You can measure an object by finger length or use the distance between your wrist and elbow. If you carry a tote bag or an umbrella, you can also use these lengths to determine the size of the object. For example, if a traffic pole is the length of eight umbrellas

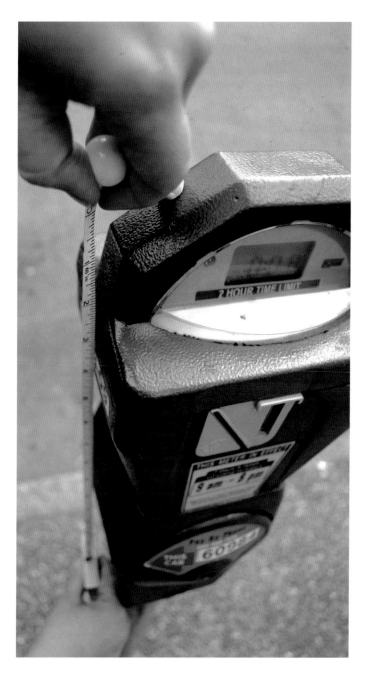

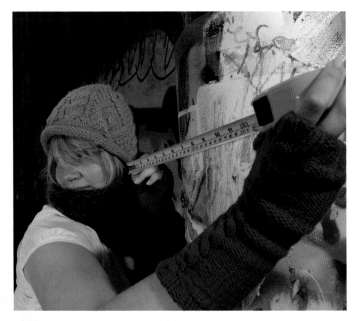

stacked end to end, and the umbrella is eleven inches long, the pole is eighty-eight inches long. It's probably about one umbrella strap in circumference. It's not a perfect equation, but it will do in a pinch. How far can you reach around a pole with your thumb and forefinger? What about with both hands? It's easy to measure your hands when you get home. The nicest thing about most yarn graffiti is that it's stretchy, so your measurement can be off by an inch or two.

Starting off, there was a lot about measuring things or making things for [specific objects]. You go out a couple of times with pieces that you've just put together, and you realize that you just can't fit them on. [You think] this is way too big for a light pole and way too small for a giant light pole and way too big for a fence, so I'll just keep it. Then you start to get comfortable with the diameter of a pole or a fencepost. You get stuff that you can put anywhere. That's kind of the point that I'm at. But I'm thinking of specific areas where I just attach things. —MICRO-FIBER MILITIA

Yarn or dental floss is also a good way to measure circumference. Dental floss is great because it is thin and therefore hard to see from far away. Wrap the dental floss around a pole and then break the floss or tie a knot once you've measured the diameter. You can use this measurement as a guide when you crochet your tag. (See Chapter 3 for more information about how to make tags to fit a specific target.)

Show your stealth

While we think that wearing disguises to remain incognito can be fun, experienced bombers know that the best disguise is confidence. Generally, if you act like you are doing exactly what you are supposed to be doing, most people will assume that your actions are perfectly normal. You may get some funny looks when you are tying pompoms to the door of your nearest shop or affixing an antenna cozy, but if you act nonchalant and keep doing what you are doing, passersby will generally keep on walking.

I was on Princess Street, which is the busiest street in Edinburgh, and it was 5 p.m. on a very busy Friday. I was standing on a bench hanging up something, and there was a woman sitting next to me. She didn't even look at me. —JAN FROM KNITTED LANDSCAPE

Occasionally, someone who will want to know what you are making may approach you. Usually, these are people who are needle workers themselves or who have romantic notions that you'll create a sweater for them. Sometimes you may want to tell them exactly what you are doing. Keep in mind, however, that yarn bombing can turn into a long philosophical debate with strangers. In the interest of social deviancy and safeguarding your time for mad tag creation, you may want to stretch the truth a little. Who said that anarchists were honest?

When people ask me what I'm making, I just tell them that I'm making a swatch or I'm making a scarf. It's always a good excuse.
—EDIE OF THE LADIES FANCYWORK SOCIETY

Here are a few ideas for pat responses that you can give to curious bystanders:

- It's a sweater.
- It's a scarf.
- It's something big.
- I don't know yet, what do you think it should be?
- It's a horse blanket.
- I'm just experimenting.
- A large car shammy.
- A tent.
- I'm just trying to use up all the wool that I have.
- A piece of urban art.
- I don't know—I figure the yarn will tell me what it wants to be at a certain stage.

The JafaGirls have another tactic to end speculation. They say, "Just tell them it's for a public art project."

★ How to knit and crochet in stealth

• If you are a knitter, remember that circular needles are smaller than regular straight needles—they sit well in your lap and do not draw a lot of attention.

• As pretty as metallic jewel-toned crochet hooks are, sometimes it is less conspicuous to use dull-colored tools in public. Save the glow-in-the-dark knitting needles for non-tagging projects.

• If your project is huge, do not pull it out and display it. We find that large cotton shopping bags will hold most large tags well, and you can just crochet slightly above the bag, concealing the rest of the project inside.

• If possible, don't knit in public. Several of the crews that we talked to prefer to knit or crochet only at home. Rather than creating while on your commute, make your tags in front of the television or while you're enjoying your Sunday morning paper. Some yarn bombing office workers pull down the blinds and knit behind a closed door during coffee breaks.

• Make your piece in bits—when you are in public, only work on small parts of your tags, and piece them together in the privacy of your own home.

• When you are knitting or crocheting while on public transit, always take the back seat.

• Take a lesson from the ninja handbook—wear all black.

• Keep a small basket or bag with you to hold your balls of yarn. There is nothing more conspicuous than having stray balls of wool roll away from you across the floor.

• If you are a knitter, use needles made of plastic or wood; they are quieter than those made of metal.

Incogknito

We interviewed a group of guerrilla knitters from a small seaside town on the southeast coast of England. Hailing from the town of Whitstable, members Dropztitch, K.1.P.1., Beat-Knit, P-Wise, and Knit Nurse are showing their stealth skills and love of the needles through their collective, known as Incogknito.

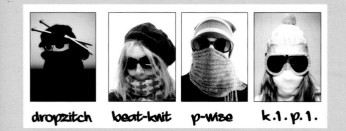

dropzitch beat-knit p-wise k.1.p.1.

Q: Tell us about yourselves.
A: Our day jobs are: teacher; self-employed design/crafts; teacher/artist; bookseller/ceramist. We range from age thirty-two to fifty-three; our average age is thirty-nine-and-a-quarter!

Q: How did you get into textile graffiti?
A: We were inspired by a Texan friend whose car had been graffitied by Knitta. We wanted a project for the Whitstable Biennale [a contemporary arts festival, see **whitstablebiennale.com**], and we wanted to incorporate outdoor sites and make the project accessible to the community.

Q: Do you do it alone or with others?
A: We are a core group of four members, but we encourage other knitters to join in through self-promotion.

Q: How long has your crew been together?
A: We have been together since December 2007.

Q: How did the members meet each other?
A: Whitstable is a small town, and we've been involved in other art projects together.

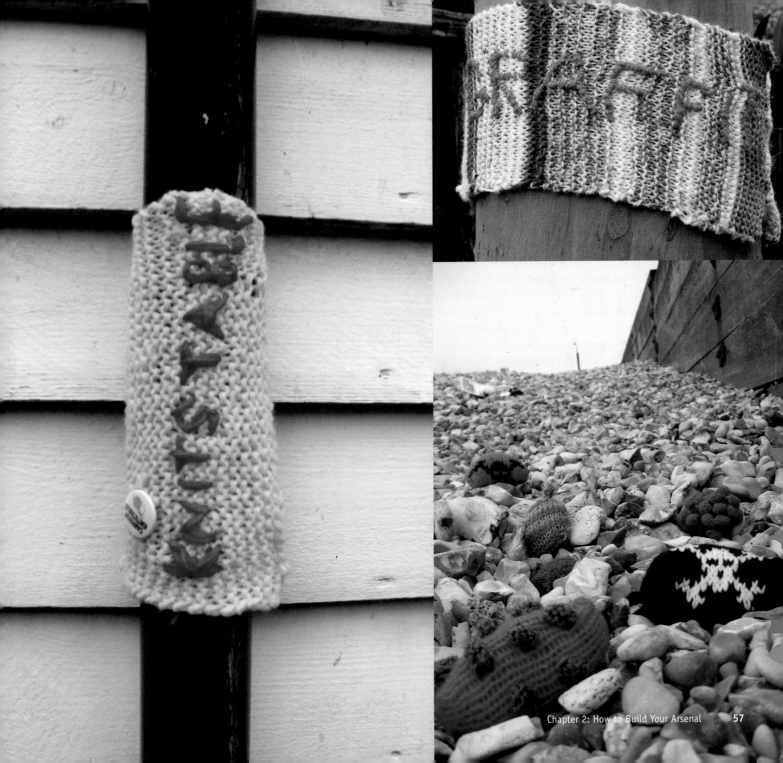

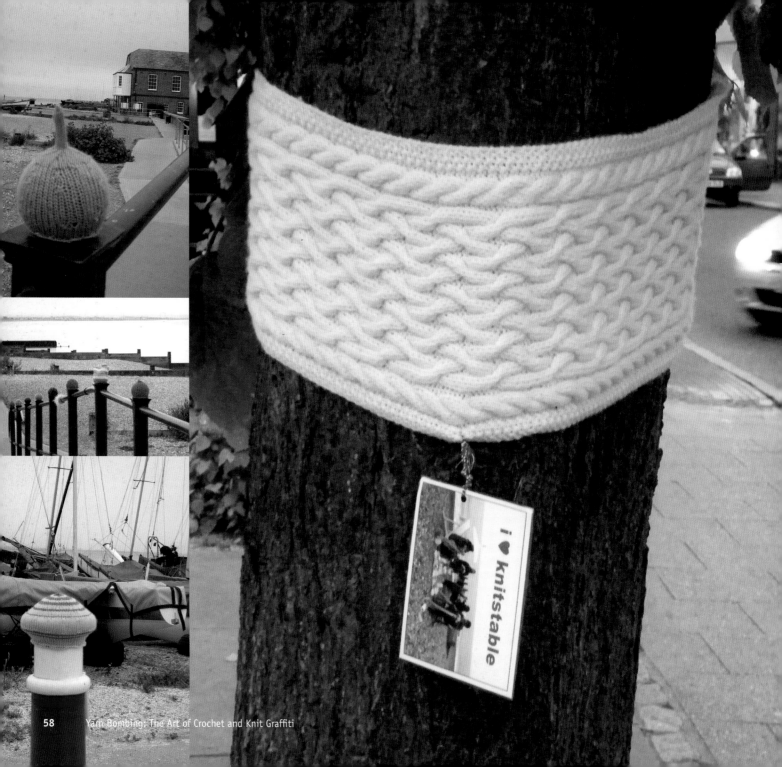

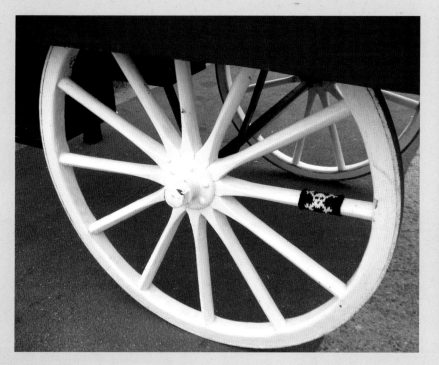

Photos: Incogknito

Q: Where do you create your tags?
A: We create our knitted tags at home and during regular meetings at each others' houses and beach huts.

Q: What sort of materials do you work with?
A: As well as all sorts of yarn (wool, cotton, nylon), we have used shells, pebbles, sweets, and lollipops. We have also used reclaimed knitting, recycled from charity shops and jumble sales.

Q: Do you knit or crochet or do both?
A: We knit and crochet specifically designed patterns and shapes for selected locations. We also adapt reclaimed knitting and make pom-poms.

Q: What are your favorite objects to tag?
A: We specialize in bespoke coverings for sea front bollards [short posts used for mooring boats].

Q: Do you have a signature style?
A: To each knitted piece, we attach our laminated postcards, which we designed in a traditional seaside style. They have our website address on them and encourage others to join in. Knit Nurse also likes to knit a skull and crossbones design into her work.

Q: How do you attach your tags?
A: To attach we sew firmly, often using translucent strong thread.

Q: How do you get your inspiration for tags? What else inspires you?
A: We survey the town and create site-specific pieces. We also incorporate into our knitted patterns the spray-painted permanent graffiti tags from around town.

Q: What parts of the world have you tagged?
A: London, New York, Montreal, Copenhagen, and Paris, as well as our own town of Whitstable in Kent, UK.

Q: Does your family know you do this? Do your co-workers know?
A: Yes—but only those who can be trusted!

Q: What do you say when people ask you what you are knitting?
A: Dropztitch says, "I am knitting a bra for a pig."

Q: Have you ever been caught in the act of yarn bombing?
A: Yes, by early-morning shift workers.

Q: What did you do?
A: We tagged them—a fisherman's oyster barrow and a street cleaners' rubbish cart!

Q: What's the best piece of knitting graffiti you've ever executed?
A: Seafront bollards—a knitted installation; a skull and crossbones on a wagon wheel; knitted pebbles on the beach; and, when a local newspaper wrongly attributed our work to other artists, we snuck down in our disguises at night and tagged a huge banner across the offices that read, YOU KNITWITS!

CHAPTER 3

Basic Tagging:
Rectangular Tags

Rectangular tags are easy to make and versatile to use, and they provide a perfect shape for all kinds of experimentation.

MANY OF THE YARN GRAFFITI TAGS out there are rectangular pieces that have been sewn around a cylindrical object. There's a good reason for this: rectangular tags are easy to make and versatile to use, and they provide a perfect shape for all kinds of experimentation. If you are so inclined, you can have a creative and satisfying yarn graffiti life without ever making anything but rectangular tags.

Making rectangular tags can be as simple as beginning with whatever number of stitches strikes your fancy, from two to 200, and knitting or crocheting until you get sick of it. The resulting piece will fit around something, somewhere. When we interviewed local knit graffiti artist KnitGirl, she told us about the tiny tag she made for the leg of a stool at her workplace:

Some of my co-workers know about my yarn graffiti work. We have those really uncomfortable stools, utilitarian school stools at my workplace. I took a tiny, little wee tag with one button, just three or four stitches wide, and tagged the bottom of a stool. And that way when you're doing mundane chores at work, you can feel inspired by the tag! It's kept me going. —KNITGIRL

The usefulness of simple rectangular tags is especially good news if you are a new knitter or crocheter. One of the frustrations common to new yarn wranglers is that it's difficult to make an object of a predictable size, as even tension comes only with a bit of experience and comfort with the tools and techniques of yarn craft. It's not a concern, however, if you use your first few bits of work as yarn graffiti tags.

The irregular shapes and textures of beginner pieces need not detract from their loveliness when applied to a friendly neighborhood signpost. These early swatches can also be tarted up with embroidery, appliqué, buttons, or anything else that strikes the artist's fancy; take a peek at Aliza Sollins' Appreciation Tags on page 102.

Once you're fairly comfortable as a knitter or crocheter, however, you may want to plan tags of a specific size, to fit a particular tagging target. To do this, you will need to understand the basics of gauge.

Gauge is your friend

PREVIOUS PAGE, PHOTOS AT TOP, LEFT, AND RIGHT: Whimsical rectangular tags knit by Finish artist Knit Sea. CENTER: KnitGirl covers an antenna with a rectangular cozy. Photo: KnitGirl. LEFT: KnitGirl uses a bobble stitch pattern to create a dynamic rectangular tag. Photo: Knitgirl. RIGHT: Masquerade's infamous colored ring. Photo: Masquerade

The sad truth is that a lot of experienced crafters have gauge frustration. If you read yarncraft blogs, you may form an impression of Gauge: The Mighty and Terrible, or at least The Tricky and Unreliable. But, in fact, if you want to have control over the results of your work, a familiarity with this fundamental factor of knitting and crochet is indispensable.

To put it most simply, gauge (also known as tension) is the number of stitches and rows over an area with a particular measurement. In North America, Europe, and Australia you will most often see gauge measurements expressed over a 4 in/10 cm square; for example:

20 stitches and 27 rows = 4 in/10 cm

In patterns, gauge is usually measured over a particular stitch pattern, generally a stitch pattern used in the project. In the pattern for the Switcheroo Sweater on page 143, for example, the gauge is measured over stockinette stitch (right-side rows are knit, wrong-side rows are purled), because that is the stitch pattern used for the body of the sweater.

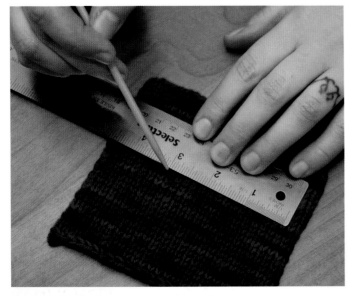

Counting stitches in knitting.

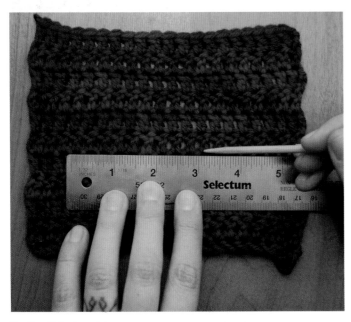

Counting stitches in crochet

If more than one size of needle or hook is used in the project, the gauge listing will also specify which tool size the stitch pattern is worked with:

20 sts and 27 rows = 4 in/10 cm in stockinette st
using US #7/4.5 mm needles
or
16 sts and 17 rows = 4 in/10 cm in crocheted seed stitch
using US K/10.5 / 6.5 mm hook

If you are working from a pattern, it is imperative to achieve the listed gauge. Otherwise, the piece you've spent scads of time making will not turn out the size you expect it to be. We can't stress this enough: *If your gauge is different from the gauge listed, the piece you knit will be a different size than the size listed.*

Here's something else about gauge that is important to know: You don't need to get the gauge listed using the tool size listed. The tool sizes listed in patterns are recommended sizes only. Build up a good collection of needles and hooks so that you have a wide range of sizes in the material (wood, metal, plastic, etc.) you prefer. This way, when you want to start a project and don't get the listed gauge using the same tool size as the designer, you will have the smaller or larger tools you need to try again. Remember: Correct gauge is important, recommended tool size is not!

But how do you find out your gauge with any given yarn and tool?

Swatching

Swatching is the term used for working a practice piece of knitting or crochet. You cast on or chain a bunch of stitches, and work in a given stitch pattern until you have a large enough sample to give you the information you need, then you bind off or fasten off. If you're swatching to determine your gauge for a garment, you would then block the swatch (see page 66), but since we're talking about yarn graffiti here, you don't really need to worry about it.

People swatch for all sorts of reasons: to try out stitch patterns and color combinations, to experiment with a yarn and learn about its qualities, and, of course, to check gauge. In all cases, the larger the swatch you knit, the more accurate the information will be that you gain.

To get an accurate gauge measurement, it's a good idea to work a swatch that's about 6 in/15 cm square. If you are crocheting, work a chain that is a bit less than 6 in/15 cm long; your chain will likely be tighter than the main part of your swatch.

If you are knitting, you'll need to do a bit of math to determine the number of stitches (usually abbreviated as sts) to cast on. Take a look at the recommended ball band gauge over 4 in/10 cm. For this example, I'll use a hypothetical yarn with a ball band gauge of 18 sts = 4 in/10 cm. If you are swatching in the stitch pattern used for a particular project, use the pattern gauge over 4 in/10 cm, instead of the ball band gauge.

For example, let's say you want 6 in/15 cm worth of stitches, which is 1.5 times the number of stitches you need for 4 in/10 cm (6 inches divided by 4 inches equals 1.5. Or, 15 centimeters divided by 10 centimeters equals 1.5).

So, 18 stitches times 1.5 equals 27 stitches to cast on. If your resulting number is not a whole number, round up or down, as you prefer. This number does not need to be exact.

Now, work in the stitch pattern until your swatch is about 6 in/15 cm long, or until you're really, really bored. If, after you've worked a few inches, you find that your fabric is looser or tighter than you would like it to be, work a row or two in a different color or pattern (for example, purl a row on the right side of a stockinette st swatch, or work a row of single crochet through front loops only on a double crochet swatch), then switch to a different sized needle or hook and keep going.

If you're crocheting, you can measure your swatch without fastening off, but if you're knitting, be sure to bind off fairly loosely before measuring your swatch. Measurements taken with work still on the needles are rarely accurate.

If you are making a garment or something else that will be washed at some point in its life, or if the piece you're planning has a stitch pattern

Photo: The Ladies Fancywork Society

that must be blocked in order to finish it, block your swatch (see section on blocking, page 66) and allow it to dry completely before measuring. The gauge will change when you block it!

Lay the work flat on a table (not on your lap). If the swatch is very curly, weight or pin the edges down, taking care not to stretch it. Lay a ruler (not a tape measure) on the work, so that its long edge is parallel with a row of stitches. Align the zero mark with the edge of a stitch, beginning several stitches in from the edge of the work. Count the

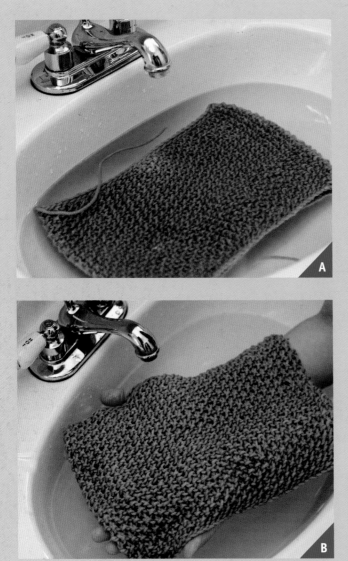

★ Blocking

Worked in the finishing stages of a knit or crochet project, blocking is a process with magical superpowers. It evens out the fabric and improves its drape. It makes seaming easier. If you've made a garment, it allows you to fine-tune the fit. Blocking a piece worked in a cable or lace pattern will open up the pattern and allow it to take its intended form, effecting a transformation that's hard to believe until you've experienced it.

Although some projects you may work in your yarn crafting life will require quite precise and detailed blocking, it's easy to learn the basics by blocking a few small swatches or tags. This takes very little time and space and will help you understand what to do when a pattern instructs you to block—and why you should do it.

If possible, use a wool or wool-blend yarn for your blocking experiments. Wool and other animal fibers respond wonderfully to blocking, while synthetic or plant fibers, such as acrylic or cotton, may not.

There are three common techniques for blocking: wet blocking, spritz blocking, and steam blocking. As with any other aspect of knitting or crochet, each method has its devotees and its detractors, and there are myriad variations on each technique.

1. WET BLOCKING

This is the technique that was used for the sweaters and swatches shown in this book. To wet block, immerse the piece in lukewarm water and allow it to soak for at least fifteen minutes, until it is thoroughly saturated (A). Lift it carefully from the water, taking care to support all parts of the piece (B). Wool is incredibly stretchy and malleable when wet, and can easily be distorted. If you have a large piece like a sweater, I recommend first placing it in a large colander to let some of the water drain out.

Gently squeeze (but never wring) the piece to get out as much of the water as possible. If you have a large piece, roll it up in a towel and carefully squeeze it until the towel is soaked (C).

Once you have removed as much water as you can, lay the piece out on a flat surface covered in a nonporous material such as a plastic bag. Some people prefer to block on a towel, and this works well if the piece is fairly thin. If a piece is thick or has layers, however, this can slow the drying process and lead to really gross problems such as mildew.

If you're blocking a small piece, a blocking surface can be as small as a book wrapped in a plastic bag and placed on a shelf to dry. If you are blocking a sweater, however, you'll need a flat surface such as an out-of-the-way patch of carpet or an unused bed. Blocking boards, often covered in a moisture-wicking material, are sold

for this purpose (D). If you search online, you can find directions for building your own blocking board using inexpensive materials such as cardboard, wood, or insulation sheets.

Shape the piece to the desired dimensions, carefully stretching and molding it as needed. You may wish to pin out the edges. If you've used a stitch pattern like the chevrons shown in the green swatches [page 72], pinning the points will give a crisply defined shape when the piece is dry.

Allow the piece to dry. Don't be tempted to scrimp on drying time; you must be patient, or the piece will distort when used or worn. A single layer of fabric worked in a lightweight yarn can dry in a few hours, but a piece can easily take several days to become thoroughly dry. If you are blocking a thick piece of something with moisture-trapping layers, it is best to block it in a warm room with good ventilation.

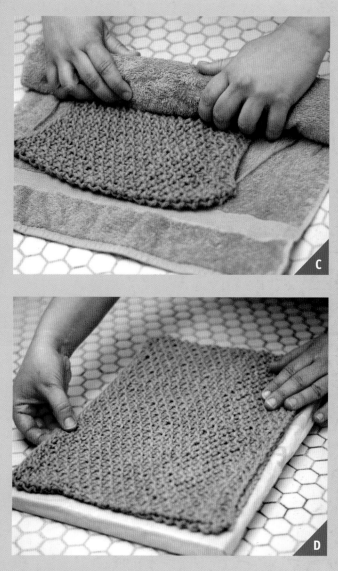

2. SPRITZ BLOCKING

This blocking technique is like a lightweight version of wet blocking and is a good choice when a pattern tells you to "block lightly." It can be quite effective for fabrics made of lightweight yarns but won't do much for heavier fabrics.

To spritz block, lay the piece flat, pinning if necessary to achieve the desired shape. Fill a spray bottle with water and spritz the piece until it is damp but not soaked. Carefully smooth the piece, adjusting its shape as needed, then let it dry.

3. STEAM BLOCKING

The advantage of steam-blocking is that it does not require nearly as much drying time as the other methods do. The disadvantage is that it is easier to damage your piece, so be careful! If you plan to steam block a large piece of knitting, it's a good idea to first practice on a swatch in the same yarn (don't ask us how we know this).

Before steam blocking, lay your piece out on a surface that is safe for ironing on, such as a table covered in several layers of towels. Fill your iron with plenty of water; if your piece is large, you may need to refill it before you're done. Be sure to set your iron to the right temperature for the fiber you're using; even if you don't scorch the fabric, steaming with too hot an iron can "kill" a fabric, changing its drape permanently and making it floppy and lifeless.

If you read up on steam blocking, you'll see different directions for what to do with your iron once it's ready. Some people float the iron an inch or so above the piece, saturating the fabric with steam while fine-tuning its shape or surface. Others cover their work with a damp pillowcase and iron gently through it. Still others prefer to iron the fabric directly, though this technique may elicit cries of horror from other crafters. All of these techniques have their place; again, testing first on a swatch will help you figure out which one will best suit your needs.

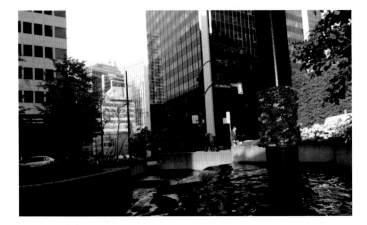

number of stitches over four inches, using a needle or some other pointer to aid in counting them. Make a note of the number of stitches you have, then move the ruler to a different part of the swatch and count again.

You may have differing gauges within the same swatch (or within the same section of the swatch, if you worked a swatch with different sections); the more measurements you take, the more accurate your gauge will be. If you do have different numbers, find an average gauge between them. For example, if your gauge is 16 sts = 4 in/10 cm in one part of the swatch and 18 sts = 4 in/10 cm in another, your average gauge is 17 sts = 4 in/10 cm. It will sometimes happen that your tension towards the end of your swatch is more even than at the beginning. This is only natural, since by the end of the swatch your hands will have found their rhythm with the combination of yarn and tool you used. If this is the case, use only the gauge as measured in the top portion of the swatch.

One very important note: You may be swatching because you are trying to achieve the gauge listed in a pattern you want to make. If you don't get the gauge you want on the first try and are choosing your needle or hook to try again, remember the following:

- If you have too few stitches to 4 in/10 cm, your stitches are too big. Switch to a smaller tool.
- If you have too many stitches, your stitches are too small. Switch to a larger tool.

For example, if the pattern calls for 14 sts = 4 in/10 cm and you have 15 sts = 4 in/10 cm, you are working more tightly than the designer. Don't try to change your tension to match the designer's! Instead, continue to work in the way that's natural for you, just try switching to a needle or hook that's one size larger and swatch again.

Put gauge to work for you

Now that you've got your gauge measured, you can start using it to plan tags. Of course, the gauge swatch itself can be used as a graffiti tag; it's sure to fit something. But if you want to make a tag for a telephone post or a statue, you'll need to do a bit of planning, and for that, there's one more measurement to take—the measurement of the piece you are planning to tag. Most often, the circumference measurement is the one you'll need.

Let's plan a rectangular tag that will wrap around a light post with a circumference of 21 inches. (For the sake of making this example easy to understand, I'm going to switch to using only inches. Of course, the principles and method are the same, no matter which unit of measurement you use.) I've made a gauge swatch and measured it and found that my stitch gauge is 16 sts and 20 rows = 4 in.

Because knitted and crocheted fabrics are stretchy, it's often a good idea to make the tag a little smaller than the piece you're making it for. In this case, a snug-fitting tag will stay in place around the pole better than a loose one would, so I'll plan a tag that's 20 in wide.

The formula for working out the number of stitches needed to make a piece of a specific width is pretty straightforward:

[Number of stitches per inch or centimeter] ×
[width of desired piece] =
[number of stitches needed]

To find that first variable, I have to find the stitch gauge per inch. Since my gauge measurement is given over four inches, I will divide it by four:

16 sts ÷ 4 in = 4 sts/in.

I already have the second variable (20 in, to fit the light post circumference of 21 in), so I can plug these values into my equation:

[4 sts/1 in] × [20 in] = 80 sts

To make a tag to fit the light post with the needles, yarn, and stitch pattern I used for my gauge swatch, I would begin with 80 stitches. It's as easy as that.

Of course, you could always just begin with a random number of stitches and knit or crochet until your work was long enough to fit around the piece you want to tag. That's a perfectly good approach, but understanding the basics of gauge will give you a lot more flexibility and creative control.

Next, I'll plan another tag with numbers that don't work out quite as nicely and with a stitch pattern that makes things a little more complicated.

To make a really big tag that will fit around a wooden telephone pole with a circumference of 42.75 inches, I'm going to use the knitted chevron pattern shown in the swatch on page 72, using the green yarn in the photo. In this swatch, the stitch gauge is 19 sts/4 in. For the chevron pattern, I need a multiple of 12 stitches plus 1.

First, I'll find the stitch gauge per inch:

[19 sts/4 in] ÷ 4 = 4.75 sts/1 in

I'll use this formula again:

[Number of stitches per inch or centimeter] ×
[width of desired piece] =
[number of stitches needed]

★ Masquerade's Manifesto

- Patterns are for inspiration, not for following.
- Remember, knitters and crocheters can work together.
- There are no mistakes, only techniques not yet invented.
- There is no such thing as a dropped stitch (just make sure your piece won't unravel, by any means necessary).
- Fastening loose ends is voluntary (again, make sure your work won't unravel, by any means necessary).
- Super glue is not cheating!
- Bring your knitting wherever you go and take every opportunity to knit.
- A knitted tag can never be the wrong size—it's just a matter of finding the right pole.
- All colors match.
- Do travel, and when you do, think versatile, stretchy (rib stitch), and go for decorations that are not sensitive to stretching, such as pearls, buttons, crocheted flowers, and loose ribbons.
- *Nemo attexet sobrius* (Nobody knits sober).

I'll use the actual pole circumference for the equation; I don't want the piece to stretch too much or the chevrons will be distorted:

[4.75 sts/1 in] × [42.75 in] = 203.0625 sts

Next, I'll find a number near 203 that is a multiple of 12:

17 × 12 = 204

I need a multiple of 12 sts + 1, so I will cast on 205 sts.

Fun with swatches

After all that, it's probably time to get back to the fun part of swatching and making rectangular tags—experimenting with color and texture! There are endless places to search for inspiration: hunt down street art in your city for exciting shapes and color combinations, pore over a stitch dictionary to find interesting patterns, or hit the sale bin at your favorite yarn shop to find something you'd never have thought of working with before. Check out Chapter 7 for more ideas about where to find inspiration.

The great thing about yarn graffiti is that anything goes: you don't need to worry about finding a style and color to flatter your figure or using a yarn that will wear well. You can use bizarre color and yarn combinations that wouldn't easily fit anywhere else in your life. Your projects can be as simple or as technically challenging as your heart desires. You don't even need to worry about weaving in your ends if you don't want to; they can be used to sew up your tag when you install it, and any extra yarn tails can be tucked in behind the tag.

As a starting point, here are directions for a couple of basic stitch patterns that are fun to experiment with. Included are the knitted and crocheted versions of both chevron and bobble patterns, as well as stripes, for beginners who are shy about incorporating more than one color in a project.

A glossary of terms and abbreviations used in these patterns can be found on page 226.

Stripes

Stripes are almost as easy as working in a single color; all you have to do is change color every few rows, as your whims dictate. We've worked two-row stripes, which are particularly easy because the yarn not in use can be carried loosely along the side of the work without leaving long yarn floats.

KNITTED STRIPE PATTERN:

Using color A, cast on any number of stitches. K 1 row.

Using color B, k 2 rows. Using Color A, k 2 rows. Repeat these 4 rows until work is desired length.

K 1 row using the next color in the sequence, then bind off using the same color.

Note: When you begin the first stripe with color B, simply knit the first stitch with the new color, leaving a tail at the back of the work. The first stitch will feel loose and sloppy, but can be tightened up later by tugging the yarn tail.

CROCHETED STRIPE PATTERN:

There is a bit of a trick to working stripes in crochet: when you are working the last stitch of the row before a new stripe, the stitch is finished using the color of the new stripe. In the single crochet (sc) stripes used in this swatch, the last stitch of the row before the new stripe is worked like this: Insert the hook into the stitch and pull up a loop using the old color, yarn over (yo) using the new color, and draw through both loops on the hook.

Using color A, work a chain 1 st longer than the desired number of sts. Sc in second ch from hook and in each ch to end.

Work 1 row sc, as follows: ch 1, sc in first sc and in each sc to end.

Work 2 rows sc using color B. Work 2 rows sc using color A. Repeat these 4 rows until work is desired length. Fasten off.

Striped pattern created with knitting.

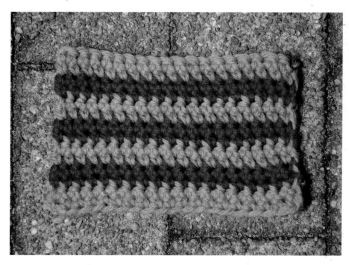

Striped pattern created with crochet.

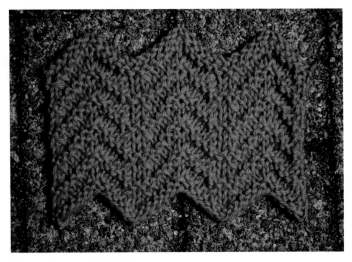

Chevron pattern created with knitting.

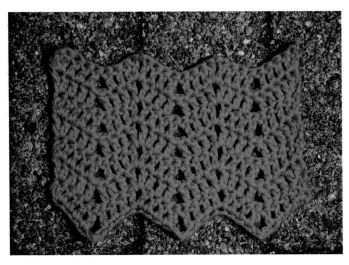

Chevron pattern created with crochet.

Chevron

Chevrons are a very popular and versatile type of stitch pattern, with countless variations in both knitting and crochet. The key to making the chevron shape is to work columns of increases and decreases, separated by groups of stitches. Devise your own chevron pattern by changing the number of stitches worked in each stitch repeat, the frequency of shaping rows, the types of increases or decreases used, or the stitch pattern worked between them. Chevrons also look great worked in stripes!

KNITTED CHEVRON PATTERN:

Cast on a multiple of 12 sts +1 (swatch is worked over 37 sts).

K 1 row (a WS row), then begin pattern:

Row 1 [RS]: K1, [k2tog, k2, kfb, kfb, k3, ssk, k1] to end.

Row 2 [WS]: P all sts.

Row 3 [RS]: Work as for Row 1.

Row 4 [WS]: K all sts.

Repeat Rows 1–4 until piece is desired length, then bind off all sts.

CROCHETED CHEVRON PATTERN:

After the set-up row, this pattern is worked over a multiple of 9 sts + 1. The turning chain (the ch 2 at the beginning of each row) does not count as a stitch.

Chain a multiple of 9 sts + 3 (swatch is worked on a 21-st base chain).

Set-up Row: 2 dc in 3rd ch from hook, dc in next 3 ch, skip next 2 ch, dc in next 3 ch, [(dc, ch 1, dc) in next ch, dc in next 3 ch, skip next 2 ch, dc in next 3 ch] to last ch, 2 dc in last ch.

Pattern Row: Ch 2, 2 dc in first dc, dc in next 3 dc, skip next 2 dc, dc in next 3 dc, [(dc, ch 1, dc) in ch-sp, dc in next 3 dc, skip next 2 dc, dc in next 3 dc] to last dc, 2 dc in last dc.

Repeat Pattern Row until work is desired length, then fasten off.

Bobbles

Bobbles are another classic pattern with many knitted and crocheted variations. To make a knitted bobble, one stitch is rapidly increased into a group of stitches, then this group of stitches is worked back and forth several times before decreasing rapidly back to one stitch. When the following row is worked, the bobble is worked as a single stitch.

To make a crocheted bobble, a group of stitches is worked into the same stitch, though the new stitches are not completed; once the required number of partial stitches has been formed, a single loop is drawn through all stitches to complete them and to gather them back into a single stitch. Again, on the following row, the bobble is treated as one stitch. In some crocheted bobble patterns, like the one shown, a taller stitch is used for the bobbles than for the surrounding fabric. This makes the bobble pop out from the fabric and gives it more fullness.

For the bobble patterns below, the abbreviation MB will be used. This means "make bobble," as follows:

KNITTED BOBBLE: [K1, yo, k1, yo, k1] in next st; 1 st increased to 5 sts. Turn work, p5; turn work, k5; turn work, p2tog, p1, p2tog; turn work, k3tog.

CROCHETED BOBBLE: [Yo, insert hook in st and pull up a loop, yo and draw through first 2 loops on hook] 5 times in same st; yo, draw through all 6 loops on hook.

KNITTED BOBBLE PATTERN:
Cast on a multiple of 5 sts + 4 (swatch is worked over 29 sts).
Work 5 rows in stockinette st, beginning and ending with WS row.
Next Row [RS]: [K4, MB] to last 4 sts, k4.
Repeat these 6 rows until work is close to desired length, then work 5 more rows in stockinette st. Bind off all sts.

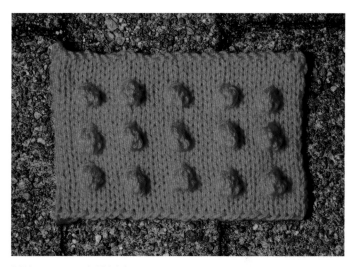

Bobble pattern created with knitting.

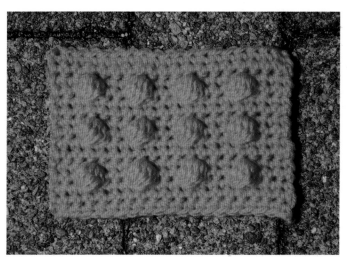

Bobble pattern created with crochet.

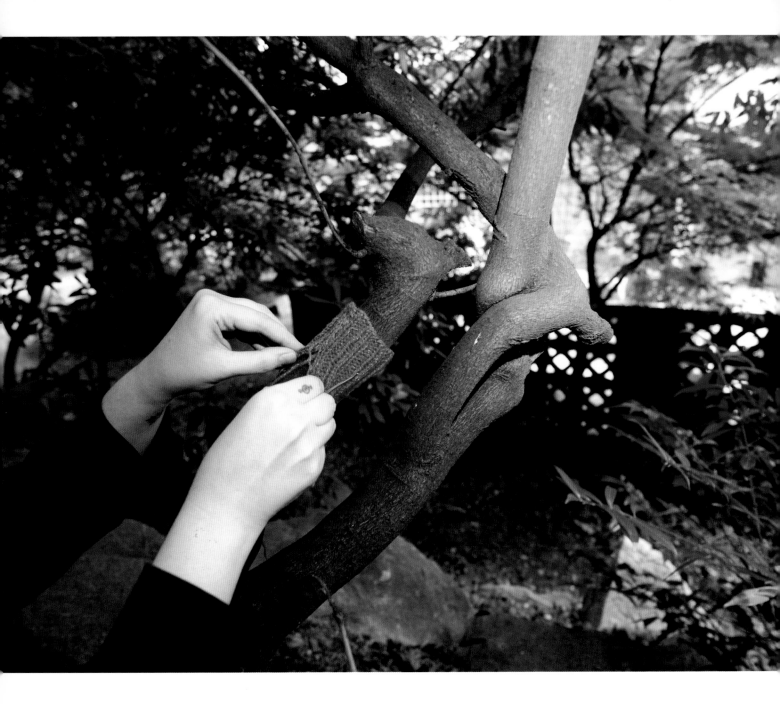

CROCHETED BOBBLE PATTERN:

After the set-up row, this pattern is worked over a multiple of 4 sts + 3.

Chain a multiple of 4 sts (swatch is worked on 20-st base chain).

Set-up Row: Sc in second ch from hook and in each ch to end.

Work 2 rows sc as follows: Ch 1, sc in first st and in each st to end.

Bobble Row: Ch 1, sc in first st and next 2 sts, [MB in next st, sc in next 3 sts] to end.

Work 3 rows in sc.

Repeat these 4 rows until work is desired length, then fasten off.

Sewing it up

Once you've got some tags made, it's time to go put them up. You don't need finely-honed sewing skills for this, but if you're inexperienced, it may be helpful to practice a bit at home first. When you're making graffiti tags, it's a good idea to leave long yarn tails at the beginning and end of your work, to use for sewing up. In general, it's good to have a yarn tail approximately one and a half times the length of the edge to be sewn.

Whip stitch is probably the best and fastest way to go and is easy to learn. Practice by positioning your piece so that the edges to be sewn meet along their length, with the yarn tail to be used for the seam coming from the lower corner of the piece on your right. Thread the yarn tail onto a yarn needle and proceed as follows, beginning at the lower corners and working upward along the joined edges:

Draw the needle from back to front through the piece on your left, and pull the yarn through.

Draw the needle from front to back through the piece on the right, and pull the yarn through.

Repeat these two steps for whip stitch. A simple and clear tutorial can be found online at: **knittingfairy.com/techniques3.htm**

Some taggers prefer to button their tags instead of sewing them. This provides fun design opportunities for the types of buttonholes and buttons you can use to complement your design. Buttonholes can be incorporated along one edge of a piece as you work it, or they can be added later by working stitches along one edge to form a buttonhole band. Here are some resources that show different ways to make buttonholes:

KNITTING:

knitty.com/ISSUEsummer07/FEATsum07TT.html

knittingonthenet.com/learn/buttonholes.htm

CROCHET:

crochet.about.com/cs/infohintscharts/a/032004.htm

ehow.com/how_2093631_crochet-buttonhole.html

PATTERNS: What else can you do with a rectangular tag?

Here are a few ideas for ways to push the rectangular tag a bit further. The claws on the monster feet require simple decreasing, but other than that these tags are made with no shaping at all.

Monster Feet

CHELSEA GUNN

Originally designed to be placed at the bottom of those big blue American mail boxes, these paws can be put in any number of unexpected places, instantly animating the object they're sewn onto. They are simple to knit and customize with your own colors or number of talons. If you've ever been given a skein of faux-fur style yarn and wondered what on earth to make with it, then monster paws may be the ideal solution. The more furry and fuzzy the yarn, the more monstrous these look!

FINISHED MEASUREMENTS

Foot circumference: 11.75 in/30 cm
Foot height: 5 in/12.5 cm

Knitted version

MATERIALS

Cascade Yarns Cascade 220 [100 percent wool; 220 yd/201 m per 100 g skein]; less than 1 skein each color:
[MC] #2409 Palm
[CC] #7827 Goldenrod

1 set US #8/5 mm straight needles, or size needed to obtain gauge

Yarn needle

GAUGE

17 sts and 24 rows = 4 in/10 cm in stockinette st

PATTERN NOTES

The terms and abbreviations used in this pattern can be found on page 226.

PATTERN

Foot
Using MC, cast on 51 sts.
Work in stockinette stitch (knit RS rows and purl WS rows) until work measures 5 in/12.5 cm. Bind off all stitches; break yarn, leaving a long tail.

Claws
Using CC, CO 12 sts.
Work 4 rows in stockinette stitch, ending with a WS row.
Next Row [RS]: K2tog, k to last 2 sts, k2tog. 2 sts decreased.
Purl 1 row.

Repeat these 2 rows 3 times more. Bind off remaining 4 sts; break yarn, leaving a long tail.
Make two more claws in the same way.

FINISHING

For each claw, use yarn tail to sew side edges together, forming a cone. Sew wide base of each claw to lower edge of foot.

To attach to desired target, wrap foot around base of target and sew side edges together using yarn tail.

Crocheted version

Adapted from knitted version by Mandy Moore

FINISHED MEASUREMENTS

Foot circumference: 11.75 in/30 cm
Foot height: 5 in/12.5 cm

MATERIALS

Cascade Yarns Cascade 220 [100 percent wool; 220 yd/201 m per 100 g skein]; less than 1 skein each color:
[MC] #9421 Caribbean
[CC] #8895 Christmas Red

US #10/J / 6 mm crochet hook, or size needed to obtain gauge
Yarn needle

GAUGE

13 sc and 16 rows = 4 in/10 cm

PATTERN

Foot
Using MC, ch 39.
Foundation Row: Sc in second ch from hook and in each ch to end. 38 sc.

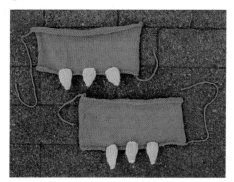

Monster Feet created with knitting.

Monster Feet created with crochet.

Next Row: Ch 1, sc in first sc and in each sc to end. Repeat this row until work measures 5 in/12.5 cm. Fasten off, leaving a long tail.

Claws
Using CC, ch 10.
Work Foundation Row as for foot. 9 sc.
Next Row: Ch 1, sc in first sc and in each sc to last 2 sc, sc2tog. 1 st decreased.
Repeat this row 6 times more. 2 sts remain.
Next Row: Ch 1, sc2tog. Fasten off, leaving a long tail.
Make two more claws in the same way.

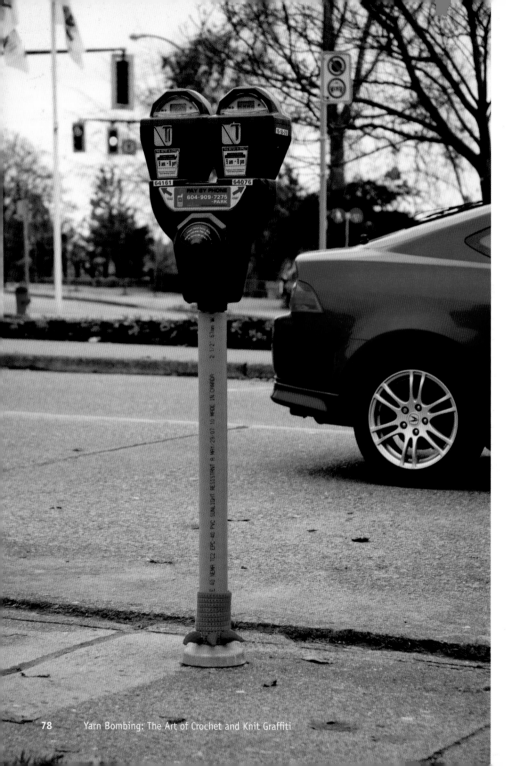

Finishing
Work finishing directions as for knitted version.

CHELSEA GUNN (Providence, Rhode Island), divides her time equally between knitting, watching the *Golden Girls*, drinking coffee, and paying attention to her cats. She first learned about knit graffiti in the summer of 2007 and immediately put out a dozen pieces, complete with funny notes. Most of these were gone by the next morning, but Chelsea was hooked, and it remains one of her favorite ways to use up her leftover yarn scraps. She says, "I'm always trying to go big or go home." She keeps track of her crafty endeavors online at **chelseacreature .wordpress.com**.

Chainlink Weave

MIKE RICHARDSON

This simple series of knitted strips becomes
unexpected and beautiful when woven
through a chainlink fence. It provides endless
opportunities for exploring combinations of
color and pattern.

The pattern the designer provided looked like this:
1. Cast on 12.
2. Open bottle of wine.
3. K every row until sober.
4. Bind off.
5. Repeat steps 1–4 seven more times . . .

. . . and then assemble. We think this is a great approach to this kind of project: don't worry about the length; knit until you think it's long enough; have fun working out an aesthetic arrangement later on. It's also a perfect project for adapting to crochet; work some long strips in double crochet, then sew them together in the same way as for this piece.

However, if you want to replicate the piece shown, follow the instructions below.

FINISHED MEASUREMENTS

Height: approx. 24.5 in/62 cm; each strip is 3.5 in/9 cm wide

MATERIALS

Cascade Yarns Cascade 220 [100 percent wool; 220 yd/201 m per 100 g skein];
 1 skein each color:
[A] #9484 Stratosphere
[B] #9421 Caribbean
[C] #7812 Lagoon
[D] #2409 Palm

1 set US #10.5/6.5 mm straight needles

Yarn needle

GAUGE

14 sts and 21 rows = 4 in/10 cm in garter st

PATTERN NOTES

The terms and abbreviations used in this pattern can be found on page 226.

PATTERN

For each strip, cast on 12 sts, work in garter st (knit every row) to length given below, then bind off. Leave yarn tails approximately 10 in/25.5 cm long at each end.
Using A (dark blue), work two strips approx. 46 in/117 cm long.
Using B (aqua), work two strips approx. 34 in/86 cm long.
Using C (blue-green), work two strips approx. 36 in/91.5 cm long.
Using D (green), work one strip approx. 29 in/74 cm long.

FINISHING

Lay the pieces on the floor with long edges touching and lengths overlapping approximately 6 in/15 cm, with alternate pieces leading in opposite directions. Order of colors shown is: A B C D C B A.

Use yarn tails to sew edges of pieces together along overlapping 6 in/15 cm of length. The shape of the assembled piece will resemble a columnar central body, with four arms reaching outward in one direction and three arms in the other.

To install piece in fence, wrap central body around post of fence and tack edges in place. Weave each arm of piece horizontally into chainlink, using yarn tails at ends of arms to sew arms in place.

MIKE RICHARDSON (Washington): "I'm a stay-at-home father of two, living in the Pacific Northwest. I hate knitting with patterns and enjoy finding my own way to make things. Being a male knitter is great because it sometimes draws a lot of attention, and I enjoy meeting new people. Everyone I've met has been supportive and enthusiastic about my knitting. So I'd like to say a big thank you to everyone who has helped me along my knitting way."

▶ "I Wasn't Here" Embroidered Tag

MASQUERADE

Masquerade believes that patterns are for inspiration, not for following. This one is intended for graffiti knitters on the road, when you don't have the luxury of measuring poles and rails beforehand. Fast to make, this tag will stretch to fit lamp posts wherever. It's a combination of a stockinette knitted part, and a crocheted mesh part. Add your own touch by embroidering the message of your choice.

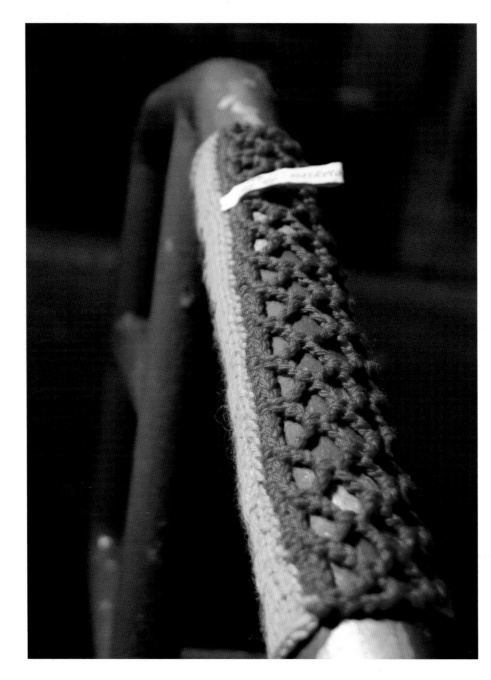

The tag shown is 12 in/30 cm long and 7 in/18 cm high, with crocheted mesh lightly stretched. This is a pretty good standard size to use for a tag when you don't know where you'll put it, and it's a sufficient length to embroider a message several words long. The knitted portion of the tag should be approximately half as wide as the crocheted portion when the crocheted mesh is lightly stretched. This way, the letters you embroider on the knitted part will be visible from one side of the pole instead of bending around it so you can't read them.

MATERIALS

Yarn information for the piece shown is not available. To achieve the same effect, use a wool yarn with a ball band gauge of 24 sts = 4 in/10 cm. However, as with most graffiti projects, this piece will work using just about any gauge of yarn you care to try.

1 pair US #4/3.5 mm straight needles and 1 US #4/E / 3.5 mm crochet hook, or size appropriate for yarn chosen

Yarn needle

GAUGE

24 sts = 4 in/10 cm in stockinette st

PATTERN NOTES

Terms and abbreviations used in this pattern can be found on page 226.

This pattern is presented as more of a recipe than a strict pattern so that it can be easily adapted to the yarn you wish to use, the message you want to embroider, and the object you plan to tag.

PATTERN

Crocheted section

Ch 57. To make the piece longer or shorter, ch another multiple of 4 sts + 1.

Row 1: Sc in second ch from hook, and in each ch to end. 56 sc.

Row 2: [Ch 5, skip 3 sc, sc in next sc] to end.

Row 3: [Ch 5, sc in ch-5 space] to end.

Repeat Row 3 six times more, or to 2/3 desired depth of completed tag when lightly stretched.

Last Row: Ch 1, sc in first sc, [3 sc in ch-5 space, sc in next sc] to last ch-5 space, 2 sc in last ch-5 space. Fasten off, leaving a long tail to use for installing tag.

Knitted section

Knitted portion of tag shown is 2.5 in/6.3 cm wide. If you are making a tag of the same size and are working at the same gauge (24 sts = 4 in/10 cm), cast on 15 sts. Otherwise, determine approximate number of sts to cast on to achieve one-third the desired height of the tag. Remember, these numbers need not be exact; close is good enough!

Work in stockinette st until work is same length as long edge of crocheted section. Bind off.

FINISHING

Embroider your message, picture, or signature of choice on the knitted piece. Sew the two parts together along the long edges, and that's it! You're ready to hit the streets in any town.

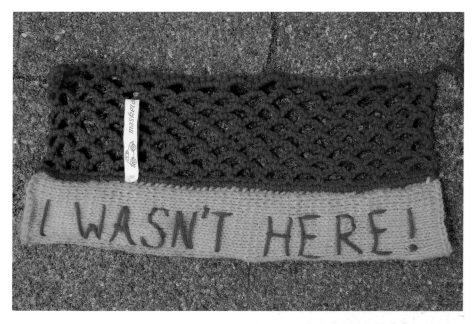

MASQUERADE (Stockholm, Sweden) was founded in Paris in 2006 after a night of a lot of red wine and chocolates. Although founded in Paris, they're based in Stockholm and are a part of the infamous Los Fulanos street art crew. "We tend to knit really tight—even tighter than the jeans we wear—so if you're more of a sweatpants-knitter, you might have to alter our patterns a bit. Actually, we think you should alter the patterns anyway; knitters are way too caught up in following patterns and rules. Street art is illegal, a dropped stitch in your tag is not."

AN INTERVIEW WITH
Knitted Landscape

Knitted Landscape is composed of two Dutch artists, Jan ter Heide and Evelien Verkerk, who are best friends. As Knitted Landscape, Jan and Evelien have been populating the world with acrylic rocks, water lilies, and tulips. Their work is delightful and when placed in the landscape creates a humorous and beautiful juxtaposition between the natural and the handmade.

NEXT PAGE: Knitted Landscape's Diamond Hill piece in Connemara, Ireland. Photo: Evelien Verkerk

Q: What inspired the name Knitted Landscape? Did you know right away that you wanted to focus primarily on doing landscape pieces?
A: Yes, that was how it started; the idea was to make something and leave it somewhere in a beautiful landscape.

Q: Can you tell us a bit about what you do in your nine-to-five lives?
A: [Jan] I teach fashion design and do international projects. One day a week I'm off, working together with Evelien on art.

[Evelien]: We're artists, and I also work at two museums; a historic museum, and a toy museum.

Q: How did Knitted Landscape start?
A: [Jan]: We had a feeling we wanted to knit again. Evelien has knitted almost her whole life, and I've knitted, on and off, for the last few years. We thought, "Why not knit again?" And then we talked and talked and talked and the idea came up.

[Evelien]: At first we had the idea for an exhibition about knitting, also with other artists, and later that idea changed to an exhibition with only the two of us. At first we started knitting other things, and suddenly we did see something on the Internet about people knitting things on the street, and we were already knitting plant-like shapes. And then came the idea to do something in combination with nature and landscape. Jan was going to Ireland for a holiday, and I was going to France. We said, well, let's do something in the landscape. So that's when we started knitting covers for rocks and stones and leaving them somewhere. That was the start of it, and later we made other shapes, like knitted mushrooms and flowers.

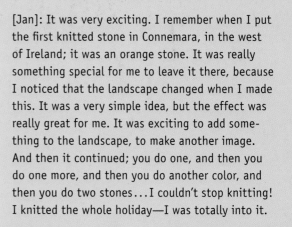

[Jan]: It was very exciting. I remember when I put the first knitted stone in Connemara, in the west of Ireland; it was an orange stone. It was really something special for me to leave it there, because I noticed that the landscape changed when I made this. It was a very simple idea, but the effect was really great for me. It was exciting to add something to the landscape, to make another image. And then it continued; you do one, and then you do one more, and then you do another color, and then you do two stones...I couldn't stop knitting! I knitted the whole holiday—I was totally into it.

Q: It sounds as if placing things in the landscape is almost as addictive as knitting.
A: Yeah, it was very exciting, too, to do it in secret, and to walk away and take a picture. I don't need to see it, if people find it, but the idea that someone takes it home or takes it in his car or her car, that's really the exciting idea for me.

Q: Wow, that's cool!
A: The landscape changes for us, and the landscape changes for other people also. They look at it differently because there's something there that's strange, that can make them smile or think "what person leaves a thing like that?"

Q: When I came across your website I was in awe. I think it's just beautiful. People really seem to react to it. How many years have you been doing Knitted Landscape?

THIS PAGE: Knitted Landscape in Lithuania, Photo: Evelien Verkerk. NEXT PAGE: Knitted Landscape in Iceland. Knitting and photo: Bjarni Ketilsson. Yarn fungi in the woods of Almen, the Netherlands. Photo: Evelien Verkerk

A: Two years. And now we want to change, because we notice that a lot of people are sending pictures. In a way, the website is taking over, because we've invited people to knit, to send us the pictures. So we are now thinking of another direction.

Q: Do you do all the knitting yourselves, or do you have help from friends?
A: We do it ourselves.

Q: I'm curious, if you're putting stuff in nature, do you use wool yarn, or do you use acrylic?
A: [Evelien]: We use all kinds of yarn. Sometimes I think that it's not a good idea to leave things in nature that are made of acrylic, but I always leave them in a place I'm sure someone will find them— and they look so appetizing that people want to take them home.

[Jan]: Last year, when I was doing Diamond Hill in Connemara, I decided to go up early in the morning. It's quite a steep climb. I left this little stone tower, and I was taking pictures of it, and there were people there that didn't even react. Just before I left, two men came over to the summit, and I heard one man saying, "Gosh, what's that?" He started taking pictures, "Oh, Knitted Landscape! Oh, wonderful, wonderful!" And so I walked down, really smiling—and he hadn't noticed that I was the one who put it there.

[Evelien]: Once I planted a little mushroom in a ruin somewhere in France. Within a minute of putting it there, someone picked it up and walked away with it. I didn't even have enough time to take a picture!

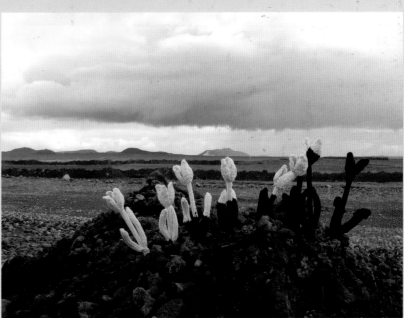

Q: We were talking to someone here, who does the same sort of thing, and she has a website where she'll put up her photos after she's tagged a place, but she's recently found that pieces disappear even before she's gotten home to post the picture. She's received comments from people saying, "I went to go look for it, and it was gone!" So she's trying to figure out how to deal with that now.

A: That's always the risk. Last year I did some small stones on the beach in Connemara, and I came back one hour later and they were all gone. I don't mind, even if it's taken away after five minutes, as long as people like it and have fun with it.

Q: That's wonderful. Do you do your stones with double-pointed needles? It's mostly knit?

A: [Jan] No, no double-pointed needles for me. [Evelien]: I recently tried to knit the shape of the stone into the knitting, but I think I did it on two needles. I picked up stitches and tried to make a sort of cube.

Q: Stones and flowers and mushrooms seem to be signatures of yours.

A: Flowers and the mushrooms I do on double-pointed needles. But for the coverings for stones, I just knit something, and I wrap it around the stone and knit it roughly under, so you don't see where it sticks together. Then I take a picture and add a tag.

Q: Do you just knit little random pieces and find stones they'll fit?

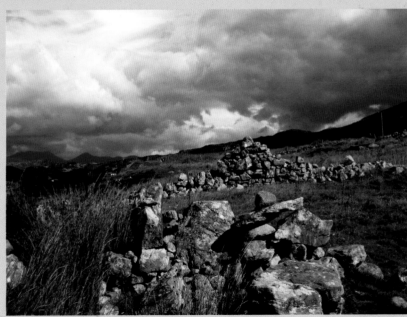

Knitted Landscape hits the coast of Ireland. Photos: Evelien Verkerk

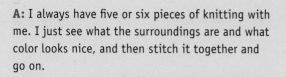

A: I always have five or six pieces of knitting with me. I just see what the surroundings are and what color looks nice, and then stitch it together and go on.

Q: Have you ever knit for a particular place—known what the location would be before you made the pieces?
A: That was how we did the knitted road signs, here in Deventer, to give directions to our exhibition—from the train station, to the exhibition, to the gallery. Everywhere in the center of the city, there were little knitted things, and they were made especially for these places. Jan knitted a long string of green leaves and put it around the head of the sculpture on the fountain.

Q: Do you have any big plans for new projects that you want to do?
A: Maybe knitted statements, words or text, a poem, a part of a poem, or strange words...we've been thinking about it, but it's not totally clear yet!

Note: See patterns by Knitted Landscape on page 159.

Knitted Landscape plants mushrooms at the Glasgow School of Art. Photo: Evelein Verkerk

Get Your Crew Together

PART OF THE FUN of being a yarn bomber comes from connecting with like-minded knitters and crocheters. Becoming tight with a crew offers many advantages. With the support of like-minded individuals, you'll have a group that plans projects together, teaches each other stitching techniques, and provides support and inspiration. A crew will cheer you on and will help you make the most of your art-making efforts.

XXL or XXS?

A yarn bombing crew does not need to be big. Two friends formed the infamous Swedish yarn bombing group Masquerade, and having only two members has not limited the reach of this crew's work. One member knits and one member crochets, and together they create beautiful work using these two different types of needlework. Masquerade has hit cities as far apart as Los Angeles, New York City, and Rome. While Masquerade is made up of only two women, the group is part of a larger group of street artists in Stockholm called Los Fulanos.

Larger crews have the advantage of having many members to carry the yarn bombing torch. The more hands your crew can rely on, the more territory you may be able to cover.

Good reasons to build a crew

- There's safety in numbers. It's always good to have someone to watch your back as you climb a tree or tag after dark.
- Fast tag production: An army of knitters and crocheters can create many pieces quickly when they share the work.
- Assistance with developing your technique: It's great to have someone who can teach you new skills, from fancy new stitches to different ways to bind off.
- With a crew, you'll be able to take advantage of different skill sets.

You might have a great technical knitter, a color-harmony obsessed knitter, or a sculptural-crochet addict in your crew.
- A stitch 'n bitch session can become a think-tank to brainstorm new locations and tag types.
- The ability to go all-city: The more crew members you have, the further you can spread your group's name. When members go on vacation, they can take tags with them. You might be surprised to find out where your group's work ends up.
- Group pride: There's something awe-inspiring about discovering a tag on the street and knowing that it was made by a member of your crew.
- Camaraderie: Your family, co-workers, and the general public may not always understand yarn bombing, but your crew members will.

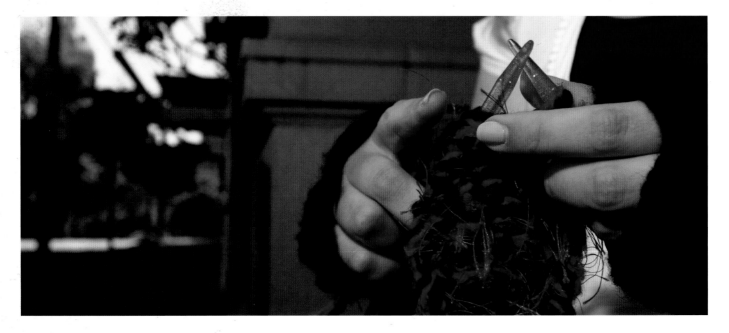

How to recruit crew members

While knit graffiti is not yet a mainstream art, we find that most knitters and crocheters instantly react fondly to the idea of knit graffiti once they are shown it. Yarn bombing has an "I-gotta-try-that" effect.

Start small at first. It helps if you have a fiber-obsessed friend or two who might be into the idea; each of you can then brainstorm ideas for other people who might be suitable. Think about the experiences, skills, and aesthetics that you'd like in your crew, and then figure out who you know who could help. Ask your friends if they would be willing to bomb with you. At first, it might mean that you have to knit all the tags, but a night on the town will have them ... er, hooked. If they don't know how to crochet or knit, a tagging adventure will make them want to learn. Have friends that are unconvinced? Tag their cars or front doors. Invite them over for coffee and a knitting session in which they can use up the ends of eyelash and slub yarns hidden in the bottom of their knitting bag.

Knitta started from a group of friends and quickly grew among extended family members. The crew behind the Ladies Fancywork Society tapped a network of crafty ladies—some friends, some acquaintances—a motley crew of young professional women whose co-workers would never suspect that they spend their weekends crocheting ruffled pole cozies adorned with skulls.

If you are lucky, your connections will easily grow into a crew of folks dedicated to the cause. However, if your personal connection with needleworkers is small—do not fret! There are tons of ways to connect with other fiber aficionados.

LOOK FOR THEM IN PUBLIC

Knitters and crocheters tend to find each other easily. Whether it's by seeing a guy with amazing looking fingerless gloves and chatting him up, or recognizing the handspun you were drooling over online in someone's bag on the subway, one crafter can often spot another in the crowd. Starting a conversation with another crafter can be as easy as saying, "What size of hook is that?" and an instant bond is usually

★ Converting the unlikely

Not all yarn crafters are the renegade type who will instantly take a shine to knit and crochet graffiti. You may get some strange reactions. Some knitters may even ask you questions such as, "Why would I want to waste my time doing that?"

Often people will not understand why you could possibly want to spend your time creating cast-off items when there are so many keepsake items you could make. These people are probably not your audience. While you could take the time to try to convince them why yarn graffiti is important, you are better off moving on and finding the folks who'll be genuinely interested.

However, if the reticent but potential yarn bomber is your uncle or mother or best friend—and you think that he or she would make a valuable addition to your crew but just doesn't get the concept—do not be deterred. They can be convinced! Most fiber snobs, somewhere deep down, possess a stash of yarn they are embarrassed by, a stash they know they will never get rid of, but cannot bring themselves to knit with. It might be the acrylic they bought when learning how to make that first chain, or unusable yarn they inherited from a well-meaning friend. All yarn hoarders have a secret—they want this stash to be obliterated so it can be rebuilt with luxury yarns like Noro and Koigu and alpaca blends. Show them that yarn bombing will use up every scrap of their "stash of shame," freeing up room for coveted yarns—and you'll have a convert.

★ Find your crib

Knit graffiti crews need a regular place to gather. When members meet face to face, you can discuss your latest ideas for tags and get excited about group projects. Whether your crew gets together to commiserate about a hard day at school or work, to drink a few beers, or just to hang out and crochet, regular meetings will ensure that the group remains thick as thieves.

There are all sorts of places that your crew can call home:

- a friendly neighborhood pub with great lighting (bonus points if it's a hoity-toity British pub or a biker bar)

- a crew member's living room—preferably someone who can make great snacks

- a large porch or veranda—a classic knitting location in good weather

- a meeting room at a local library—one that has walls so you can chat

- the food court of a shopping mall

- outside, in a public park, sitting on the grass

- in a subway car, so the scenery changes as you knit, try picking a route that has a great local yarn store (LYS) or thrift shop at the end of the line

- at your local laundromat (washers and dryers are a bonus for those doing felted work)

- in a busy city square so you can people watch as you knit

- on a small commuter ferry

- at a kids' soccer game (be sure to tag the bleachers when you leave)

formed. You might not like making the same kinds of items or even using the same material, but if you are addicted to the stitch, you will have a common understanding from which to start a conversation.

Most crocheters and knitters will be comfortable with an invitation to get together and craft. The needle arts have a long history of social interaction. It is usually easy to find stitch 'n bitch circles in almost any city, town, or suburb. Groups are diverse, varying from new moms meeting at playgrounds to bearded hipsters crocheting at the local legion hall and grannies visiting their favorite yarn shops and drinking coffee while knitting around the table in the back.

VISIT YOUR LOCAL YARN STORE

Local yarn stores provide a great way to get to know other knitters and crocheters. Every yarn shop, from the down-home and friendly ones to the high-end boutiques, has a unique atmosphere. Find the one in your community that suits your style, and you'll be sure to meet other crafty folks who share your interests. Take your time to browse, be friendly, and talk to likely candidates about their yarn selections.

Shop owners are not only knowledgeable about patterns and yarn, but also about their community. They may even be willing to put up a poster that advertises your next crew meeting.

If you make a poster, be sure to include a photograph of your work and promote the time and place where the group is meeting.

Most yarn stores also have classes or open drop-in nights where you can show up with a bag of yarn and meet other knitters or crocheters. These offer opportunities to get to know the interests of others who frequent your favorite yarn shops. The hive-mind of knitters is great for inspiration, stitch fixes, and brainstorming. Visit a yarn store on drop-in night, find someone talking about that crazy knitter who made a bike cozy, and you'll be on the lead of a potential co-conspirator.

MEET THEM ON THE INTERNET

Never underestimate the power of social networking on the Internet. Visit online knitting and crochet communities (see page 194), and declare your intentions. Chapter 7 is chock-full of resources that will help you connect with others online.

Now what? Meet with your crew

Once you have a network of friends and you've spread the word, pick a time and place to meet up and discuss goals for your crew.

When picking a time and location, consider what you know about members and their commitments. Do they work nine to five? Do they have small children to care for? Are they students? Pick a time that will work for the majority of people—a mid-week evening will probably work. If most of the group is made up of strangers, we'd suggest meeting in a public place—a coffee shop is often a good choice—but a well-lit pub or library meeting room could work as well. Plan to get together for an hour or two.

Do pick a place that is well lit so that you can see your stitches. You will also need a place that is quiet enough to allow you to hear each other talk—nothing is worse than music so loud you can't hear over it when you're planning your yarn revolution!

★ Keep the conversation going

Most crocheters and knitters love to chat while working on their projects. Here are a few conversation starters that are sure to get some strong opinions and sparks flying about the room:

Big needles vs. small ones—Big needles allow you to work fast and cover a lot of territory. Small needles allow you to do more detailed, delicate work.

Crocheting vs. knitting—This is a conversation you want to avoid having. Don't start it!

Tag attachment—What is the best way to attach tags? Buttons, sewing, twist ties, or crocheting?

Knitting in the round—Do you prefer circular needles or double-pointed needles?

Synthetic vs. natural fibers—Synthetic fibers will last forever and retain their color through the worst weather conditions, while natural fibers will fade. Natural fibers can also get smelly and eventually turn moldy. But natural fibers don't have the same environmental impact as non-biodegradable synthetics. Synthetic fibers, on the other hand, are vegan-friendly.

It's normal for people to be shy when meeting strangers, but over time your crew will become more comfortable with each other.

Be prepared with some ice-breakers for your first meeting: some really yummy-feeling wool to pass around, a map of your town with possible bombing locations marked, and a photograph of your last tag are great ways to get the conversation started.

Ask everyone to show up with a work in progress. Have extra needles and bits of scrap yarn to lend to others. Ask expert crocheters and knitters to give lessons to novices. It won't take long to get everyone talking about the next place to bomb.

DO YOU STITCH TOGETHER, BOMB TOGETHER, OR BOTH?

Every yarn graffiti crew has its own identity. It's good to chat with potential crew members about the sort of group they want to form and what they would like to achieve.

Every group has a mix of personality types. Here are a few that you may find in your crew:

THE ORGANIZER: In every group, there is someone who tends to be the social organizer. These people are invaluable to your crew. They will find the coolest coffee house to crochet at and get there early to meet the cute waiter and save the best table in the back. This person will usually send out the emails to remind the crew when your latest knit-in will occur, and they'll get everyone together to give up their Saturday nights to yarn bomb. This person is the glue that will keep your crew together. All hail the organizer!

THE BLOGGER: This technophile will set up a website for your group, post photos of your bombing mayhem, and write witty personality profiles so you can post your claim to fame for all the world to see.

THE PRO: While the simplest tag in the world can have a big impact, it's always great to have someone in your group who lives, breathes, and sleeps yarn. This is the person who began knitting in college and was making intarsia sweaters the next month, the person who can spot handspun a mile away, the one who dreams about lace stitch patterns at night. The pro will keep you on your toes and stretch your skills.

THE TROUBLE MAKER: This feisty member might have a few beers tucked in her satchel while bombing. She is ready to knit an anarchy symbol onto her toque and will generally take up the rallying cry when you are bombing. She is the one who will come up with the wild ideas—such as scaling a public monument or protesting the newest manufactured-clothing chain store with a riot of yarn on their front door. The trouble maker will keep things interesting.

THE MEDIATOR: This will be the person who intervenes when things get out of control; she can smooth ruffled feathers during an argument. If you have a trouble maker in your group, it is also valuable to have a mediator.

THE DESIGNER: This artistic member will mix colors you never thought of, sketch wild ideas for group projects on a napkin, and figure out how to dye yarn with glow-in-the-dark paint.

THE INSIDER: If you really want to get up that bell tower, cover the mansion in the heart of the city, or tag boats at the local marina, this group member is so well connected she knows everyone and can get keys and private invitations into any place your crew wants to bomb.

Talk about your goals as a crew. Will you get together and knit tags? Will you crochet alone at home and meet only when you bomb? Will you knit and bomb independently, but assign yourself the same moniker (such as Masquerade does), or are you starting a public art project to which anyone in the world can contribute (such as Knitted Landscape or Incogknito)? Only the members in your group know how it will function.

Maybe your group is the type that will get together every week at a member's house to knit tags and watch old movies. Maybe your group lives in separate cities, but you agree to tag on the same day and post photographs to your Flickr group. Or your group might be the type to slowly knit a giant blanket for a football field—meeting at the end of the project to piece all the parts together.

NEW MEMBERS

Ask how new members will be added: does the group need to agree, or is it more casual than this? Can new members just join at the invitation of another member? If you meet at someone's house, you may want to keep the group limited; if you meet in a public place, it's not as important. How new members are inducted will matter if your group decides to be anonymous or use code names; anyone you reveal yourself to may jeopardize the sanctity of the pseudonyms your fellow crew members use.

To name or not to name?

Most knit graffiti crews have a self-assigned crew name. Sometimes these names express a streetwise attitude (such as Micro-Fiber Militia, and Incogknito). Other names allude to the type of work created by the crew, such as The Ladies Fancywork Society (who crochet lacy items) or Knitted Landscape (who leave knitted natural forms outside). Once your group has had a jam session, you'll be able to figure out an appropriate crew name.

In addition to a crew name, individual members may want to pick their own pseudonyms. The women behind The Ladies Fancywork Society chose individual names that reflected the old-fashioned Victorian sensibilities of their work. Members go by monikers such as Lucille Lynn, Esther, Vivian, The Twins, Jeanne Lois, and Lady Magdalena Pompelthwaite.

There are a number of ways to come up with a good street name. You may already have a nickname that you love. You can also select a name from a type of yarn or needlework technique. To brainstorm, you may want to start with a common list of knitting and crochet terms.

Taking a cue from graffiti artists of the past, you could also name yourself with a street address number or hook or needle size.

Examples of names that we came up with using this method:

- En-gauge
- C$shmere
- Cast-on 203
- Synthetic 5
- DPN 2 mm
- Needle-point

Some of the best yarn bombing names are plays on words that have to do with knitting. Here our some of our favorites:

- beat-knit (Incognito)
- Dropzitch (Incognito)
- K.1.P.1. (Incognito)
- KnitGirl (solo artist)
- Mascuknitty (Knitta)
- PolyCotN (Knitta)
- GrannySQ (Knitta)
- SeniorMysterioso (solo artist)
- CoveredinKnit (solo artist)

TYPES OF KNIT STITCHES:

- knit
- purl
- cast-on
- cable
- stitch
- increase
- yarn over
- slip
- I-cord

TYPES OF YARN:

- mohair
- cashmere
- alpaca
- angora
- silk
- acrylic
- nylon
- worsted
- chunky

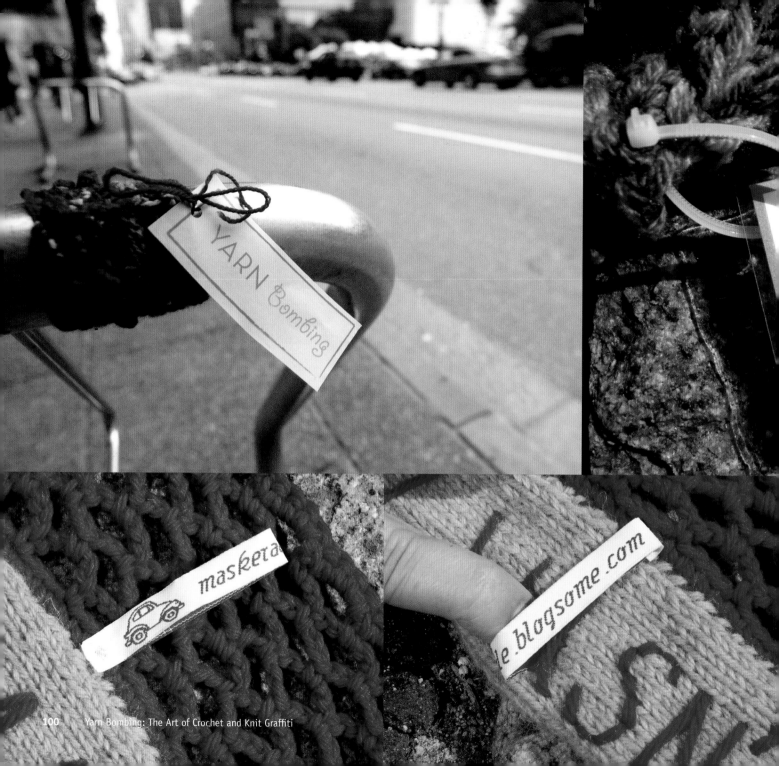

YARN Bombing

maskera

e.blogsome.com

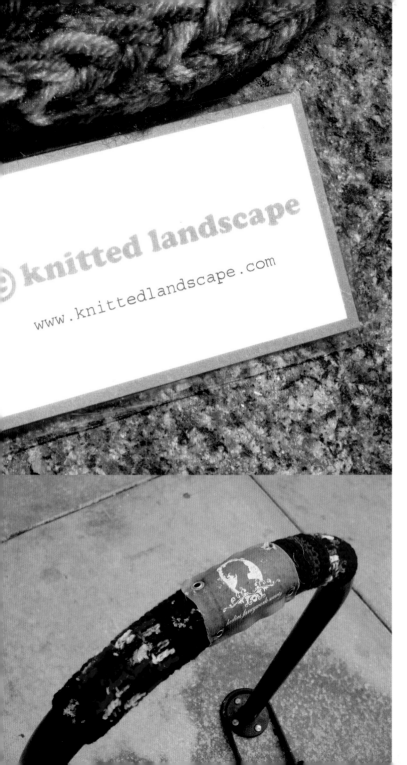

SPREAD YOUR NAME—LABEL YOUR TAGS

Some yarn bombers like to leave a calling card behind when they tag. This can be done in a variety of ways, including adding a name with intarsia knitting, or embroidering a name straight onto the work with embroidery thread or yarn.

If you leave a URL (website) on your tag when you bomb, this will encourage others to check out your work online. You'll spread word about your skills and perhaps even meet some interested recruits for your crew.

Paper tags are really effective, particularly when they've been laminated for longevity. To create artwork on your tag, you can typeset your name and print this out with your home computer, or you can get more inventive and create a custom stamp. Most stationery shops can create a stamp from your artwork for around twenty dollars, or you can carve your own from a white eraser.

The type of paper you choose will also make an impression; you may want to print on colored cardstock, recycled cardboard, or an unusual paper such as transparent vellum or one that contains sparkles or dried flowers. When designing your tag and picking your materials, consider how important it is for the tag to stand up to the elements. Once the tag is laminated, use a hole punch to create an opening, and thread a piece of wool or embroidery thread through it to attach it to your piece. Some crews also order machine embroidered tags with a special design. Masquerade has a tiny red and white car on their tag, while the Ladies Fancywork Society has a Victorian-style cameo.

Multimedia Appreciation Tags

ALIZA SOLLINS OF BALTIMOREDIY

A knit graffiti artist in Baltimore, Aliza Sollins has developed a variety of ways to make yarn bombing badges. These fabric badges can be used to identify your own work or they can be attached to others' work in order to show appreciation of their style.

This project was inspired by the many doorways and alleys covered with an endlessly mutating mural of Sharpie pens and spray paint. I love looking at the variety of tagging styles, from basic scrawls to multi-toned stencils, and the way a blank area of the city is eventually converted into a public collaboration. By attaching small handmade add-ons, any knit cozy can become this same kind of shared space for crafty taggers. For this project, it was fun imagining an eco-activist sewing felt leaves; bikers and anarchists sewing on home-made patches; bands pinning on buttons; and crafters embroidering or adding felt appliqués and buttons and attaching them to cozies around the city.

By sewing on a patch, pinning a button, or clipping on a key chain, we are able to interact with the knitted tags instead of just viewing them passively. After I put up my first knit cozy (a sweet little hot pink sweater sleeve sewn onto an old signpost), I realized that anyone who saw the cozy would walk by and think, "Hmm…interesting," and then walk on. To welcome people into our fuzzy little world, I created a patch with my blog name on it so that anyone who was curious to learn more could contact me. To stay in keeping with the craftiness of it all, and also because I was afraid that paper would dissolve with the first rainstorm, I embroidered the blog name onto a piece of felt and stitched it on to the cozy.

Once that first patch was up, my mind started running wild with different modifications and fun things to do. Posting website names on the patches is great because it opens the door for contact from crafter to crafter—or between crafters and the public. Also, I think it's interesting to think about these lo-fi cozies combining forces with the Internet to spread information and create communication.

This is a complete list of tag materials you can use if you'd like to create everything on the sample that you see; however, you can take one element of this design and be inspired to create a single appreciation tag.
- green, white, and blue felt
- embroidery thread in purple, orange, and yellow (Frida Kahlo) and white, blue, and black (the Yeti face)
- an embroidery hoop
- a white seamstress pencil
- buttons—mixed colors and sizes
- printed T-shirts you no longer wear, preferably with small patterns
- scrap yarn in various colors—this project uses orange, blue, and burgundy
- chopsticks
- a utility knife
- craft paper—in various colors
- grommets
- a sewing machine (optional)
- rubber stamps
- fabric scraps (natural fibers preferred)
- fabric paint
- an iron and ironing board
- scrap paper

EMBROIDERED FELT (as seen in the leaf-shaped Greenie Tag, the Yeti Face, and the baltimorediy tag): To embroider your crew name onto a piece of felt, it's easiest to embroider the name first and then cut the piece into the shape that you desire. Lay the piece of felt flat and use a seamstress pencil or a regular pencil to draw the words you'd like to stitch onto the felt. Insert the felt into an embroidery hoop, and pull the edges taut, then follow the line of your letters using a simple chain stitch. Once you've completed your stitching, double knot the thread in the back, and remove the piece from the hoop. Feel free to cut the felt into whatever shape you desire (e.g., leaves, stars, hearts, skulls, etc.). Embroidery resources are discussed on page 196.

FABRIC TAGS (as seen on the This Is It and cyclist tags): A design can be transferred to fabric using a variety of methods. The easiest way is to paint a rubber stamp with fabric paint and then transfer this to a scrap of fabric. Once the paint is dry, you can heat-set the image by using an iron on a low setting. Use a piece of newspaper between the iron and the fabric to ensure that paint does not transfer to the surface of your iron. A similar but more professional look can also be achieved by silk screening or using a Print Gocco, which is a small Japanese silkscreen machine, made for the home. More silkscreen resources are discussed on page 196.

OJO DE DIOS OR GOD'S EYE: Take a chopstick and cut it into two even lengths with your utility knife. The length of these halves is the size of your finished God's Eye. Cross the two sticks so that they form an 'X' and tie them together with a scrap piece of yarn. Once the sticks are firmly held together, begin to weave your yarn over one stick and under the next. Make sure the yarn is pulled tight as you weave. Build your design outward from the centre of the cross, changing color when you feel like it. Once you have completed weaving, cut the yarn and tie it around one stick. Leave a tail of yarn on both ends to stitch the God's Eye onto a larger tag.

 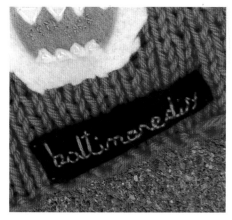

FLAT TAGS: There is no limit to the variety of ways you can make paper tags. This project uses two types of paper tags. The first is a rubber stamp of a grasshopper on a piece of paper flecked with grain. The paper has then been laminated. The second is a piece of machine embroidery on a vinyl tag. Both pieces have been hole punched and grommets have been added. Grommeting tools (available at most hardware and craft stores) come with their own instructions for grommeting. The grommeted pieces are hung on a key chain clasp, which is easily affixed to a tag.

T-SHIRT TAG (as seen with Frida Kahlo): Loosely cut out the print that you like from an old T-shirt, and use the print as a guideline for your embroidery as you attach it to a knitted tag. Use several colors and stitch variations to add variety.

ALIZA SOLLINS (Baltimore, Maryland) believes that yarn bombing makes the world a little more bright, fuzzy, and connected. She collects, crafts, and is an amateur writer who first learned about knit graffiti through a link to the knit cozy around a dock ring in Sweden. Current projects include brewing kombucha tea, unsuccessfully growing tomatoes indoors, and assembling her first zine, *Bound Printed Matter*. Seashells, wrapping paper, miniature cardboard boxes, and a dead bumblebee are some of her favorite collected items. **baltimorediy@gmail.com**.

Write your manifesto

Some knit and crochet graffiti groups have written manifestos. Your crew may want to brainstorm on what would be included in yours. Here is the manifesto created by Incogknito, a crew in Whitstable, England (see interview with Incogknito on page 56):

> We anonymously promote knitting as adventure.
>
> We aim to soften the edges of an otherwise cruel, harsh environment.
>
> We juxtapose vandalism with the non-threatening nature of knitting.
>
> We aim to readdress the nature of graffiti with a nonpermanent, nondestructive, cozy medium.
>
> If you don't like it, just unpick it.
>
> We are a non-discriminating collective.
>
> We aim to recruit members to tag on an international scale.
>
> Knitstable today, the world tomorrow!
>
> Actively contributing to a more positive type of global warming.
>
> Do you have too much responsibility in your life? Do you yearn for something pointless?
>
> If the answer is yes, then join the movement and become an outlaw knitter.

INSTRUCTIONS FOR JOINING:

1. Knit graffiti.
2. Attach to street furniture.
3. Take photographic evidence of graffiti and email to us for inclusion in the gallery.
4. Optional: If you'd like to be in our rogues' gallery, send us a picture of yourself—and remember to be "incogknito."

Join the campaign!

Group projects

While any piece of yarn graffiti can be created by an individual, it is fun to brainstorm projects that your crew can work on together. The advantage of creating projects as a group is that you can create large, eye-catching pieces with minimal efforts.

Photograph objects you wish to tag, or, better yet, take the group on

Will you have rules? Will everyone be required to provide elements for a project with exact dimensions, or is it okay to improvise? Who will be responsible for seaming the pieces together?

Your crew could stitch for a special occasion, such as:

- St. Patrick's Day
- Valentine's Day
- Halloween
- Groundhog Day
- the opening of a community housing project, a new school, or an arts center
- Robbie Burns Day
- Knitting Olympics
- International Women's Day
- Summer Solstice
- International Knit in Public Day

BEAUTIFY SOMETHING UGLY: Pick a location that has personal meaning. Is there a piece of urban architecture that everyone agrees is ugly? Your knitting could probably improve it.

CELEBRATE SOMETHING WORTHY: Is there something that requires a crocheted homage? This could be a structure such as a statue honoring suffragettes, a coffee shop that takes the time to host poetry readings, or a community garden that is lovingly cared for.

MAKE THE ORDINARY EXTRAORDINARY: Tag sites that, normally, you wouldn't give the time of day to—sewer lines, chain link fences, alleys, dumpsters. What obscure place can you tag to bring a smile to a passerby?

JOIN A LOCAL EVENT: What can you knit that will celebrate your local community coming together? The Ladies Fancywork Society created knit hearts for Valentine's Day, art pieces for a public garden, and red, white, and blue stars for the Denver Democratic convention. Make someone feel better: tag the view from a hospital ward or an old folks' home. Crochet a pile of mug cozies to keep coffee hot and fingers snug at a recovery center. Tag with items that can be used by others—dress statues with scarves and hats that the homeless can take and wear.

a walk and photograph street furniture that you'd love to tag in the future. If someone in the crew likes to draw, they can create a few sketches of your ideas while you talk, so that you can refer to them over the course of creating the work. The best group projects are the ones where everyone gets to be creative and feel they've had a hand in the end result.

Here are some ideas for large-scale group projects:

- Crochet a sail for a ship.
- Knit a blanket for a car.
- Crochet curtains for a freeway overpass.
- Cover the trunks of a pathway of trees en masse.
- Design sweaters for a group of statues.

Decide how many people can work on this project—then decide what commitment crew members can bring to it. When Knitta hit an overpass in Houston, Texas, everyone in the group had to knit something that was two feet by six feet, and it had to be pink.

AN INTERVIEW WITH
Edie of the Ladies Fancywork Society

The Ladies Fancywork Society began in Denver, Colorado, but now also has members in Chicago and Amsterdam. The Ladies Fancywork Society is interested in reviving the grandmotherly arts and uses all the ruffles and lace patterns that crochet has to offer. This group doesn't say bombing or tagging; they say they are "putting skirts on the world." Crew meetings have been supplemented with cupcakes and vintage movies.

With ten members ranging in age from twenty-two to thirty, the group has managed to hit places as far apart as Amsterdam, Syracuse, Athens, and New York. Some projects are individual, others are group collaborations.

Their work is just as sweet and delicious as you would expect—flouncy, lacey, and pretty—though sometimes adorned with skulls or rocket ships.

Q: How did you all meet?

A: My friend Vivianne and I talked about getting together and making some street art, and getting this kind of group going. So we each invited our favorite people, who we thought would want to be involved, and came up with a conglomerate of girls and just started making art.

Q: You are in Amsterdam, and the rest of the group is in Denver. How did that work?

A: We've done a little bit of sharing. Vivianne came over to Greece for the summer and put up a few things in Athens and sent a couple of pieces my way from the girls in Denver. We've been trying to take advantage of the fact we live apart.

Q: Do you all go by the name The Ladies' Fancywork Society?

A: Yes. I take care of the website and make sure that [photographs of] everyone's pieces get posted. Some people work more independently than others. In Denver, when Vivanne and I were still there, we'd have get-togethers every week and just hang out, make cupcakes, make fancyworks, and watch vintage movies with each other. Kind of like a little granny circle.

Q: In knitting circles or craft groups, you get a wide range of people.

A: It brings all the hens out! I absolutely love that. Especially the people who are older; I really appreciate that age group. It's a different demographic when you have crafting, it's really widespread.

Q: What sorts of day jobs do the members of your crew have?
A: They really range. Some of them are masters-degree intellectual types. Some just got out of college and are illustrators. One girl is an animator and another is an industrial designer and is trying to get into designing shoes.

Q: What about code names?
A: My code name is Edie. There's Vivianne, there are two girls who just go by the moniker, The Twins. And there's Esther and Jeanne Lois. One girl goes by the name Lady Magdalena Pompelthwaite. It's all one name!

Q: Can you tell us how you got started with crochet graffiti?
A: My friend Vivianne found out that I was a crafter when we first met. She was just graduating from the Art Institute, and she was really gung-ho about doing street art. And I said, that's great, I know a couple of other girls—let's do it!

And then before I knew it, she'd made a tag and stuck it outside my husband's business in Denver. I marched right over to her and said, "What are you doing? We are supposed to start a group!" And the very next week we had five girls sitting out front together, making plans, talking about the future of it all.

Q: The first time you put up a tag, were you alone, or was there a group of you doing it together?
A: Vivianne and Esther and I put out, between us, about fifteen tags. We took a ladder, we had a driver. Actually, my six-year-old son came along and stayed in the car while we went out—we went out family style! We tagged trees. We did posts. We hit a variety of things. Then we went back and had hot cocoa and watched a Dr. Seuss movie.

Q: Did anyone ask you what you were doing?
A: No, that's when we got away without anyone seeing us. It was early evening, so it was a little bit dark out. Nobody said anything. I've only been

Photos: The Ladies Fancywork Society

afghan looking, and it's funky-kitschy American—or, I guess, every country—kitschy. It's beautiful, and it's sculptural, and it has all these other aspects to it that are not accessible with knitting.

I think there are a couple of styles that are starting to develop in the group. People have their favorite type of stitches. I'd say that one girl is very much into the zigzag stitches. I'm probably the only one that has color work with designs; I do the ones with the skeletons, the skull and crossbones.

Q: Do you do tapestry crochet for those?
A: No, it's kind of like intarsia. I don't worry about how the back looks; it's just going to go out on the good side. I make a little grid or find one, and then just go for it. The good thing with crochet is that it hooks together, so you don't really have to worry about there being a gap in between the two colors, like with knitting.

Q: Do you generally scope out what you are going to do tags for?
A: I usually just make them and then figure out where they will fit. But there have been a couple that I made for specific places. One was a rocket ship on a banner that I made for a specific post. A lot of the other girls make them for certain places. They'll find their favorite bar, their favorite coffee shop, their favorite cupcake shop, and they'll tag those places. In that sense, many of the pieces are custom made.

Q: I'm curious about the name Ladies Fancywork. How did you come up with that?
A: We got our inspiration from Knitta. One of the things we first talked about is what we wanted to

confronted one time, in Amsterdam, by a woman who was really, really curious about what we were doing. A friend was helping me put up a hanging banner. The woman asked if I'd crocheted that. Sometimes people don't know crochet is any different from knitting, but it was evident that she was also a crafter and she was really curious about it. We said, "Its just art," and moved on. That's the only time I've been busted!

Q: You knit, too, so why do you prefer crochet for this?
A: Yeah, I totally knit. My mom taught me when I was really young, but the other girl, who I started the group with, only crochets. We had that in common. When we talked about it with the group, the girls felt that crochet needed more power. Crochet is cool, and it's granny-square, and it's

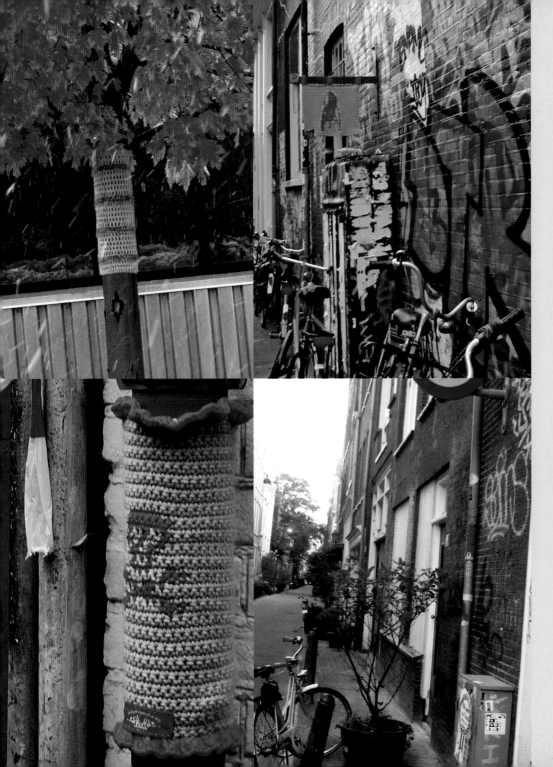

do like them, and what we wanted to do that was different. Knitta has the street feel; they're a little more on the hard side, and we wanted to be a bit fancier and girlier. We're all into vintage style—everyone has their own era. Some are into the Victorian fluffy, skirty type thing, others are into a more 1950s or 1960s style. We chose an older feel and an older, more generic sounding name. We joked about having funny long names like Lady Magdalena Pompelthwaite. Fancywork sounds Colonial or Victorian. It has a link to an older time.

Q: Where else do you get your inspiration for tags? The skull and crossbones tag is a little different from fancywork...
A: I try to make things that are pretty. The skull and crossbones have the soft-hard thing going on. Two skull and crossbones tags are placed at an artist collective in Denver. Another is outside of a squat in Amsterdam. And those are both places that have a bit of hardness to them.

The other one is a scooter, and I was inspired by a nearby scooter shop for that one. We did hearts inspired by Valentine's Day. We work with a local group in Denver called the Magnet Mafia and we

affixed them all with magnets and put them up all over the city.

Our flower mural is in a building in Denver that has all these great murals, maybe twelve feet by twelve feet, all done by various local artists. This was our version of the flower mural. We did a big flower installation by basically stapling [flowers] onto the wall with a big staple gun. It's perfect, it goes straight into drywall.

Some of the girls in Denver participated in a project that the Denver Botanical Garden started called Urban Nature. They sent this email out with a picture from Knitta's site showing a knitted piece around a tree, and the email said they wanted to do this in their botanical gardens. A whole bunch of pieces [got done] in conjunction with the Botanical Gardens. A civic organization is really embracing this thing that might be a bit edgy for them.

Q: What's your craziest yarn graffiti fantasy? Would there be anything else you'd love to do, given all the resources in the world?
A: We've always talked about doing bigger pieces with a lot of people. One of the pieces we talked about is the flower mural. [We want to do] strips to go into chainlink fences. Or make a bigger message—but the little things make a big impact. Small piece, big impact.

CHAPTER 5

Taking It to the Streets

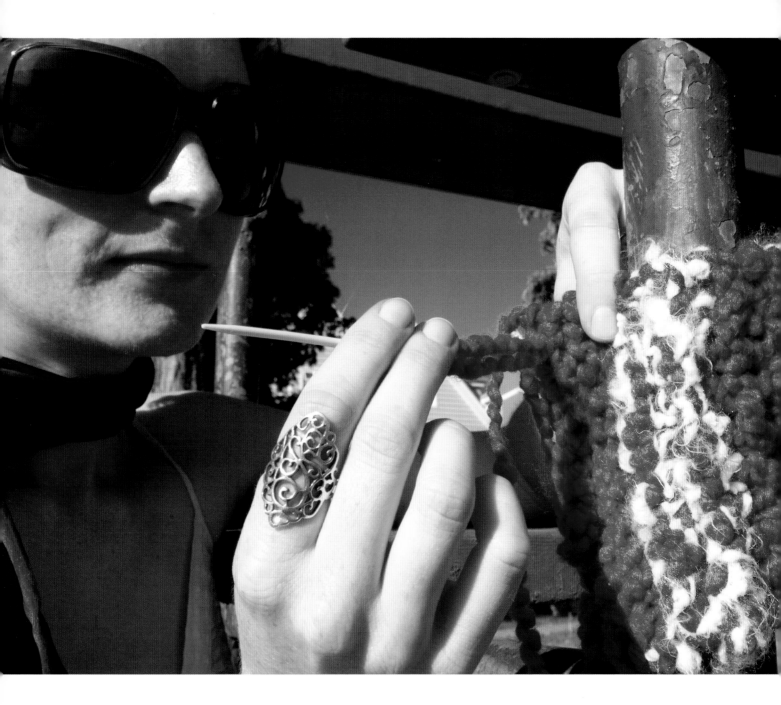

> ### The act of tagging is what sets yarn bombers apart from other knitters and crocheters.

ONCE YOU HAVE COMPLETED A TAG OR TWO, it's time to hit the streets with your newly made art. The act of tagging is what sets yarn bombers apart from other knitters and crocheters. Stitch by stitch, they anticipate with tingling fingers the moment when they get to leave their piece behind. There's a mystery to tagging—your piece might stick around for months and be a pleasant surprise to hundreds of people, or it might be spotted minutes after it has been left and pulled down. Once you tag, the process is entirely out of your hands.

There is nothing as thrilling as hitting the streets with work that you've created yourself. Whether in the middle of a busy shopping district or a quiet alley in a deserted part of town—bombing is where you get to see all of your hard work in action. When you see strangers slow down to take a look or overhear co-workers talking about that strange piece of intarsia they saw down the block, you'll know that you've earned your yarn bombing cred.

Some taggers prefer to go sign unseen and dress up in a covert fashion; others like the anonymity of looking normal on a busy street. This chapter offers useful tips and tricks, no matter what sort of tagger you are. After a few hits, you'll find out what your preferences are and discover your own graffiti style. Grab your hooks and needles and get ready to bomb!

Why we love to tag

INTRIGUE: We love to be part of a mystery. We know that the next day someone will be wondering what a tag is and where it came from. They will likely think, "Who would do that?"

BE FREE OF CRITIQUE: It's nice to add a bit of insanity to the world. The anonymous act of tagging can be a huge relief to artists and crafters who are used to having their work evaluated and inspected by others.

STRANGERS SUDDENLY HAVE YOUR BACK: A corner where bike couriers hang out or office workers take their daily smoke is a good spot to bomb. Not only will you brighten someone's day, but because some of the regulars feel they own those spaces, your tags may find self-appointed caretakers, people who reinstate the tags if they sag after a heavy rain shower or patch a few holes when the yarn starts to rot.

Sarah put up [a tag] on a signpost for Oranienstrasse in Berlin, outside the Search & Destroy skate shop. It seemed to have vanished after about a week of being installed. Then, the next day, she walked past, and somebody had tied it to the top of the pole, making sure it would stay there! [It was] the most shining compliment we've ever received. Somebody liked it enough to tie it back up! Perhaps this will become a permanent feature on what is already the most beautifully decorated and stickered-up signpost in Berlin. —ARTYARN

YOU CAN SHOW OFF YOUR MAD SKILLS: Most knitters and crocheters have one thing that they know how to do really well. You might be really good at lacework, inventing new stitches, intarsia portraits, or wild combinations of sequins with faux-fur yarn. Knit graffiti lends itself really well to stitch and color combinations that you wouldn't wear—or ever wish upon your loved ones.

TEAMWORK: There's nothing more satisfying than working with a team to execute your vision. When you work well with your crew, you feel you can take on the world. It's great to see a street covered with your collective work. Everyone may knit or crochet differently, but together your needle work becomes a unified visual force. Take your team out to celebrate afterward and talk about how it all went down.

Get started

PICK THE RIGHT TIME: Decide what time of day you are going to bomb. If it's a busy, well-maintained area, you may choose to put your tags up after the city clean-up crew has called it a day. This will give your tags some more airtime. The night is a great time to put things up when you don't want to be discovered. However, some bombers get a rush out of tagging in broad daylight. If you are in a crew, you want to pick a time that will work for everyone. It would be terrible to have one of your crew members feeling left out if he or she is unable to participate.

SET IT UP: When approaching your target, act normal. You won't be suspect if you pretend that you are just out for a walk. You may want to take your camera with you—it gives you an excuse to pause, and you can examine the site at home later on to look for potential hazards.

Anticipate how fast you will have to leave your tag; this may determine how you will choose to fasten it. Buttons may be good on small pieces such as a door handle. Antenna cozies that are knit like hats can be slipped over an antenna as soon as the car owner turns his or her back. Flat tags can be stapled to construction hoarding in seconds. Some tags take longer than others and are worth the wait—long seams stitched up telephone poles may be a group effort, but if sewn right, they'll have the chance to last days, weeks, or even years.

Show your smarts

Many beginning yarn bombers worry that they could be being caught in the act of putting up a tag. They worry that they will be seen, or worse, approached by a curious bystander, a security guard, or even a police officer. While a heightened sense of danger can add to the thrill that knit graffiti provides, you never want to place yourself in harm's way. Remember, safety always comes first—for you, members of your crew, and the public at large.

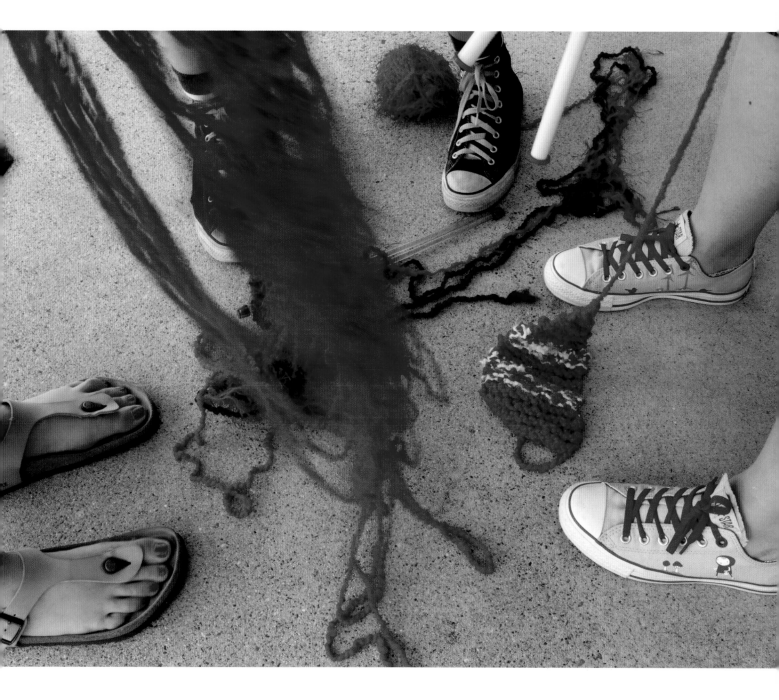

Watch out for:

- guard dogs
- car alarms
- private property
- telephone lines
- unsafe climbs
- private security systems
- perfectly manicured streets
- sprinklers
- electric fences
- patrol cars
- fresh paint or concrete
- flowerbeds or newly planted grass

Be smart. Do not attach your tags in places that pose a threat to yourself or to others. While covering a stop sign may seem cute at the time, causing a three-car pile-up isn't funny. Tagging the pole will cause passersby to smile; covering the reflective sign may lead to consequences you don't want to think about. Make sure your tags do not restrict vital utilities such as fire hydrants, building escapes, and doorways.

The same holds for attaching tags in high-up places—if you think you shouldn't be scaling that wall or that you don't have the skills to balance on the edge of a fence, you probably shouldn't try. Nothing ruins a night of bombing more than a crew member with a broken appendage. A piece wrapped at ground level can be just as lovely as one in a place that you had to risk your skin to get to. Never coerce a member of your crew to do something that she or he is not comfortable with.

An ounce of paranoia never hurt anyone.

Is Big Brother watching?

Look around carefully as you survey your potential target. What is the area like? Who is around? Is it near heavy traffic? Are there surveillance cameras? If you are in an alley, are there a lot of windows facing on to the area?

A residential street may have a neighborhood watch or just a few nosy neighbors. Be sure to check the area out before you start to tag. The last thing you want is the loudest dog on the street barking at your heels when you're halfway through attaching your tag.

An ounce of paranoia never hurt anyone. The more you can do to be unseen, the better. This includes the clothing you wear while you bomb. Ninjas wear a lot of black for the simple reason that it blends in well at night and is hard to see. We suggest you do the same. Also, wear sneakers or other soft-soled footwear—there is nothing more conspicuous than clattering heels on concrete when you are running away from a bombing site.

★ Things to take with you when you bomb:

ESSENTIALS:

- a city map
- flashlights
- some sort of reflector to wear when you are on the roads at night
- extra yarn to sew on tags
- a long plastic yarn needle
- a crochet hook
- a bag that will let you hold your supplies hands-free, such as a messenger bag or packsack
- duct tape or long stitch holders to hold the tag in place while you sew it together (especially useful for solo bombers)
- comfortable shoes that you can run in
- twist-ties for attaching tags quickly
- your favorite hand-made items to keep you warm—e.g., hats, cowls, fingerless gloves, a scarf

NICE TO HAVE:

- snacks (like nuts or granola bars) to keep your energy up
- a getaway vehicle
- a camera person to document your process
- a small step ladder
- thick gloves to protect your hands if you are sewing your tag onto heavy chain link or rusty pipes
- a construction crane
- a thermos of something warm to drink (spiked or not—your choice)
- night-vision goggles
- a change of clothes for your sneaky get-away

Disguises can also be a lot of fun to wear. A wig to change your hair color, a balaclava to obscure your face, or a convertible piece of clothing such as our Switcheroo Sweater (see page 143) are all great ways to throw observers off their guard.

And don't forget to check the atmosphere of your potential target—would you say it's a place that is extremely well-kept? If you've worked really hard on a large piece, you may want to think twice before you place it on the pole of that perfect looking house with the manicured lawn, motion lights, and watchful owner. It can be disheartening to have a tag that you've worked on for weeks taken down minutes after placement by someone who does not appreciate it. Likewise, neither the police station nor that trendy bar with a lineup out front are the best places to tag.

Bombing with two—or a crew

If you have a crew that creates tags together, it is definitely a big coup to get the whole gang together for a night (or day) of tagging together. With most groups, each participant will fall into natural roles. There will be the person who loves being the lookout, the skillful stitcher who can bind tags around poles in seconds, and the daredevil who will place her tag in a place you'd never expect. In most groups, certain individuals will always gravitate towards the same roles, but chat about this before you go bombing, in case one of your members really has her heart set on putting up a certain piece.

If you are putting up multiple pieces, you may want to work it out with the group that several things will be sewn up at the same time. Knitta did this when they covered a highway overpass with fuzzy pink yarn on Valentine's Day. Not only did each crew member contribute a piece, but each person brought along a friend or family member to help them with the stitching.

If your crew is attempting a big project, it may be worth deciding on a code word to use if you get caught, something to call out if someone is

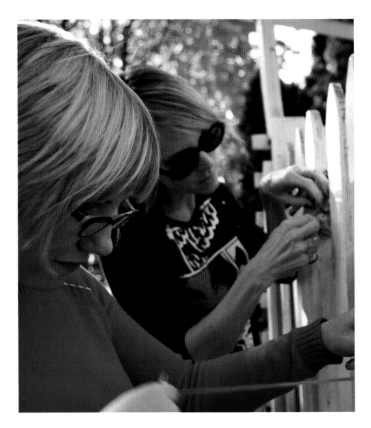

coming. This will tell the bombers who are stitching tags to either hurry up or conceal their tools. We like the following phrases for this purpose: "cast-off," "play hooky," and "the stitch is up." If you're not comfortable calling out a warning, you may want to experiment with flashlights.

It's always valuable to post one or two members who can watch for potential trouble. As they will be the closest to approaching killjoys, they should be prepared to be diplomatic. Make sure they have something entertaining to do while they keep watch, such as knitting a new project, and be sure to give these people some relief so that they can join in the fun, too.

If you don't have a big crew, team up in pairs. One person can hold the tags up against poles while the other person stitches them.

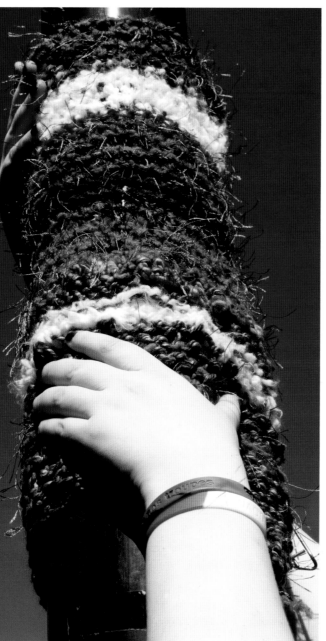

★ What's the sneakiest way to sew a yard-long cozy to a telephone pole? While the fastest way to get a large cozy up is to use buttons or Velcro as your closure, sewing always ensures that a piece will stay up longer. If you need to sew up a big piece fast, we suggest creating a few running stitches on the piece before you arrive at your bombing site. Get three or four needles, pre-threaded, worked into the piece and have a large posse of friends who can help.

Once you hit the site, use some of your crew for cover—let them shelter you from view by clustering around you. We suggest stitching close to the ground, one crew member for each ready needle, and then hoisting the cozy up to its proper height before making the last few tight stitches to keep it in place. With extra hands, you should be able to stitch up to a yard in less than five minutes. When it comes to going undetected, every second you can save counts!

How to improvise if your tag doesn't fit

Sometimes you'll have carefully planned a tag, but when you attempt to attach it to an object, it just will not fit. We suggest finding a new location for this tag, as well-fastened tags tend to have more longevity. However, if this particular location or fixture is really important to you, there are a few ways you can try to fix this problem.

If the tag is too small:
- See if you can stretch the tag. Knitting and crochet generally have a lot of give.
- If you think you have enough time, and you have an extra ball of yarn on you, you can pick up stitches from the finished edge and create more fabric by knitting or crocheting the length you require. The disadvantage of this tactic is that you will remain at the scene of the crime for quite a while.
- If you have more than one tag with you, you can patchwork these together to create a larger piece.
- Sew up the piece using long stitches, cinching the edges together in the same way a corset is laced. If the closure is done with flair, it will not look like a mistake.
- Use twist ties as a quick and expandable closure.
- When in doubt, move on and find a more appropriate home for your piece.

If the tag is too big:
- Overlap the edges when sewing it on.
- Take it home to felt in the washing machine (natural fibers only).

What if you get caught?

While part of the thrill of being a yarn bomber is the subversive feeling, this can quickly sour if you're stopped by less-than-appreciative authorities. While it is a police officer or security guard's job to inspect anything out of the ordinary, you may feel a bit threatened. This is normal—just remember, the easier you can make it for the officer to do his or her job, the faster the confrontation will end.

Remember to remain calm. Take a deep breath if you need to. Both of you want a solution to this problem. Take the time to answer any questions that the officer asks and be honest. Explain to the officer that you are an artist and that you are creating public art. Demonstrate

that the work is removable and does not damage property. This may be the one situation where you may want to skip the use of the word graffiti—"art project" has a much more subdued feeling to it.

If you are lucky, this will likely be the end of it, and you can go on your merry way with a warning. However, if you live in a city with a harsh littering policy, you may be subject to a ticket or a fine. Unfortunately, you will have to pay it. This is the risk that street artists take. Street artist superhero Shepard Fairey, the designer of the iconic Obey Giant sticker (**obeygiant.com**), has been arrested many times, but has managed to post over half a million of his stickers in public. Before you have to deal with an encounter with the authorities, take the time to decide what you are willing to risk in the name of yarn bombing. Determine what you are personally willing to do and not do. If you are knitting with a crew, especially if you are all bombing under the same guise, make sure that everyone shares and respects the same boundaries, as you all may have to share the consequencess.

Occasionally, a bomber may question his or her own yarn bombing motives. Having a tag removed quickly can feel like a deterrent, especially when you've put many hours into creating it. Some yarn bombers worry that others may think they are creating trash, or worry that they are contributing to the broken-window syndrome, attracting other tags and vandalism. These doubts can arise when you are confronted with a bystander who doesn't understand your motives or what you are doing.

Something that I've thought about many times is, is it just littering, in the end? Is it going to end up the trash-fabric of the city? You have to account for a certain amount of joy that people get from yarn graffiti— that counts for something. —EDIE OF THE LADIES FANCYWORK SOCIETY

When you are feeling unsure, evaluate what the act of yarn bombing means to you. Revisit the reasons that inspired you to pick up this book in the first place. Street art may not always be understood by the general public, but that's what makes it so compelling. It is eye-catching, unusual, and it can give you a sense of liberation when you're doing something you're not supposed to be doing. We strongly believe that if you try yarn bombing, you will receive a lot more positive feedback than negative comments.

PATTERNS:
Yarn bombing essentials

We couldn't resist including some garment and accessory patterns inspired by the conversations and interviews we had while planning this book! On the following pages you will find some patterns to keep you looking stylish and subversive while you are on the lam. Knit yourself a toolkit cuff and gloves that you can wear while cycling. Make a convertible sweater or hoodie vest. These patterns will keep you warm—and looking good.

Knitting Kninja Threads

DEBORA OESE-LLOYD

The bright colors of the luscious hand-dyed yarn used for these pieces provides fanciful urban camouflage.

FROM THE DESIGNER: About four years ago when my daughter Kassi and I were out on a retailing expedition, I dragged her into a local yarn store. The eye rolling and comments about not taking all day suddenly changed into enthusiastic oohs and ahhs. She had come across a display of Koigu yarn. By the time I came over to bask in her interest, she was drooling over a hand-dyed camouflage. "Mom, how many skeins would I need for a pair of really long arm warmers?" she asked me.

These are ideal for street-bombing wear. With our cold winters here in Canada, I knew they needed a matching balaclava to keep the knitting kninjas warm. As the word "balaclava" would mean mixing my cultural metaphors, I asked my neighbors Hiro and Natsumi for the Japanese translation of balaclava—zukin. Here is the pattern for the arm warmers and matching zukin.

FINISHED MEASUREMENTS
Lengths
Arm warmers: 13 in/33 cm
Zukin: 12.5 in/32 cm
Zukin length is measured at back; front is approx. 2 in/5cm longer.

CIRCUMFERENCES
Widest portion of arm warmers will stretch to comfortably fit up to 13 in/33 cm.
Zukin will stretch to comfortably fit up to 27 in/68.5 cm

MATERIALS
Koigu Premium Merino (KPM) and Koigu Premium Painter's Palette Merino (KPPPM) [100 percent Merino Wool; 175 yd/160 m per 50 g skein]
[MC] KPPPM #P806 Pinks and Purples; 3 skeins

[CC] KPM #3000 Deep Plum; 2 skeins
1 set US #2.5/3 mm double-pointed needles, or size needed to obtain gauge
1 set US #3/3.5 mm double-pointed needles, used only for casting on and binding off in order to keep the edges loose

Safety pin
Waste yarn
Yarn needle

GAUGE
31 sts and 43 rows = 4 in/10 cm in 3×3 rib

PATTERN NOTES
The terms and abbreviations used in this pattern can be found on page 226.
3×3 rib (Worked in the round over a multiple of 6 sts):
All Rounds: [K3, p3] to end.

The cable cast-on method is used to make the thumb and face openings for this piece. To cast on in this way, with other sts already on needle, turn work so that sts are on left needle. Insert right needle from front to back between first two sts, wrap yarn around right needle and draw it through to front of work. Slip this st to left needle; 1 st has been cast on. Repeat for each st to be cast on.

The fabric of these pieces is very stretchy and flexible, so the pattern as written will fit a wide range of people. However, it's a good idea to try the pieces on periodically while working them to ensure that the shaping is in the right places for your unique body and features. More stitches can be added if needed for either piece to fit more comfortably.

Arm warmers
PATTERN

RIGHT HAND

Using larger needles and CC, cast on 48 sts. Divide sts between needles, placing 15 sts each on Needles 1 and 2, and 18 sts on Needle 3. Join to begin working in the round, being careful not to twist. After you have worked the first few rounds, place safety pin in work to indicate beginning of round. Work 25 rounds in 3×3 rib.

Thumb opening and gusset:

Bind off 6 sts, continue in pattern to end. 42 sts. Turn work; the next few rows are worked back and forth.

Work 2 rows in pattern. At end of second row, turn work and use cable cast-on method to cast on 12 sts; turn work again so that RS is facing. Slip newly cast on sts onto an empty needle, then, being careful not to twist new sts, use this needle to work sts from Needle 1; continue in pattern to end of round. 54 sts.

Redistribute sts between needles as desired. Work 9 rounds in pattern, incorporating newly cast on sts into pattern.

Shape wrist

Round 1: K3, sl 1, p2tog, pass slipped st over, continue in pattern to end of round. 52 sts.
Round 2: K3, p1, continue in pattern to end of round.
Round 3: K2, sl 1, k2tog, pass slipped st over, k2, continue in pattern to end of round. 50 sts.
Round 4: K5, continue in pattern to end of round.

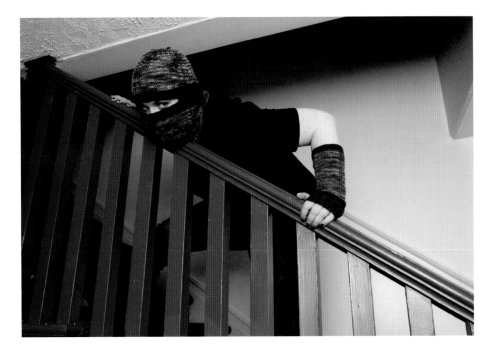

Round 5: K1, sl 1, k2tog, pass slipped st over, k1, continue in pattern to end of round. 48 sts.
Work 7 rounds in pattern. Break CC.
Using MC, work 47 rounds in MC, or until work measures 10 in/25.5 cm.
Note: If you have short or long arms, try the gloves on; you may want them to be longer or shorter before beginning forearm shaping.

Increase for forearm

Round 1: K1, m1, k2, continue in pattern to end. 49 sts.
Round 2: K4, continue in pattern to end.
Round 3: K2, m1, k2, continue in pattern to end. 50 sts.
Round 4: K5, continue in pattern to end.

Round 5: K3, m1, k2, continue in pattern to end. 51 sts.
Round 6: K6, continue in pattern to end.
Round 7: K3, m1p, continue in pattern to end. 52 sts.
Round 8: K3, p1, continue in pattern to end.
Round 9: K3, m1p, p1, m1p, continue in pattern to end. 54 sts.
Continue in pattern until work measures 12 in/30.5cm, or 1 in/2.5 cm less than desired length. Break MC.
Using CC, work 1 in/2.5 cm in pattern, then use larger needle to loosely bind off all sts in pattern. Weave in ends.

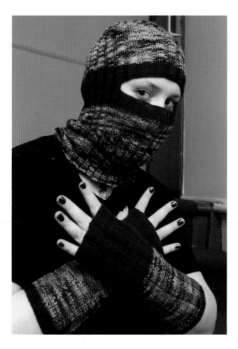

LEFT HAND

Work as for right hand up to beginning of thumb opening.

Thumb opening and gusset

Next Round: K3, bind off 6 sts, continue in pattern to end. 42 sts. Turn work; the next few rows are worked back and forth.

Work 2 rows in pattern. At end of second row, turn work and use cable cast-on method to cast on 12 sts; turn work again so that RS is facing. Slip newly cast on sts onto an empty needle, then, being careful not to twist new sts, use this needle to work sts from Needle 1; continue in pattern to end of round. 54 sts.

Work first 6 sts from Needle 1 onto Needle 3; this point will now be beginning of round. Redistribute sts between needles as desired. Work 9 rounds in pattern, incorporating newly cast on sts into pattern.

Continue as for right arm warmer.

Zukin

TOP OF CROWN

Using smaller needles and MC, cast on 12 sts. Divide sts between needles and join to begin working in the round, being careful not to twist.
Odd-numbered Rounds 1–13: K all sts.
Round 2: [K1, m1] to end. 24 sts.
Round 4: [K3, m1, k3] 4 times. 28 sts.
Round 6: [K1, m1] to end. 56 sts.
Round 8: K all sts.
Round 10: [K2, m1] to end. 84 sts.
Round 12: K all sts.
Round 14: [K3, m1p] to end. 112 sts.
Rounds 15–17: [K3, p1] to end.
Round 18: [K3, p1, m1p] to end. 140 sts.
Rounds 19–21: [K3, p2] to end.
Round 22: [K3, p2, m1p] to end. 168 sts.
Work 35 rounds in 3×3 rib.

SHAPE FOREHEAD

Forehead is shaped using short rows. Throughout this pattern, when you come to a stitch that has been wrapped on a previous short row, work the wrap together with the wrapped stitch. If the stitch is a knit stitch, do this by inserting the right needle into both the wrap and the stitch, and knitting them together. If the stitch is a purl stitch, use the tip of left needle to pick up the wrap and place it on left needle, then purl the wrap and stitch together through their back loops.

Row 1 [RS]: Work 63 sts in pattern, W&T.
Row 2 [WS]: Work 42 sts in pattern, W&T.
Row 3 [RS]: Work 45 sts in pattern, W&T.
Row 4 [WS]: Work 48 sts in pattern, W&T.
Row 5 [RS]: Work 51 sts in pattern, W&T.
Row 6 [WS]: Work 54 sts in pattern, W&T.
Row 7 [RS]: Work 57 sts in pattern, W&T.
Row 8 [WS]: Work 60 sts in pattern, W&T.
Row 9 [RS]: Work 63 sts in pattern, W&T.
Row 10 [WS]: Work 66 sts in pattern, W&T.
Row 11 [RS]: Work in pattern to end of round.
Work 1 more round in pattern. Try on zukin; piece should be approximately 1 in/2.5 cm shorter than desired length to eye opening. Break MC.

Eye band

Using CC, work 10 rounds in pattern.
Next Round: Work 21 sts in pattern, bind off next 45 sts, work in pattern to end of round, then continue in pattern to bound-off sts. 123 sts. Turn work; the next few rows are worked back and forth.

Work 2 rows in pattern. At end of second row, turn work and use cable cast-on method to cast on 21 sts; turn work again so that RS is facing. Join work and work in pattern to end of round. 168 sts.

Work 10 more rounds using CC, then break CC and switch back to MC.
Work 17 rounds in pattern.

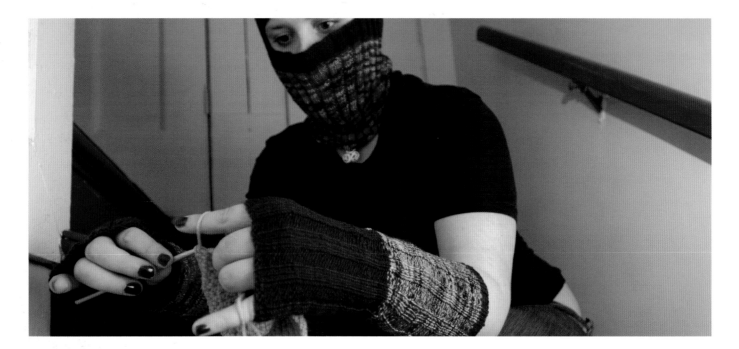

SHAPE CHIN

Chin is shaped using short rows.
Row 1 [RS]: Work 69 sts in pattern, W&T.
Row 2 [WS]: Work 54 sts in pattern, W&T.
Row 3 [RS]: Work 51 sts in pattern, W&T.
Row 4 [WS]: Work 48 sts in pattern, W&T.
Row 5 [RS]: Work 45 sts in pattern, W&T.
Row 6 [WS]: Work 42 sts in pattern, W&T.
Row 7 [RS]: Work 39 sts in pattern, W&T.
Row 8 [WS]: Work 36 sts in pattern, W&T.
Row 9 [RS]: Work in pattern to end of round.
Work 1 more round in pattern.

SHAPE FRONT NECK

Round 1: [K3, sl 1, p2tog, pass slipped st
 over, k3, p3] seven times, continue in
 pattern to end of round. 154 sts.

Rounds 2–12: [K3, p1, k3, p3] seven times,
 continue in pattern to end.

SHAPE LOWER HEM

Front hem is shaped using short rows.
Row 1 [RS]: Work 69 sts in pattern, W&T.
Row 2 [WS]: Work 68 sts in pattern, W&T.
Row 3 [RS]: Work in pattern to end of round.
Round 4: Work all sts in pattern.
Repeat Row 1–Round 4 twice more. Try on
 zukin; piece should be approximately 0.75
 in/2 cm shorter than desired length. If it is
 too short, work these short rows several
 times more.

FLARE HEM

Round 1: [K3, m1p, p1, m1p, k3, p3] seven
 times, continue in pattern to end. 168 sts.
Rounds 2–6: Work in 3×3 rib as set.

FINISHING

Loosely bind off all sts using larger needles.
Weave in ends and let the street knit
adventure begin.

DEBORA OESE-LLOYD (Nelson, British
Columbia) is surrounded by the Kootenay
Mountains, stacks of yarn, and the love of her
wonderful husband, Patrick. Every autumn the
four huge maple trees in her front yard carpet
the ground with golden and red leaves
inspiring her to dye, knit, and crochet up
creations for Archie, Cassandra, and Zachary,
her grown children who live across Canada.

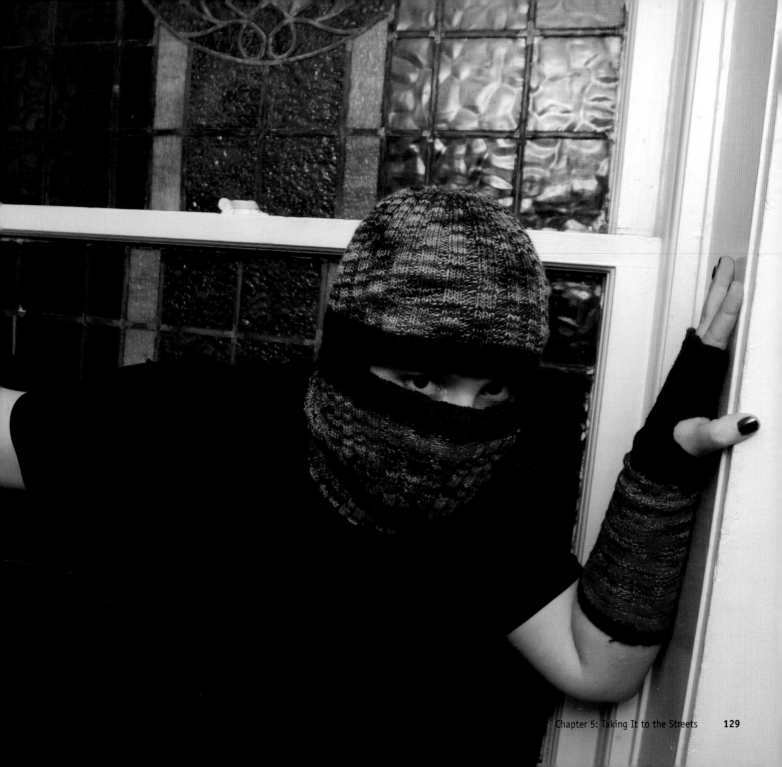

Convertible Biking Gloves

LEANNE PRAIN

Safety first, kids! These knitted black arm warmers can be worn two ways. Wear them reflector side out when you are cycling to your yarn bombing site, then fold the upper portion over to hide the reflective tape once it's time to tag.

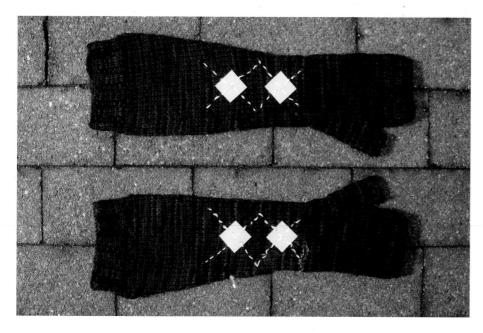

FINISHED MEASUREMENTS
Length: 14.75 in/37 cm
Will comfortably stretch to fit forearm up to
15 in/38 cm

MATERIALS
Dream in Color Classy [100 percent Superfine
Australian Merino Wool; 250 yd/229 m per
4-oz skein; color: #360 Black Parade; 1 skein]

1 set US #6/4 mm double-pointed needles,
or size needed to obtain gauge
1 set US #8/5 mm double-pointed needles,
used only for casting on and binding off in
order to keep the edges loose
Safety pin or split ring marker
Stitch markers
Waste yarn
Yarn needle
Sharp needle (used for embroidery)
1 skein cotton embroidery floss

1 package Coats Patons Press-on Play Safe
Reflectives in neon yellow REF 1005 (this
material also comes in silver and orange,
which would also look great on this pattern.)

GAUGE
20 sts and 27 rows = 4 in/10 cm in
stockinette st

PATTERN NOTES
Terms and abbreviations used in this pattern
can be found on page 226.
Both gloves are worked in the same way;
there is no difference between right and
left gloves.

2×2 rib (Worked in the round over a multiple
of 4 sts):
All Rounds: [K2, p2] to end.

1×1 rib (Worked in the round over an even
number of sts):
All Rounds: [K1, p1] to end.

PATTERN
Ribbed cuff
Using larger needles, cast on 48 sts. Divide
sts between needles and join to begin
working in the round, being careful not to
twist. After the first few rounds have been
worked, place safety pin or split ring marker
in work to indicate beginning of round.
Switching to smaller needles, work 10 rounds
in 2×2 rib.

Arm
K 5 rounds.
Decrease Round: K1, k2tog, k to last 3 sts,
ssk, k1.
Repeat these 6 rounds 7 times more. 32 sts.
K 19 rounds; work should measure approx.
8 in/20 cm; if further length is desired,
continue in stockinette st until piece is
desired length to wrist.

Hand
Set-up Round: K1, m1, k14, place marker, m1r,
k2, m1, place marker, k14, m1r, k1.
36 sts.

K 3 rounds.
Thumb Gusset Increase Round: K to first
marker, slip marker, m1r, k to next marker,
m1, slip marker, k to end.
Repeat these 4 rounds 3 times more. 44 sts.

K 3 rounds.
Dividing Round: K to first marker, remove
marker, and place next 12 sts on waste yarn,
remove second marker and join to continue
working in the round, k to end. 32 sts.

Figure 1: Stitch pattern

Figure 2: Photocopy this diamond template as a guide for cutting your reflective material. We cut out a plain diamond and traced it onto the back of the reflective material in order to make a precise shape.

Upper hand
K 7 rounds. Work 3 rounds in 1×1 rib, then use larger needles to loosely bind off all sts in pattern.

Thumb
Place held sts of thumb on needles and join yarn at point where thumb meets hand. K 3 rounds, then work 3 rounds in 1×1 rib. Use larger needles to loosely bind off all sts in pattern.

FINISHING
Use yarn tail at joining point of thumb and hand to sew closed the small gap at base of thumb. Weave in ends.

Wet block gloves following directions on page 66. Blocking will ensure that fabric is smooth and flat, which is helpful when working embroidery.

Photocopy the diamond shape in Figure 2. Cut out the paper shape and trace it onto the wrong side of the reflective material. Cut out four diamonds.

Count 36 rows from bottom cuff upward and mark this row with waste yarn. From the 37th row, count up 35 rows more (to the 72nd row). Mark this row in the same way. The argyle design will be placed between these 2 rows. See stitching diagram in Figure 1.

Remove backing from adhesive diamonds and center them on the gloves, spacing them so that they are 5 rows apart, and 5 rows away from marked rows.

Use embroidery floss to stitch lines as shown, crossing the diamonds to complete the argyle motif.

See Leanne Prain's bio on page 231.

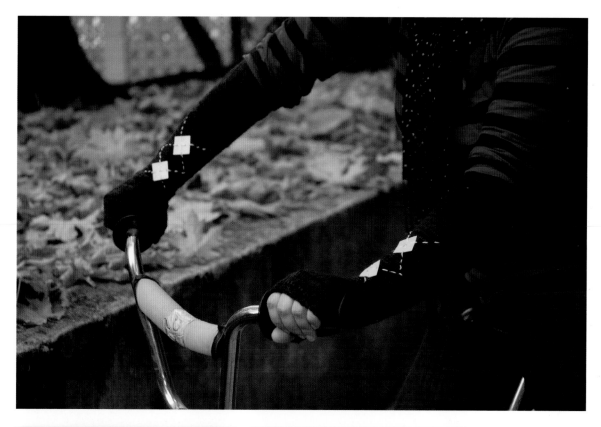

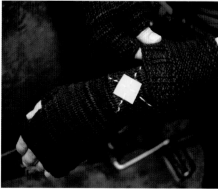

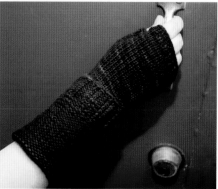

Turn your convertible gloves into an instant disguise by concealing the reflectors with a turn of the cuff.

Tagging
Toolkit Cuff

LEANNE PRAIN

With just enough room for a yarn needle,
folding scissors, and a few yards of extra
yarn, the pocket in this cuff provides a
stylish way to keep your tiniest tagging
tools at your fingertips.

FINISHED MEASUREMENTS

Circumference: Will stretch to comfortably fit up to 11 in/28 cm.

Height: 4.5 in/11.5 cm

MATERIALS

Cascade Yarns Cascade 220 and Cascade 220 Heathers [100 percent wool; 220 yd/201 m per 100 g skein]; 1 skein each color

[MC] #2452 Turtle

[CC] #8400 Charcoal Grey

1 set US #7/4.5 mm double-pointed needles, or size needed to obtain gauge

1 set US #9/5.5 mm double-pointed needles, used only for casting on and binding off in order to keep the edges loose

Crochet hook, approx. US #5/F / 3.75 mm

Safety pin or split ring marker

Stitch marker

1 yarn needle

Small piece woven cotton fabric, for lining

Sewing needle and thread

Button, approx. 0.75 in/19 mm diameter

Steam iron

GAUGE

20 sts and 28 rows = 4 in/10 cm in stockinette st

PATTERN NOTES

Terms and abbreviations used in this pattern can be found on page 226.

1×1 rib (Worked in the round over an odd number of sts):

All Rounds: [k1, p1] to last to, k1.

Elizabeth Zimmermann's sewn bind off

Work this bind-off method using a yarn tail 3 to 4 times the length of the edge to be bound off. Thread tail through yarn needle, hold work so that all sts are on left needle, then work as follows:

Insert yarn needle from right to left through first two sts, draw yarn through. Bring yarn needle back around front of second st on needle and insert from left to right through first st on needle. Drop first st from left needle. Repeat from * to * until 1 st remains on left needle; insert yarn needle from right to left through last st, then drop from left needle.

Illustrated directions for this bind-off method can be found at **knitty.com /ISSUEsummer06/FEATsum06TT.html**

PATTERN

Cuff

Using larger needles and MC, cast on 46 sts. Divide sts between needles and join to begin working in the round, being careful not to twist. After the first few rounds have been worked, place safety pin or split ring marker in work to indicate beginning of round.

Switching to smaller needles, work as follows:

Set-up Round: Work 31 sts in 1×1 rib, k1, place marker, k15.

Work 11 more rounds in pattern as set, working first 31 sts of round in 1×1 rib and last 15 sts in stockinette st.

Work 8 rounds in pattern using CC.

Work 12 more rounds in pattern using MC.

Break yarn, leaving a tail approx. 40 in/101 cm long. Using Elizabeth Zimmermann's sewn bind-off method, bind off first 31 sts of round (all sts to marker). Rejoin MC to remaining 15 sts with WS facing; this will now be the RS of the work, so that when flap is closed, RS will be facing.

Flap

Work 6 rows in stockinette st using MC, then work 6 rows using CC. Repeat these 12 rows once more, then bind off.

Pocket body

With RS facing, pick up and k16 sts along cast-on edge of stockinette st portion of cuff (these sts will be directly opposite flap).

Work 25 rows in stockinette st beginning with a RS row, so that when pocket is folded up, the RS will be facing outward. Bind off all sts.

FINISHING

Weave in ends on cuff and flap, but leave tails for pocket to use in sewing up after lining has been inserted. Block cuff as directed on page 66–67.

Lining

Cut a rectangular piece of lining fabric that is 9.5 in/24 cm long and 3.5 in/9 cm wide. Turn all edges under 0.25 in/6 mm and press.

With knitted pocket body opened out and RS of cuff facing, center fabric right side up over stockinette portion of cuff and inside of pocket body. Use sewing thread to sew edges of lining to knitted fabric. Fold pocket body up and use sewing thread to sew sides of pocket in place along edges of lining, ensuring that lining meets along edges. Use MC to sew edges of knitted fabric in place.

Fold flap down and mark location of lower edge of front of pocket. Sew button in place just below this point. Using CC, work a crochet chain approx. 1.75 in/4.5 cm long. Fold chain into a loop and sew ends securely to inside of flap to form a button loop.

See Leanne Prain's bio on page 231.

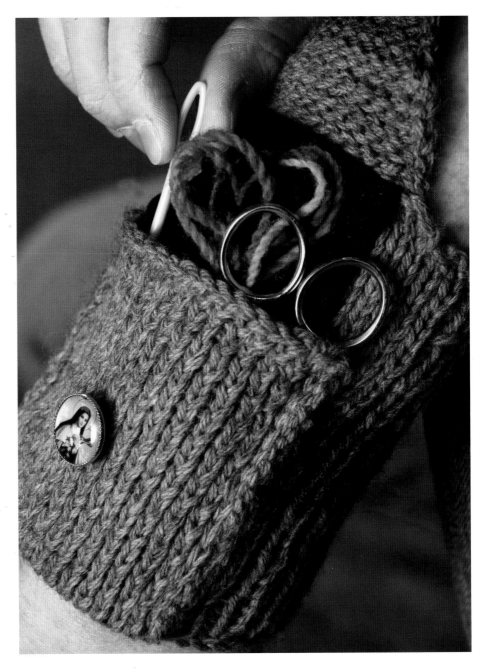

Hoodie Vest

MANDY MOORE

Hoodies seem to be the quintessential graffiti clothing. This sleeveless version has a toasty shawl collar, a shapely hood, and deep armholes, which facilitate layering. It is designed to work well for both men and women.

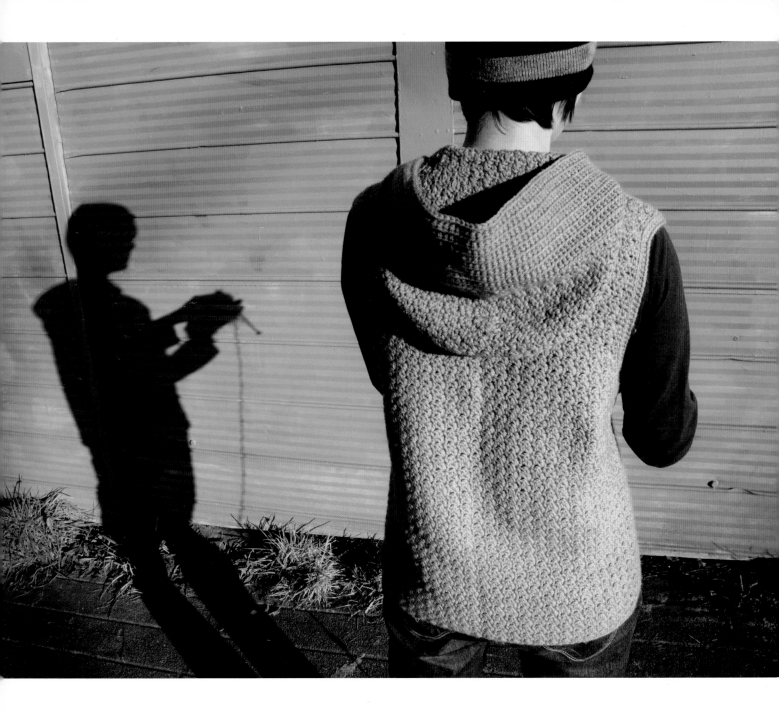

SIZES
A [B, C, D, E]

FINISHED MEASUREMENTS
Chest: 30[36, 42, 48, 54] in / 76[91.5, 107, 122, 137] cm
Length (excluding hood): 24[24.5, 25, 25.5, 26] in / 61[62, 63.5, 65, 66] cm

MATERIALS
Cascade Yarns Cascade 220 [100 percent wool; 220 yd/201 m per 100 g skein]; #4010 Straw; 4[5, 6, 7, 8] skeins

US #10/J / 6mm crochet hook, or size needed to obtain gauge
US #8/H / 5mm crochet hook, or 2 sizes smaller than larger hook

Yarn needle
Safety pins

GAUGE
In pattern stitch using larger hook,
10 sts = 3 in/7.6 cm and 16 rows = 5 in/12.7 cm

PATTERN NOTES
Terms and abbreviations used in this pattern can be found on page 226.

The back and front of this piece are shaped differently at the shoulders. The back shoulders are shaped at a fairly steep angle, and the front shoulders are straight across. When the shoulder seams are sewn, the seam will sit to the back of the shoulder, and the front pieces will fold at a graceful angle along the shoulder line.

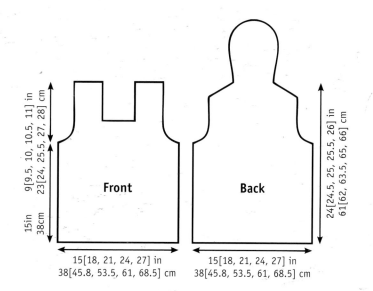

The armholes of this piece are quite deep. If you wish to have shallower armholes, work fewer rows before neckline and shoulder shaping for both front and back; be sure to shorten each piece by the same amount. Working 3 rows fewer will shorten the piece by slightly less than 1 in/2.5 cm.

Pattern stitch (worked over an even number of sts):
Pattern Row: Ch 1, sc in first st, [dc in next sc, sc in next dc] to last st, hdc in last sc. Repeat this row for pattern stitch.

Increasing and decreasing in pattern:
Inc: Increase by working [dc, sc, dc] in next sc. 2 sts have been increased.

W2tog: Work next 2 sts together (decrease) in pattern, as follows:
If next st to be worked would be a sc: Insert hook in next st, pull up a loop; yarn over, insert hook in following st, pull up a loop, yarn over and draw through first 2 loops on hook, yarn over and draw through remaining 3 loops on hook.

If next st to be worked would be a dc: Yarn over, insert hook in next st, pull up a loop, yarn over and draw through first 2 loops on hook; insert hook in following st, pull up a loop, yarn over and draw through remaining 3 loops on hook.

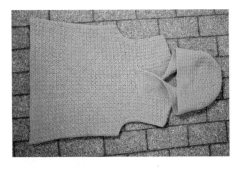

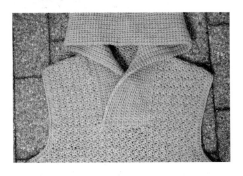

PATTERN

Back

Using larger hook, ch 51[61, 71, 81, 91]. Sc in first ch and in each ch to end. 50[60, 70, 80, 90] sc.

Set-up Row: Ch 1, sc in first sc, [dc in next sc, sc in next sc] to last st, hdc in last sc. Work 46 rows in pattern stitch, or until piece is desired length to underarms. (When blocked, piece as written will measure 15 inches.)

Shape armholes

Next Row: Sl st in first 3[3, 5, 5, 7] sts, ch 1, sc in same st, [dc in next sc, sc in next dc] to last 2[2, 4, 4, 6] sts. Turn work, leaving remaining 2[2, 4, 4, 6] sts unworked. (Note that last st of this row is a dc.) 46[56, 62, 72, 78] sts.

Decrease Row 1: Do not work tch, skip first st, sc in next sc, sc in next dc, [dc in next sc, sc in next dc] to last 3 sts, dc2tog over next 2 sts. Turn work, leaving last st unworked. 43[53, 59, 69, 75] sts.

Decrease Row 2: Do not work tch, skip first st, sc in next sc, sc in next dc, [dc in next sc, sc in next dc] to last 4 sts, hdc in next sc, dc2tog over next 2 sts. Turn work, leaving last st unworked. 40[50, 56, 66, 72] sts.

Size A only

Next Row: Ch 1, skip first st, sc in next hdc, [dc in next sc, sc in next dc] to last 2 sts, hdc in next sc. Turn work, leaving last st unworked. 38 sts.

Sizes B, C, D, E only

Decrease Row 3: Do not work tch, skip first st, sc in next hdc, [dc in next sc, sc in next dc]

to last 4 sts, hdc in next sc, dc2tog over next 2 sts. Turn work, leaving last st unworked. -[47, 53, 63, 69] sts.

Decrease Row 4: Do not work tch, skip first st, sc in next hdc, [dc in next sc, sc in next dc] to last 3 sts, dc2tog over next 2 sts. Turn work, leaving remaining st unworked. -[44, 50, 60, 66] sts.

Size D only

Work Decrease Rows 1–2 once more. 54 sts.
Next Row: Ch 1, skip first st, sc in next hdc, [dc in next sc, sc in next dc] to last 2 sts, hdc in next sc. Turn work, leaving last st unworked. 52 sts.

Size E only

Work Decrease Rows 1–4 once more. 54 sts.

All Sizes

Work 18[18, 17, 15, 16] rows in pattern over remaining 38[44, 50, 52, 54] sts.

Shape shoulders

Note: Decrease Rows for back shoulder shaping are the same as Decrease Rows for armholes. If you are making size A, see armhole shaping directions for Sizes B–E for Decrease Rows 3–4.
Work Decrease Rows 1–4, 1[2, 2, 2, 2] times. 26[20, 26, 28, 30] sts.

Sizes A, C, D, E only

Work Decrease Rows 1–2 once more.

Next Row: Ch 1, skip first st, sc in next hdc, [dc in next sc, sc in next dc] to last 2 sts, hdc in next sc. Turn work, leaving last st unworked. 18[-, 18, 20, 22] sts.

Work hood as follows. See Pattern Notes for instructions for working increase.

Work 2 rows in pattern.

Increase Row: Work 7 sts in pattern, inc in next sc, work in pattern to last 7 sts, inc in next sc, work remaining 6 sts in pattern. Turn work. 22[24, 22, 24, 26] sts.

Repeat these 3 rows 5 times more. 42[44, 42, 44, 46] sts.

Work 10 rows in pattern.

Decrease Row 1: Work 13[14, 13, 14, 15] sts in pattern, [w2tog] twice, work 8 sts in pattern, [w2tog] twice, work remaining 13[14, 13, 14, 15] sts in pattern. 38[40, 38, 40, 42] sts.

Decrease Row 2: Work 12[13, 12, 13, 14] sts in pattern, [w2tog] twice, work 6 sts in pattern, [w2tog] twice, work remaining 12[13, 12, 13, 14] sts in pattern. 34[36, 34, 36, 38] sts.

Decrease Row 3: Work 11[12, 11, 12, 13] sts in pattern, [w2tog] twice, work 4 sts in pattern, [w2tog] twice, work remaining 11[12, 11, 12, 13] sts in pattern. 30[32, 30, 32, 34] sts.

Decrease Row 4: Work 10[11, 10, 11, 12] sts in pattern, [w2tog] twice, work 2 sts in pattern, [w2tog] twice, work remaining 10[11, 10, 11, 12] sts in pattern. 26[28, 26, 28, 30] sts.

Decrease Row 5: Work 9[10, 9, 10, 11] sts in pattern, [w2tog] 4 times, work remaining 9[10, 9, 10, 11] sts in pattern. 22[24, 22, 24, 26] sts.

Decrease Row 6: Work 7[8, 7, 8, 9] sts in pattern, [w2tog] 4 times, work remaining 7[8, 7, 8, 9] sts in pattern. 18[20, 18, 20, 22] sts.

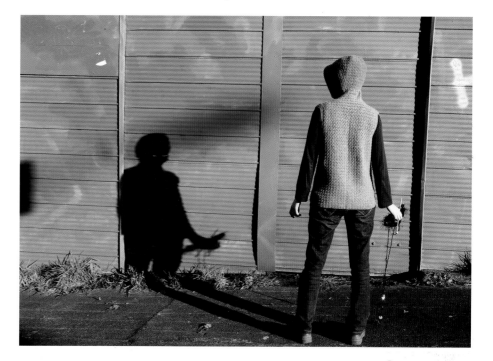

Break yarn, leaving a long tail. Draw tail through last st and pull tight, then fold upper edge of hood in half and use tail to sew halves together.

Front

Work as for back until armhole shaping is complete. 38[44, 50, 52, 54] sts.

Work 6[6, 5, 2, 3] rows in pattern.

Divide for neckline

Next Row: Work 12[16, 18, 20, 20] sts in pattern, turn work.

Work 18[19, 22, 23, 23] more rows over these 12[16, 18, 20, 20] sts. Break yarn, leaving a long tail. Draw tail through last st and pull tight.

Position work so that completed section of upper front is at your right. Counting from left edge of this section, skip next 14[12, 14, 12, 14] sts at center of piece, join yarn with sl st in next st, ch 1; beginning in same st, work remaining 12[16, 18, 20, 20] sts in pattern.

Work 18[19, 22, 23, 23] more rows over these 12[16, 18, 20, 20] sts. Break yarn, leaving a long tail. Draw tail through last st and pull tight.

Collar and hood front band

Sew back to front at shoulders, matching shaped shoulder edges of back to upper edges of front shoulders. Sew back to front at side edges below armholes.

Determine which side of the vest you prefer to be the right (outer) side. With right side facing, using smaller hook, beginning at base of neckline, work 1 row sc up right front neckline edge, around front edge of hood, and down left front neckline edge, ending at base of neckline. In vest shown, 3 sc were worked for every 2 rows of vest. Place a safety pin in work at top of shoulder on each side, where neckline meets hood.

Next Row: Ch 1, sc in first sc, [sc in front loop only of each sc to 1 sc before pin, sc2tog in front loops only] twice, sc in front loop only of each sc to last sc, sc in last sc.
Repeat this row 11 times more, moving the pin up every few rows.

Remove pins. Without further decreases, work 7[5, 7, 5, 7] more rows in pattern as set, or until band is same depth as horizontal edge at base of neckline, ending with a right side row. Do not break yarn or remove st from hook. Rotate work 90 degrees clockwise.

Lap left front collar band over right front collar band, matching lower edges. With right side facing, work 1 row sc along lower edges of bands, joining bands by working through both layers. Fasten off, leaving a long tail. Use tail to sew joined lower edge of collar to base of neckline.

Armhole edging

With right side facing, using smaller hook, beginning at bottom center of armhole, work 1 row sc around armhole. Do not join; armhole edging is worked back and forth in the same way as collar band.

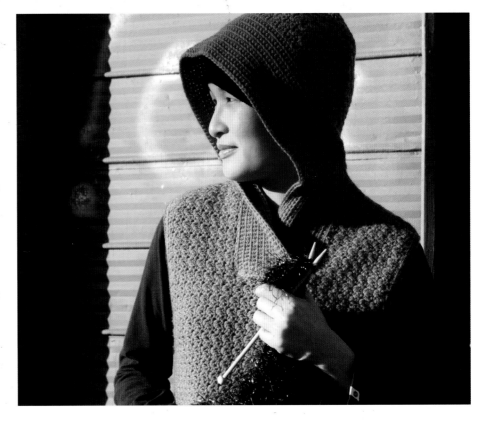

Next Row: Ch 1, sc in first sc, sc in front loop only of each sc to last sc, sc in last sc.
Repeat this row once more, then fasten off, leaving a tail approx. 6 in/15 cm long. Use tail to sew edges of armhole edging together at underarm.

Work edging for remaining armhole in the same way.

FINISHING

Weave in ends. Wet block piece to measurements shown in schematic, following directions on page 66–67, Stuff hood when blocking, to give it a rounded shape; hood of vest shown was blocked over a rubber ball with diameter of 7 in/18 cm.

See Mandy Moore's bio on page 231.

Switcheroo Sweater

MANDY MOORE

When I think about dressing for disguise, I always think of the scene near the beginning of the 1963 *Pink Panther* movie in which Madame Clouseau is running from the police. She slips into an elevator and takes off her coat, sunglasses, and wig, turns the reversible coat inside out and removes its collar. She changes shoes and puts on gloves and a turban, then packs everything away quickly enough that when she meets her pursuers several floors later, they don't recognize her.

This quick-change ensemble is inspired by that scene, and by the Yves Saint Laurent-designed costumes in the movie. It may not fool anyone about your identity, but it will give you several attractive and coordinated wearing options, with strikingly different visual silhouettes.

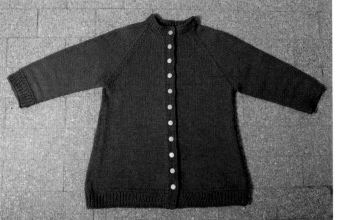

13[14, 15, 16, 17, 18, 19, 20] in
33[35.5, 38, 40.5, 43, 45.5, 48, 51] cm

8.75[9, 9.75, 10.25, 11.5, 12, 12.5] in
22.5[23, 25, 26.5, 29.5, 30.5, 32] cm

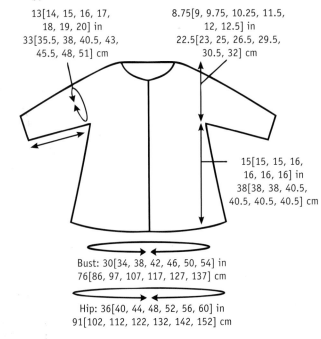

15[15, 15, 16, 16, 16, 16] in
38[38, 38, 40.5, 40.5, 40.5, 40.5] cm

Bust: 30[34, 38, 42, 46, 50, 54] in
76[86, 97, 107, 117, 127, 137] cm

Hip: 36[40, 44, 48, 52, 56, 60] in
91[102, 112, 122, 132, 142, 152] cm

SIZES
XS[S, M, L, 1X, 2X, 3X]

FINISHED MEASUREMENTS
Bust: 30[34, 38, 42, 46, 50, 54] in / 76[86, 97, 107, 117, 127, 137] cm
Hip: 36[40, 44, 48, 52, 56, 60] in / 91[102, 112, 122, 132, 142, 152] cm
Length: 23.75[24, 24.75, 26.25, 27.5, 28, 28.5] in / 60.5[61, 63, 67, 70, 71, 72.5] cm

MATERIALS
Cascade Yarns Cascade 220 [100 percent wool; 220 yd/201 m per 100 g skein]; #2448 Mallard; 6[6, 8, 9, 10, 11, 12] skeins

1 US #7/4.5 mm circular needle, 32 in/80 cm or longer (longer needle recommended for larger sizes); or size needed to obtain gauge
1 set US #7/4.5 mm double-pointed needles
1 US #6/4 mm circular needle, 24 in/60 cm or longer
1 US #8/5 mm circular needle or pair of straight needles, any length
1 set US #8/5 mm double-pointed needles

1 spare circular needle (any length) or set of double-pointed needles, US #7/ 4.5 mm or smaller

Stitch markers
Safety pin or split ring marker
Waste yarn
3 stitch holders (2 small, 1 large)
Yarn needle
11[11, 11, 12, 12, 13, 13] buttons, 7/16 in / 12 mm diameter (sweater)
4 buttons, 11/16 in / 17 mm diameter (cowl)
Note: Buy buttons after sweater is complete, to ensure correct size.

GAUGE

20 sts and 27 rows = 4 in/10 cm in stockinette st using US #7/4.5 mm needles

PATTERN NOTES

Terms and abbreviations used in this pattern can be found on page 226.

PATTERN

Lower Body

Using US #7/4.5 mm circular needle, cast on 175[195, 215, 235, 255, 275, 295] sts.
P1 row, then k1 row.

Next Row [WS]: P2, [k1, p1] to last st, p1.
Next Row [RS]: K2, [p1, k1] to last st, k1.
These 2 rows set 1×1 rib for lower edge.
Work 9[9, 9, 11, 11, 11, 11] more rows in 1×1 rib, ending with a WS row.

K 1 row.
Next Row [WS]: [P1, k1] to last st, p1.

Work 15[15, 15, 17, 17, 17, 17] rows in stockinette st, ending with a RS row.

Next Row [WS]: P15[15, 20, 20, 20, 25, 25], [place marker, p29[33, 35, 39, 43, 45, 49]] 5 times, place marker, p15[15, 20, 20, 20, 25, 25].

Shape Lower Body

Row 1 [RS]: [K to marker, slip marker, k2tog] 3 times, [k to 2 sts before marker, ssk, slip marker] 3 times, k to end. 6 sts decreased.
Rows 2–14: Work in stockinette st, ending with a WS row.
Row 15 [RS]: [K to 2 sts before marker, ssk, slip marker] 3 times, [k to marker, slip marker, k2tog] 3 times, k to end. 6 sts decreased.
Rows 16–28: Work in stockinette st, ending with a WS row.
Repeat Rows 1–28 once more, then work Row 1 once more. 145[165, 185, 205, 225, 245, 265] sts.

Work 13[13, 13, 15, 15, 15, 15] more rows in stockinette st or until piece is desired length to underarm, ending with a WS row.

Set piece aside and work sleeves. Do not break yarn; use new ball of yarn for sleeves.

Sleeves

Using US #7/4.5 mm double-pointed needles, cast on 46[50, 56, 56, 60, 66, 70] sts. Divide sts between needles and join to begin working in the round, being careful not to twist. After working several rounds, place safety pin or split ring marker in work to indicate beginning of round.

Cuff

K 2 rounds.
Next Round: [K1, p1] to end. This round sets 1×1 rib for cuff.

Work 10[10, 10, 12, 12, 12, 12] more rounds in 1×1 rib as set.
K 1 round.
Next Round: [P1, k1] to end.

Note: As written, sleeves are 12 inches long. If more length is desired, k more rounds before proceeding.

K 5[5, 5, 4, 3, 3, 3] rounds.
Next Round: K1, m1, k to last st, m1, k1.
Repeat these 6[6, 6, 5, 4, 4, 4] rounds 9[9, 9, 11, 14, 14, 14] times more. 66[70, 76, 80, 90, 96, 100] sts.

K 6[6, 6, 4, 4, 4, 4] more rounds, ending last round 3[3, 4, 4, 5, 5, 5] sts before end of round. Work measures 12 in/30 cm.

Place last 3[3, 4, 4, 5, 5, 5] sts of last round and first 3[3, 4, 4, 5, 5, 5] sts of next round on waste yarn for underarm, and place remaining 60[64, 68, 72, 80, 86, 90] sts on spare needle(s). Break yarn.

Make a second sleeve in the same way. After transferring 6[6, 8, 8, 10, 10, 10] underarm sts to waste yarn, leave sts on working needles. Break yarn.

Yoke

Using US #7/4.5 mm circular needle and ball of yarn attached to lower body, join lower body and sleeves as follows:

Joining Row [RS]: K first 32[37, 41, 46, 50, 55, 60] sts of lower body, place marker, place next 6[6, 8, 8, 10, 10, 10] sts on waste yarn; k 60[64, 68, 72, 80, 86, 90] sts of one sleeve, place marker; k next 69[79, 87, 97, 105, 115, 125] sts of lower body, place marker, place next 6[6, 8, 8, 10, 10, 10] sts on waste yarn; k 60[64, 68, 72, 80, 86, 90] sts of remaining sleeve, place marker; k remaining 32[37, 41, 46, 50, 55, 60] sts of lower body. 253[281, 305, 333, 365, 397, 425] sts.

P 1 row.

Size XS Only

Next Row [RS]: [K to marker, slip marker, k1, k2tog, k to 3 sts before next marker, ssk, k1, slip marker] twice, k to end.

P 1 row.

Repeat these 2 rows 3 times more. 237 sts: 32 sts for each front, 52 sts for each sleeve, and 69 sts for back.

Sizes L, 2X and 3X Only

Next Row [RS]: [K to 5 sts before marker, ssk, ssk, k1, slip marker, k1, k2tog, k to 3 sts before next marker, ssk, k1, slip marker, k1, k2tog, k2tog] twice, k to end.

P 1 row.

Repeat these 2 rows -[-, -, 1, -, 2, 5] times more. -[-, -, 309, -, 361, 353] sts: -[-, -, 42, -, 49, 48] sts for each front, -[-, -, 68, -, 80, 78] sts for each sleeve, and -[-, -, 89, -, 103, 101] sts for back.

All Sizes

Raglan Decrease Row: [K to 3 sts before marker, ssk, k1, slip marker, k1, k2tog] 4 times, k to end.

P 1 row.

Repeat these 2 rows 16[21, 22, 22, 27, 26, 25] sts more. 101[105, 121, 125, 141, 145, 145] sts: 15[15, 18, 19, 22, 22, 22] sts for each front, 18[20, 22, 22, 24, 26, 26] sts for each sleeve, and 35[35, 41, 43, 49, 49, 49] sts for back.

Shape Neckline

Row 1 [RS]: K4[4, 5, 6, 7, 7, 7] sts, then slip these 4[4, 5, 6, 7, 7, 7] sts to st holder; [k to 3 sts before marker, ssk, k1, slip marker, k1, k2tog] 4 times, k to end. 89[93, 108, 111, 126, 130, 130] sts.

Row 2 [WS]: P4[4, 5, 6, 7, 7, 7] sts, then slip these 4[4, 5, 6, 7, 7, 7] sts to st holder; p to end. 85[89, 103, 105, 119, 123, 123] sts.

Row 3 [RS]: K1, k2tog, [k to 3 sts before marker, ssk, k1, slip marker, k1, k2tog] 4 times, k to last 3 sts, ssk, k1. 75[79, 93, 95, 109, 113, 113] sts.

Row 4 [WS]: P all sts.
Repeat Rows 3 and 4, 2[2, 3, 3, 4, 4, 4] times more. 55[59, 63, 65, 69, 73, 73] sts: 4 sts for each front, 10[12, 12, 12, 12, 14, 14] sts for each sleeve, and 27[27, 31, 33, 37, 37, 37] sts for back.

Next Row [RS]: K1, [k to 3 sts before marker, ssk, k1, slip marker, k1, k2tog] 4 times, k1. 47[51, 55, 57, 61, 65, 65] sts.
Place all sts on st holder. Break yarn.

Collar
Rejoin yarn at right front edge and use US #7/4.5 mm circular needle to k 4[4, 5, 6, 7, 7, 7] held right front neckline sts, pick up and k 6[6, 8, 8, 9, 9, 9] sts along right front neckline edge, k 47[51, 55, 57, 61, 65, 65] held neckline sts, pick up and k 6[6, 8, 8, 9, 9, 9] sts along left front neckline edge, k 4[4, 5, 6, 7, 7, 7] held left front neckline sts. 67[71, 81, 85, 93, 97, 97] sts.
Row 1 [WS]: [P1, k1] to end.
Row 2 [RS]: K all sts.
Row 3 [WS]: P2, [k1, p1] to last st, p1.
Row 4 [RS]: K2, [p1, k1] to last st, k1.
Repeat Rows 3 and 4 twice more.
P 1 row (a WS row). K 1 row.
Loosely bind off all sts.

Buttonhole Band
Using US #6/4 mm circular needle and beginning at lower right front corner, pick up and k 3 sts for every 4 rows along right front edge. Count sts; if necessary, decrease 1 st in next row to obtain an odd number of sts.
K 4 rows, ending with a RS row.

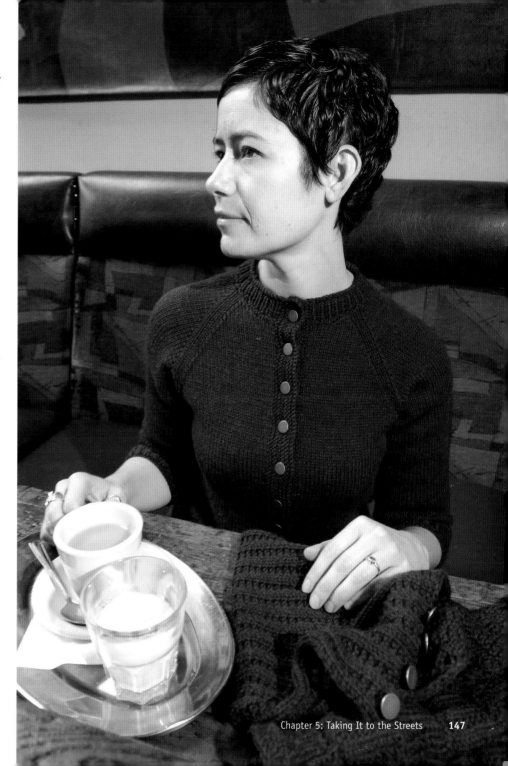

Note: When working next row, if body has been lengthened or shortened, you may wish to work more or fewer buttonholes. Note that as designed, buttonholes do not go all the way to lower edge of sweater.

Next Row [WS]: K1, p1, k1, p2tog, yo, [(p1, k1) 4 times, p2tog, yo] 10[10, 10, 11, 11, 12, 12] times more, [p1, k1] to end. K 5 rows, ending with a RS row. Bind off all sts knitwise on WS.

Button band

Using US #6/4 mm circular needle and beginning at upper left front corner, pick up and k 3 sts for every 4 rows along left front edge. Be sure to pick up the same number as for the buttonhole band. K 4 rows, ending with a RS row. Next Row [WS]: K1, [p1, k1] to end. K 5 rows, ending with a RS row. Bind off all sts knitwise on WS.

Finishing

Graft sts of sleeves to sts of body at under-arms. Weave in ends and block as desired. Sew buttons to button band opposite buttonholes.

Cowl

Using US #8/5 mm needle(s), cast on 52 sts. Row 1 [WS]: Sl 1 purlwise, [p2, k2] to last 3 sts, p3. Row 2 [RS]: Sl 1 knitwise, k to end. These 2 rows set pattern or cowl. Work in pattern until work measures 16[16, 18, 18, 20, 20, 20]in/41[41, 46, 46, 51, 51, 51]cm, ending with a WS row.

Work buttonholes

Row 1 [RS]: Sl 1 knitwise, k to last 6 sts, ssk, yo, k2tog, k2.
Even-numbered Rows 2–8: Sl 1 purlwise, p2, work in pattern as set to end.
Odd-numbered Rows 3–7: Sl 1 knitwise, k to last 4 sts, k2tog, k2.
Repeat Rows 1–8 twice more, then work Rows 1–5 once more. 37 sts.

Next Row [WS]: [P2tog] twice, pass first st on right needle over second st to bind it off; bind off remaining sts in pattern.

FINISHING

Weave in ends and block, following directions on page 66. Sew buttons to CO end of piece, using photo (page 144) as a guide.

Arm warmers (make 2)

Using US #8/5 mm double-point needles, cast on 48[52, 60, 60, 64, 64, 64] sts. Divide sts between needles and join to begin working in the round, being careful not to twist. K 1 round.
Set-up Round: [K12(13, 15, 15, 16, 16, 16), place marker] 3 times, k12[13, 15, 15, 16, 16, 16]. Place safety pin or split ring marker in work to indicate beginning of round.

Begin rib pattern

Round 1: [P1, k1] to end.
Round 2: K all sts.
Rounds 3–12: [K1, p1] to end.
Round 13: K all sts.
Round 14: [P1, k1] to end.
Round 15: K all sts.
Round 16: [K2tog, k to marker] 4 times. 44[48, 56, 56, 60, 60, 60] sts.

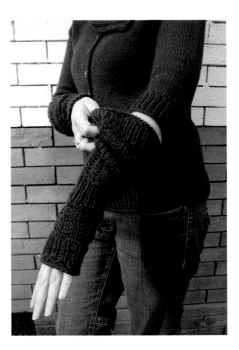

Odd-numbered Rounds 17–27: [K2, p2] to end.
Even-numbered Rounds 18–28: K all sts.
Round 29: [K2tog, k to marker] 4 times. 40[44, 52, 52, 56, 56, 56] sts.

Repeat Rounds 1–29 twice more; for size XS only, do not decrease the last time you work Round 29. 28[28, 36, 36, 40, 40, 40] sts. Work Rounds 1–15 once more. K 2 rounds, then loosely bind off all sts.

FINISHING

Weave in ends. These arm warmers do not require blocking.

See Mandy Moore's bio on page 231

AN INTERVIEW WITH
Micro-Fiber Militia

The Micro-Fiber Militia (MFM) is a Chicago-based crew best known for creating cozies for long twisting bike racks; however, one quick glance at the MFM website, and it is evident that the group has tight crochet graffiti skills. We chatted with Kristen, the founder, on future plans for the crew and how the Micro-Fiber Militia is striving to take textile graffiti to a level of expression that matches street graffiti. With work consisting of bold colors, vivid shapes, and big ambitions, we believe that the Micro-Fiber Militia is up to the challenge.

Q: We were looking at your website this morning, and it seems like there are at least three of you?
A: Around that. It kind of changes depending what people are up to.

Q: Do you mind telling us a little about yourself?
A: I'm twenty-eight. I'm just about done being a student at the School of the Art Institute of Chicago.

Q: We love the fact that you mostly work in crochet. Crochet seems a lot harder to come by, but it seems a lot more conducive for knit graffiti, right?
A: A lot faster, or a lot easier to do? Yeah, that's also something I'm surprised about. I think that Masquerade makes more crochet stuff, they just don't make a point of distinguishing it as much as we do.

Q: How did you get into textile graffiti?
A: I saw a post on Buzzfeed, a link to Knitta and to the Masquerade post that they did a little over a year ago; it was a four-colored circle by a dock. As soon as I saw it, I thought it was just perfect, so I started doing it myself.

Q: What was the first piece that you did?
A: It was a red-and-white striped piece that I put on the back pole of some bleachers in front of the Heartland Café in Rogers Park in Chicago.

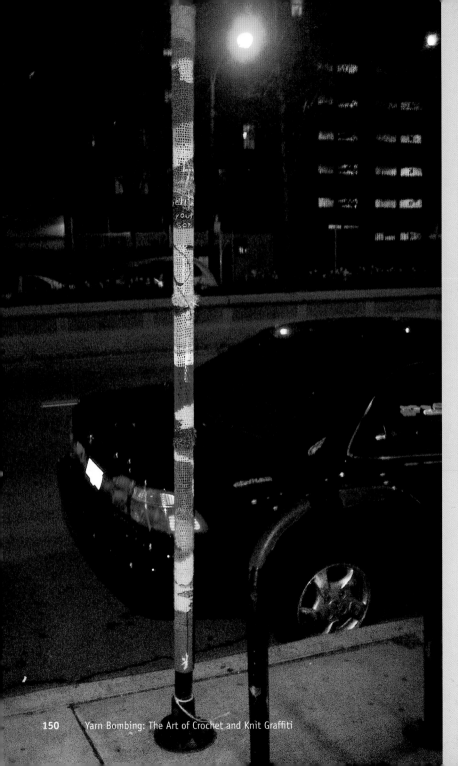

Q: Were you sneaky about it, or did you just put it up?
A: I was talking to an acquaintance of mine there and said, "Come here and talk to me on this bleacher. I'm going to sit down here, close to this pole. Don't ask me what I'm doing." She just kept talking to me, and I stitched it onto that pole real fast.

Q: How did you find the other people for your group?
A: It really is an evolving process. That's how I've found the fiber-knitting thing from the very beginning. Depending on the season, or who finds the website sometimes. It really varies, how other members join. It's normally through the website and sometimes through people I meet. I'm trying to be cagey.

Q: Are the rest of the crew members in arts-related fields?
A: I'm the only one who is actively involved as an artist. The others have crochet as a hobby or are in more professional fields.

Q: Can you tell us a little bit about how or where you create your tags? We read on your blog that you were making a piece for a bench, so you actually sat on the bench a lot of the time while you made it. Do you often crochet the piece where you are going to put it?
A: I've done a couple of pieces that way. Last summer I did one piece in rounds, directly onto a bench.

Photos: Micro-Fiber Militia

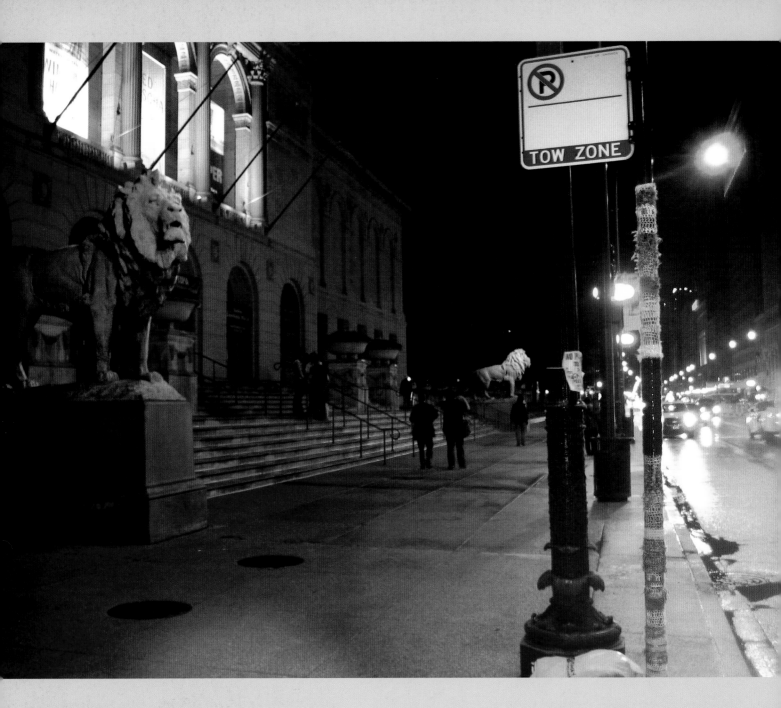

I've been creating stuff at home or on a train or a bus or at work or in a class and putting it up afterward. And the other members have similar experiences. For most of them, they do more stuff at home because of their different professions.

Q: We noticed some things by Rich Stitchin' Bitch and Timeline—are those two members who work with you? You all have different color combinations.
A: Timeline is new and has those larger pieces that obviously take a lot more time, but are more like journal pieces. Rich Stitchin' Bitch likes mohair and wool and some of the fancier fibers. Each one of us has our own motivations and own goals in terms of what we want our stuff to do, whether it has a more artistic purpose, like Timeline's stuff, or more casual pieces, like mine.

Q: I noticed that you've made a piece out of cotton and milk fiber. What other sorts of materials does your crew use?
A: It's whatever we feel like or whatever we can get. My favorite yarn store, Loopy Yarns, has an end-of-year sale so I go through the very ends and think, okay, I can make something out of this. That's provided a lot of opportunity to experiment. But because none of us know how long the pieces are going to stay up, I don't worry that much about the biodegradable factor. Stuff in the most remote areas has been taken down within a day, but some things we put in a major intersection have been there for months!

Q: Do you have a favorite object to tag?
A: I really like the curvy bike racks. They are a big challenge to do.

Q: Your tags are larger, longer, than the ones that we've seen around.
A: I often go up and down on the red line in Chicago, on the north side, and see a lot of pieces by graffiti artists. I try to look at the scope of those and push things towards that. I embrace subversive knitting and subversive crafting. I want to move more toward the graffiti aspect. We've put our pictures up in the Chicago street art pool on Flickr. It seems like the fiber knitted art is really well done, it's solid. The graffiti aspect seems a little vague. KnitGirl has some stuff that moves more toward that, and I really love that. But, in terms of the scope and risk and time involved, we've been leaning more toward larger pieces.

Q: I'm curious about something. You said that you were thinking about concentrating on the graffiti aspect of it. Does that mean that you are going to do some things that are more permanent and less easy to remove?
A: I told a friend about our pieces being taken down, and he recommended this ultra-adhesive spray-foam. And I said, no, that's perfectly all right. In terms of the graffiti aspect of it, I meant more in terms of the style, patterns you'd see on sweaters or other garments. [Fiber arts] haven't been embracing the design aspect and the graphics [of the graffiti movement].

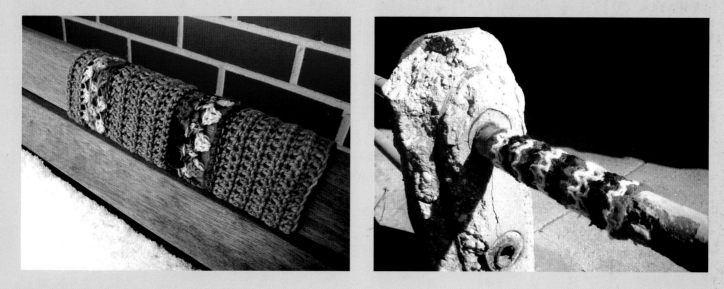

Q: The spirit of actually making something for tagging, rather than just recycling a knitting project that you're not going wear in real life...
A: It's like subversive cross stitch, knowingly taking something that is not traditional and using the traditional technique. I'm thinking more of using the traditional materials and techniques of crochet and then trying to use the more graphic style in the actual lettering and shapes of graffiti. We've used embroidery, but we'd also like to start using spray paint and stencils on top of the yarn. I think if we do stuff that has our website address on it, that it will be incorporated with more graffiti aspects. I love going on Flickr and seeing a picture of our work in street art. And eventually the traffic goes over to my site; for me, it's a thrill to see people discover it on their own and then track us down.

Q: Do you get your inspiration from other places besides the graffiti world?
A: In terms of finding the places to put stuff up, it comes from where I am a lot: walking around different neighborhoods, taking the bus or the train, seeing graffiti and thinking, "That's really visible from here." Trying to find the pipe or the thing hidden behind something that nobody notices and putting something there so somebody does notice it.

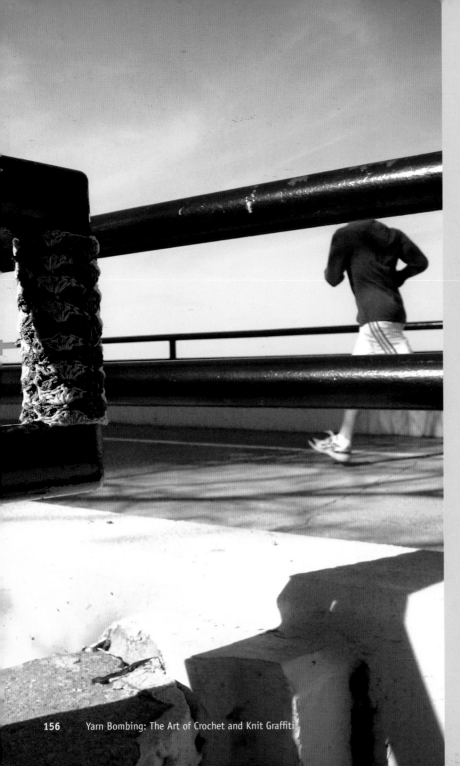

Q: Have you put your tags up anywhere besides Chicago?
A: I put up one piece when I went back to Montana. I made something while I was in town and put it up in front of the Yellowstone Art Museum, which is actually located inside the really old country jail. I put something up in honor of [an old friend there who'd been diagnosed with cancer]. She recently passed away.

Q: What was the best piece of tagging you've ever executed?
A: In terms of length, I really love the bike rack that I colored in a couple of different colors. I also love the most recent Timeline piece. It is really detailed, and the Flickr photos show some more detailed parts of it. It was a way more personal piece. I think that it really pushed more of the boundaries and incorporated more of the embroidery and pushed what we had done in a different way, an artistic and personal journal way.

Q: It's so lovely. Usually you see stuff like that and it's straight stripes, but it's got the shapes and color blocks and everything.
A: I've never made a sweater, but if I were to make a sweater and take all of that time and experience the different parts of my life that go by while making that sweater, it becomes a vertical journal. It's like in the movie *Vertigo* when she goes to the giant tree trunk and points to one ring and says, "That's when I was born and that's when I died."

Master Tagging

APPLY YOUR MAD SKILLS.

Once you've mastered the basics of yarn bombing, challenge yourself with these patterns, developed specifically for tagging the streets.

PATTERNS:
Inspired by nature

These tags can remind us, in the middle of the city, that the world is larger than the concrete jungle.

Knitted Tulip
and Mushroom

KNITTED LANDSCAPE

Jan and Evelien of Knitted Landscape have designed this charming knitted tulip and mushroom, which may be planted to cheer even the dreariest environments. If you want to use Knitted Landscape labels for these pieces, they can be printed from their website (see page 161).

© knitted l
www.knittedla

Tulip

FINISHED MEASUREMENTS
Height: 14.5 in/37 cm

MATERIALS
The tulip shown is made of acrylic yarn with
ball band gauges ranging from 20–22 sts =
4 in/10 cm. Two strands are held together
for the stem, and four strands for the leaves
and petals.

For the leaves and petals, use needles that
will yield a very firm, tight fabric; for the
tulip shown, US #8/5 mm needles were used.
For the I-cord stem, you will need two
double-point needles in a size smaller than
those used for the petals and leaves. It is
not important for the fabric of the stem to
be stiff, as a stick will be inserted into it.
US #7/4.5 mm needles were used for the
stem shown.

Yarn needle

Wooden stick approx. 12 in/30 cm long or
2 in/5 cm longer than stem; thin enough to
fit inside stem

GAUGE
Gauge is not important for this piece.

PATTERN NOTES
The terms and abbreviations used in this
pattern can be found on page 226.

While the petals and leaves are meant to be
stiff enough to stand up and maintain their
shape, you may wish to use invisible nylon
thread or sewing thread to shape them.

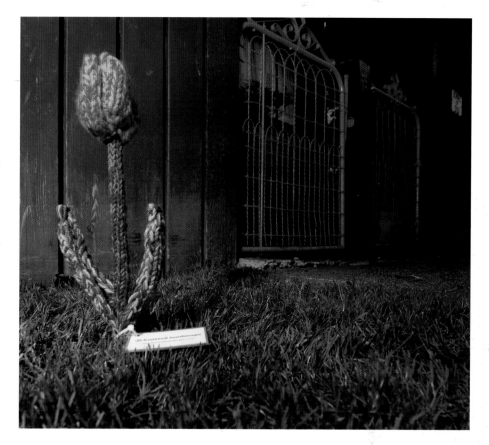

PATTERN
Stem
Using double-pointed needles and two
strands of yarn held together (or desired
combination), cast on 5 sts.
Work I-cord as follows: K 1 row. Instead of
turning the work around to work back on
the WS, slide all sts to the other end of the
needle, switch the needle back to your left
hand, bring the yarn around the back of the
work, and start knitting the sts again. After
the first 2 sts, give the yarn a sharp tug.

Repeat this row to form I-cord. After a
few rows, the work will begin to form a
tube. Continue until work measures approx.
10 in/25.5 cm, or desired length. Bind off.
Insert stick into hollow stem, and sew one
end closed.

Leaves (make 2)
Using larger needles and four strands of yarn
held together (or desired combination), cast
on 4 sts.
Rows 1–8: Work in stockinette st, ending with
a WS row.

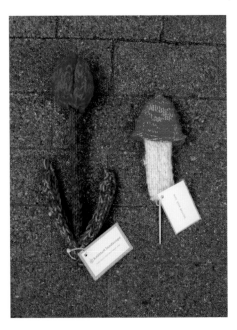

Row 9 [RS]: [Kfb, k1] twice. 6 sts.
Rows 10–32: Work in stockinette st.
Row 33 [RS]: K1, ssk, k2tog, k1. 4 sts.
Row 34 [WS]: P4.
Row 35 [RS]: Ssk, k2tog. 2 sts.
Row 36 [WS]: P2.
Row 37: K2tog. Break yarns and draw through
 last st.

Petals (make 4)

Using larger needles and four strands of yarn
 held together (or desired combination), cast
 on 3 sts.
Row 1 [RS]: K1, kfb, k1. 4 sts.
Row 2 [WS]: P4.
Row 3 [RS]: [Kfb, k1] twice. 6 sts.
Rows 4–12: Work in stockinette st.
Row 13 [RS]: K3, k2tog, k1.

Row 14 [WS]: P5.
Row 15 [RS]: K1, k2tog, k2tog. 3 sts.
Row 16 [WS]: P3.
Row 17 [RS]: K1, k2tog.
Row 18 [WS]: SPP. Break yarns and draw
 through last st.

FINISHING

Weave in ends. Sew petals together, overlap-
 ping petal bases to form tulip shape and
 leaving a hole in the center to insert stem.
 Insert top (closed end) of stem and sew
 securely to tulip. Sew leaves to base of stem.
Give your new tulip variety a special name.
 Plant it somewhere in the world. Take a
 photo of the tulip with the landscape in the
 background, then attach the label and leave
 it for somebody to find and enjoy.

Mushroom

FINISHED MEASUREMENTS
Height: 7 in/18 cm

MATERIALS
The tulip shown is made of acrylic and fluffy
nylon yarns with ball band gauges ranging
from 20–22 sts = 4 in/10 cm. Two strands are
held together throughout.

Use double-pointed needles that will yield a
firm fabric, so that the pieces will retain their
shape. For the mushroom shown, US #7/4.5
mm needles were used.

Yarn needle

Wooden stick approximately 9 in/30 cm long
or 2 in/5 cm longer than mushroom

GAUGE
Gauge is not important for this piece.

PATTERN NOTES
Terms and abbreviations used in this pattern
can be found on page 226.

PATTERN
Stem
Using two strands of yarn held together (or
desired combination), cast on 15 sts. Divide
sts between needles and join to begin
working in the round, being careful not to
twist. Work in stockinette st until piece
measures 6 in/15 cm. Bind off all sts.

Hood
Using two strands of yarn held together
 (or desired combination), cast on 36 sts.
Round 1: P all sts.
Rounds 2–4: K all sts.
Round 5: [K10, k2tog] 3 times. 33 sts.
Round 6–7: K all sts.
Round 8: [K9, k2tog] 3 times. 30 sts.
Rounds 9–10: K all sts.
Round 11: [K8, k2tog] 3 times. 27 sts.
Rounds 12–13: K all sts.
Round 14: [K7, k2tog] 3 times. 24 sts.
Rounds 15–16: K all sts.
Round 17: [K6, k2tog] 3 times. 21 sts.
Round 18: K all sts.
Round 19: [K5, k2tog] 3 times. 18 sts.
Round 20: K all sts.
Round 21: [K1, k2tog] 6 times. 12 sts.
Round 22: [K2tog] 6 times. 6 sts.
Round 23: [K2tog] 3 times. Break yarns,
 leaving a long tail. Draw tail through all
 sts, pull tight.

FINISHING
Pull yarn tail at top of hood to inside and sew
several sts to secure. Use tail to sew stem to
inside of hood. Insert stick into stem.

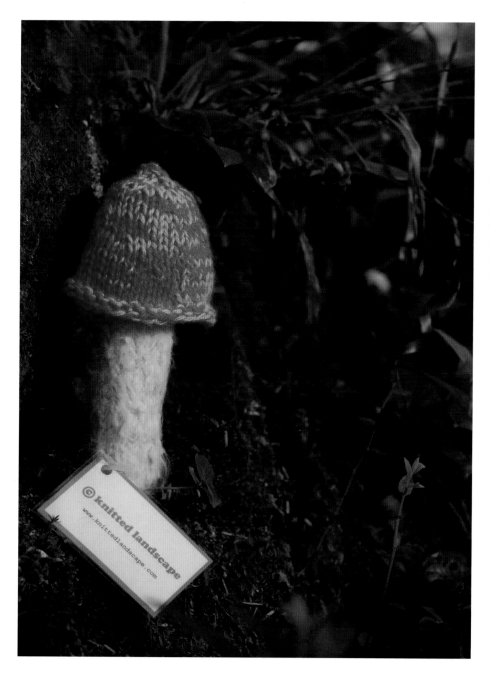

Plant your mushroom somewhere in the world. Take a photo of it with the landscape in the background, then attach the label and leave it for somebody to find and enjoy.

KNITTED LANDSCAPE (Deventer, the Netherlands) is about knitting, art, inspiration, landscape, beauty, humor, nature, photography, imagination, and making people smile. Composed of two artists who are best friends, Jan Ter Heide and Evelien Verkerk, Knitted Landscape has been populating the world with fuzzy rocks, knitted flowers, and water lilies. Jan and Evelien would love to receive photographs of your knitted tulip and mushrooms: **knittedlandscape @knittedlandscape.com**.

Prickly Pear Prosthetic

STEFANIE JAPEL

The Prickly Pear Prosthetic is a handknit segment of a prickly pear cactus. If you live in an area where these cacti are indigenous, you can confuse and amuse by adding a limb to an existing cactus. Those in colder climates can plant this hardy prickly pear anywhere they think onlookers might feel wistful for a little warmth.

FINISHED MEASUREMENTS
Height: 8.5 in/21.5 cm
Width: 6.25 in/16 cm

MATERIALS
Cascade Yarns Cascade 220 [100 percent wool;
 220 yd/201 m per 100 g skein];
 less than 1 skein each color
[MC] #9461 Lime Heather
[CC] #4011 Sparrow

1 set US #7/4.5 mm straight needles, or size
 needed to obtain gauge
1 spare circular or double-pointed needle,
 US #7/4.5 mm or smaller

Crochet hook, approx. size US #7/4.5 mm
Stitch marker
Yarn needle
Sharp yarn needle
1 piece of stiffener, approx. 9 in/23 cm by
 6 in/15 cm; plastic canvas, cardboard, or
 piece of plastic milk jug recommended

GAUGE
20 sts and 28 rows = 4 in/10 cm in
 stockinette st

PATTERN NOTES
Terms and abbreviations used in this pattern
can be found on page 226.

The first st of each row is slipped, creating
an edge that is sturdy and easy to seam.
Slip st knitwise on RS rows, and purlwise
on WS rows.

Three-needle bind off
Hold both pieces of knitting with right sides
 together. Insert needle into first st on front
 needle and first st on back needle, and knit
 them together. *Repeat this for the next st on
 the front and back needles. Draw the first st
 worked over the second st.*
Repeat from * to * until all sts have been
 bound off. Break yarn and draw through
 remaining st.

PATTERN
Cast on 36 sts.
Row 1 [WS]: Sl 1, p17, place marker, p18.
Row 2 [RS]: Sl 1, kfb, k to 2 sts before marker,
 kfb, k2, kfb, k to last 2 sts, kfb, k1. 40 sts.
Odd-numbered Rows 3–55 [WS]: Sl 1, p to end.
Even-numbered Rows 4–8 [RS]: Work as for
 Row 2. 52 sts.
Row 10 [RS]: Sl 1, k to end.
Row 12 [RS]: Work as for Row 2. 56 sts.
Rows 14, 18, and 22 [RS]: Sl 1, k to end.
Rows 16, 20, and 24 [RS]: Work as for Row 2.
 68 sts.
Even-numbered Rows 26–32 [RS]: Sl 1, k to
 end.
Row 34 [RS]: Sl 1, ssk, k to 3 sts before
 marker, k2tog, k2, ssk, k to last 3 sts, k2tog,
 k1. 64 sts.
Row 36 [RS]: Sl 1, k to end.
Rows 38 and 42 [RS]: Work as for Row 34.
 56 sts.
Rows 40 and 44 [RS]: Sl 1, k to end.
Even-numbered Rows 46–56 [RS]: Work as for
 Row 34. 32 sts.

Transfer half of sts to spare needle. Rearrange
sts as necessary so that there are two sets of
16 sts, each set on its own needle. Be sure
that needle tips are pointing outward; when
piece is folded in half, tips should point
toward edge of work (not towards fold).

Fold work so that WS is facing (right sides are
at inside of fold). Work three-needle bind off
to join halves of piece.

FINISHING
Turn work right side out and sew side edges
of piece. Cut stiffener to fit. Insert stiffener
and sew up bottom of piece. Hide remaining
ends inside piece.

Cut lengths of CC approximately 3 in/7.5 cm
long. Use sharp needle to draw one of these
lengths through piece, so that half emerges
from front of piece and half from back. Draw
another length of yarn through piece very
close to first piece. Tie lengths together at
both front and back of piece, forming "needles"
of prickly pear and securing stiffener in place.
Make more "needles" in this way.

Work two crochet chains approximately
6 in/15 cm long or desired length, and
sew to sides of piece. These ties can be
used to tie piece to target.

STEFANIE JAPEL has never knitbombed
before, but is now addicted, "planting"
confusing little knitted cactus leaves all
over the USA on her travels. Keep an eye
out, and you may just find one! Stefanie
lives in New Mexico with her husband and
daughter and is trying to convince herself
of the practicality of non-wool knits.

Mutha Earth

LEE JUVAN

Want to make a visual statement that everybody's carbon footprint counts? Knit up a few of these handy snoods for trailer hitches and doorknobs to spread the word that it's time to pay attention to this fragile planet. Next time you spy an SUV idling in the parking lot, tag that trailer hitch with Mutha Earth to remind drivers She's reached peak oil. Or, when you're skulking at night and see a McMansion lit up like a Christmas tree, leave a gift tag on the doorknob to knock some consciousness into their heads. Not only are these snoods small and compact (several can fit in the most inconspicuous bag), but they're reusable, too: they can be filled with old shredded T-shirts for a hacky sack, bean bag, or cat toy.

Photo: Lee Juvan

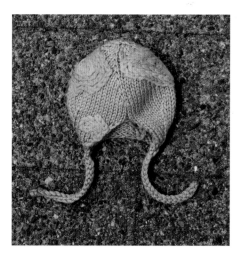

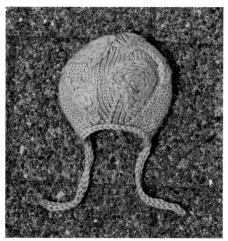

SIZE
One size fits most ball-mount hitches.

FINISHED MEASUREMENTS
Circumference: 7.5 in/19 cm
Height: 2.25 in/5.7 cm

MATERIALS
[MC] Valley Yarns Hungtington [75 percent wool, 25 percent nylon; 218 yd/199m per 50g skein]; color: #4164 Light Blue; less than 1 skein
[CC] Knit Picks Essential Kettle Dyed Sock Yarn [75 percent superwash merino wool, 25 percent nylon; 231 yd/211 m per 50 g skein]; color: #24385 Grasshopper Kettle; less than 1 skein

1 set of US #1/2.25 mm double-pointed needles
Crewel embroidery needle
Coilless safety pin or locking stitch marker

GAUGE
32 sts and 48 rows = 4 in/10 cm in stockinette st

PATTERN NOTES
Terms and abbreviations used in this pattern can be found on page 226.
The cable cast-on method is used to make the ties for this piece. To cast on in this way, with other sts already on needle, turn work so that sts are on left needle. Insert right needle from front to back between first two sts, wrap yarn around right needle and draw it through to front of work. Slip this st to lst needle; 1 st has been cast on. Repeat for each st to be cast on.

Mutha Earth is knit in the round on double-pointed needles from the top of the globe down, increasing on every other round until you reach the equator. It is then knit back and forth to create an opening for the ball-mount hitch and ended by creating integrated ties on the last two rows. The continents are embroidered freehand in chain stitch after the knitting is complete.

PATTERN
Using MC, cast on 6 sts. Divide sts between needles and join to begin working in the round, being careful not to twist. After working first few rounds, place safety pin or stitch marker in work to indicate beginning of round.

Round 1: [Kfb] in each st. 12 sts.
Even-numbered Rounds 2-16: K all sts.
Round 3: [K2, m1] to end. 18 sts.
Round 5: [K3, m1] to end. 24 sts.
Round 7: [K4, m1] to end. 30 sts.
Round 9: [K5, m1] to end. 36 sts.

Round 11: [K6, m1] to end. 42 sts.
Round 13: [K7, m1] to end. 48 sts.
Round 15: [K8, m1] to end. 54 sts.
Round 17: [K9, m1] to end. 60 sts.
Rounds 18–23: K all sts.
Round 24: [K8, k2tog] to end. 54 sts.

From this point, piece is worked back
 and forth in rows. Turn work so that WS
 is facing.
Odd-numbered Rows 25–35 [WS]: P all sts.
Row 26 [RS]: [K7, k2tog] to end. 48 sts.
Row 28 [RS]: [K6, k2tog] to end. 42 sts.
Row 30 [RS]: [K5, k2tog] to end. 36 sts.
Row 32 [RS]: [K4, k2tog] to end. 30 sts.
Row 34 [RS]: [K3, k2tog] to end. 24 sts.
Row 36 [RS]: [K2, k2tog] to end. 18 sts.

Ties

Row 37 [WS]: Cast on 20 sts using cable
 cast-on method, then bind off these 20 sts;
 p to end.
Row 38 [RS]: Cast on 20 sts using cable
 cast-on method, then bind off all sts.

FINISHING

Weave in ends. Using a length of CC approxi-
mately 36-in/91 cm long, thread the crewel
embroidery needle and begin to work chain
stitch. Starting with the outline of the
continent, work chain stitch in close rows to
fill in the space, moving circularly from the
outline inward. Weave in ends as you complete
each land mass. It's a small amount of space,
so you'll need to work a stylized version of the
globe. You can even get creative and work
shapely swirls instead of trying to reproduce
the shapes of the continents. When the
embroidery is complete, block Mutha Earth by
soaking in no-rinse wool wash, rolling in a

towel, and letting her dry on a round water-
resistant object (I used the knob on top of my
paper towel holder).

LEE JUVAN (Middlebury, Connecticut) spins,
dyes, and knits in western Connecticut, which
is dangerously close to Rhinebeck. You can
see more of her designs on **knitty.com**,
knittyspin.com, and **ravelry.com**, where
she is "workwoman."

Treesweater

ERIKA BARCOTT

In December 2005, when out on a smoke break, Erika Barcott noticed a sad-looking tree on the sidewalk outside her building. She thought, "Man, that is one sad tree. It looks cold and wet and pathetic. It needs a sweater!" She returned home and knit one up in an hour and a half. Then, standing outside in the cold at half-past midnight, she stitched it up.

The *Treesweater* became infamous on the Internet and on the cover of Seattle's *The Stranger*, an alternate arts and culture newspaper. It even has its own MySpace page (**myspace.com/treesweater**). Her original sweater has since been sweater-napped, but you can make your own using the pattern on Erika's blog, **redshirtknitting.com**. This version is extra-fancy, with a cable worked into both sides. Long live the *Treesweater*!

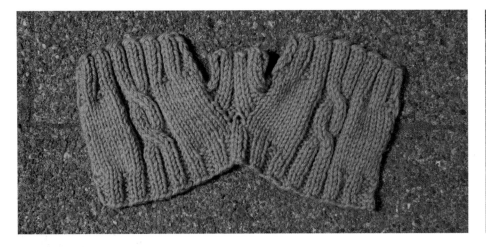

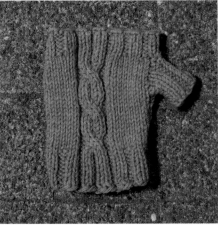

SIZE

To fit a tree with trunk circumference approx. 6 in/15 cm and branch circumference approx. 2 in/5 cm.

FINISHED MEASUREMENTS

Body circumference: 9.5 in/24 cm
Length: 5.5 in/14 cm

MATERIALS

Cascade 220 Heathers [100 percent wool; 220 yd/201 m per 100 g skein]; color: #9461 Lime Heather; less than 1 skein

1 set US #7/4.5 mm straight needles, or size needed to obtain gauge
1 set US #5/3.75 mm straight needles, or 2 to 3 sizes smaller than larger needles

Stitch markers
Stitch holder
Yarn needle

GAUGE

20 sts and 28 rows = 4 in/10 cm in stockinette st using larger needles

PATTERN NOTES

Terms and abbreviations used in this pattern can be found on page 226.

C3F: Slip 2 sts to cable needle and hold to front of work; p1 from left needle, k2 from cable needle.
C3B: Slip 1 st to cable needle and hold to back of work; k2 from left needle, p1 from cable needle.
C4F: Slip 2 sts to cable needle and hold to front of work; k2 from left needle, k2 from cable needle.

In this pattern, all slipped sts are slipped purlwise, with yarn held to front of work. When the next st is a knit st, bring yarn between needles to back of work before working next st.

2×2 rib (Worked over a multiple of 4 sts):
Row 1 [WS]: Sl 1, [k2, p2] to last 3 sts, k3.
Row 2 [RS]: Sl 1, [p2, k2] to last 3 sts, p2, k1.
Repeat these 2 rows for 1×1 rib.

Note: Cable pattern is presented in both written and charted form.
Cable pattern (Worked over 10 sts):
Row 1 [WS]: [K2, p2] twice, k2.
Row 2 [RS]: P2, C3F, C3B, p2.
Row 3 [WS]: K3, p4, k3.
Row 4 [RS]: P3, C4F, p3.
Row 5 [WS]: K3, p4, k3.
Row 6 [RS]: P2, C3B, C3F, p2.
Row 7 [WS]: [K2, p2] twice, k2.
Row 8 [RS]: [P2, k2] twice, p2.
Repeat Rows 1–8 for cable pattern.

PATTERN

Using smaller needles, cast on 28 sts. Work 8 rows in 2×2 rib (see Pattern Notes, above).

Next Row [WS]: Using larger needles, sl 1, p8, place marker, work row 1 of cable pattern, place marker, p8, k1.

This row sets pattern: work edge sts as set, work sts between markers in Cable Pattern and all other sts in stockinette st.

Continue in pattern until Rows 1–8 of cable pattern have been worked three times. If you want the sweater to be longer or shorter, work more or fewer repeats of cable pattern ending with Row 8. Break yarn and place all sts on st holder.

Make a second piece in the same way, ending when it is same length as first piece.

Next Row: Using smaller needles, work across all sts in 2×2 rib; place held sts of first piece on left needle and work all sts in pattern. Pieces are now joined; 56 sts on needle.

Work 5 more rows in 2×2 rib, then bind off all sts in pattern, leaving a long tail.

Sleeve

Place work in front of you, positioned so that RS is facing you, with joined edge of piece closest to you. Counting from the joining point upward along the inner edge of the piece on your right, count 7 slipped sts; beginning at this point and using larger needle, pick up and k 7 sts (1 st in each slipped st) along edge of right piece to joining point; pick up and k 7 sts along edge of left piece. 14 sts.

Next Row [WS]: Sl 1, [k2, p2] 3 times, k1.

Work 9 more rows in 2×2 rib as set. Bind off all sts in pattern, leaving a long tail.

FINISHING

Position the sweater on the recipient tree; the longer portion of the sweater can go either above or below the branch which will wear the sleeve, as best suits the tree. Sew

Cable Pattern

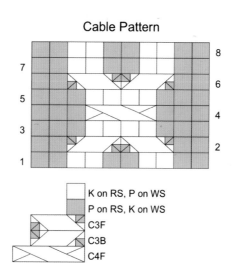

up the long edges of the sweater opposite the sleeve. Sew up the sleeve seam, and the remaining side seam. Hide ends.

Mattress stitch is recommended for the long side, as it creates an invisible seam. This gives the *Treesweater* an air of mystery, not unlike a ship in a bottle. Instructions for mattress stitch can be found at: **knitty.com /issuespring04/mattress.html.**

You may prefer to attach the *Treesweater* in the early morning or late evening, for stealth reasons; it will take a few minutes to sew up!

ERIKA BARCOTT (Deception Pass, Washington) is a knitter and blogger. Erika urges you to follow your whims, no matter how silly, because you never know which one will make you Internet Famous.

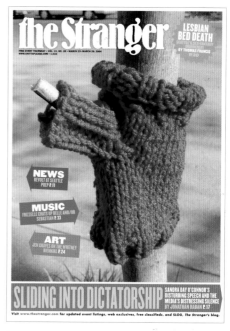

Erika Barcott's *Treesweater* on the cover of Seattle's independent newspaper *The Stranger*, art director, Corianton Hale.

PATTERNS: Shoes on a wire

We received a surprising number of submissions for patterns inspired by the urban phenomenon of shoes hung over telephone lines. With interpretations both literal and fanciful, here are a few of our favorites.

Hanging Shoes

KNITGIRL

KnitGirl has designed a knitted sculpture of a pair of sneakers, which, at first glance, resemble the shoes upon which they are based. They can incorporate the graffiti artist's name or initial as a textual element. The sole can also be knit separately as a flat piece, which can be used as a stapled tag.

FINISHED MEASUREMENTS
Length: 11 in/28 cm
Height: 6.5 in/16.5 cm

MATERIALS
Cascade Yarns Cascade 220 [100 percent
 wool; 220 yd/201 m per 100 g skein];
 1 skein each color
[MC] #7824 Burnt Orange
[CC1] #7803 Magenta
[CC2] #8010 Natural

1 set US #8/5 mm double-pointed needles,
 or size needed to obtain gauge

Safety pin
Stitch holder
Stitch markers
Crochet hook, approx. size US #8/H / 5mm
Yarn needle
Lightweight cardboard
Pinecones, chestnuts, or similar materials for
 stuffing shoes (see finishing directions)

GAUGE
18 sts and 24 rows = 4 in/10 cm in
 stockinette st

PATTERN NOTES
Terms and abbreviations used in this pattern
can be found on page 226.

Charts have been included for letters shown
on soles. If you wish to work other letters,
here are a couple of links to online charts for
knitted alphabets: **littlecottonrabbits
.typepad.co.uk/photos/alphabet/** and
vickimeldrum.com/Alphabet.html

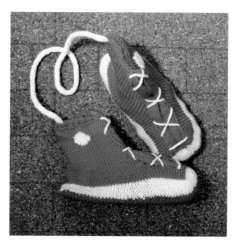

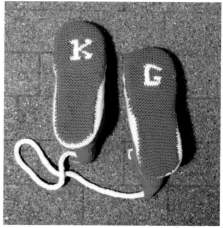

The large dot on the side of each shoe and
the letters on the soles are worked using the
intarsia method of color work. When working
in this way, different sections of each row are
worked with different colors. Use a separate
length of yarn for each area of color.

When beginning with a new color, tie the
strand of the new color in a slip knot around
the strand of the old color. Slide the knot up
close to the needle, then proceed with the
new color.

When switching from one color to the next
within each row, drop the color you have been
knitting with and bring the yarn for the next
color up under the yarn of the previous color
before you continue knitting. This will twist
the two yarns around each other. It is very
important to do this; if you do not wrap the
yarns in this way, the areas of color will not be
joined, and you will have holes in your work.

PATTERN

Right sole
HEEL
Using CC1, cast on 9 sts onto one needle.
 Sole is worked back and forth.
K 1 row.
Next Row [RS]: Kfb, k to last st, kfb. Place
 safety pin in work to indicate RS.
Repeat these 2 rows twice more. 15 sts.
Continue in garter st (k every row) until work
 measures 4 in/10 cm, ending with a WS row.

INSTEP
Row 1 [RS]: K to last st, kfb. 16 sts.
Rows 2–4: K all sts.
Row 5 [RS]: Work as for Row 1. 17 sts.
Rows 6–10: K all sts.
If letter is desired, begin working it over
 center sts now. Use stitch markers to indicate
 chart placement; different letters will be
 worked over different numbers of sts.

Row 11 [RS]: Kfb, k to last st, kfb. 19 sts.
Rows 12–14: K all sts.
Row 15 [RS]: Work as for Row 11. 21 sts.
Continue in garter st until work measures
9 in/23 cm, ending with a RS row.

TOE
Row 1 [RS]: K2tog, k to end. 20 sts.
Even-numbered Rows 2–12 [WS]: K all sts.
Row 3 [RS]: K all sts.
Row 5 [RS]: Work as for Row 1. 19 sts.
Row 7 [RS]: K2tog, k to last 2 sts, k2tog.
17 sts.
Row 9 [RS]: Work as for Row 1. 16 sts.
Rows 11 and 13 [RS]: Work as for Row 7.
12 sts.
Row 14 [WS]: K2tog, k to last 2 sts, k2tog.
Row 15 [RS]: K2tog, k next st, pass first st on
right needle over second st, binding it off;
continue to bind off until 2 sts remain on left
needle, k2tog, bind off remaining st.

Left sole
HEEL
Work heel as for right sole.

INSTEP
Row 1 [RS]: Kfb, k to end. 16 sts.
Rows 2–4: K all sts.
Row 5 [RS]: Work as for Row 1. 17 sts.
Rows 6–10: K all sts.
Continue as for right instep.

TOE
Row 1 [RS]: K to last 2 sts, k2tog. 20 sts.
Even-numbered Rows 2–12 [WS]: K all sts.
Row 3 [RS]: K all sts.
Row 5 [RS]: Work as for Row 1. 19 sts.
Row 7 [RS]: K2tog, k to last 2 sts, k2tog.
17 sts.
Row 9 [RS]: Work as for Row 1. 16 sts.
Rows 11 and 13 [RS]: Work as for Row 7.
12 sts.

Row 14 [WS]: K2tog, k to last 2 sts, k2tog.
Row 15 [RS]: K2tog, k next st, pass first st on
right needle over second st, binding it off;
continue to bind off until 2 sts remain on
left needle, k2tog, bind off remaining st.

Trace soles onto cardboard. Cut out cardboard
soles, cutting them slightly smaller than
knitted soles. Set cardboard soles aside.

SHOE UPPER
Using CC2, with RS of sole facing and beginning
at beginning of bound-off edge, pick up and k 1
st in each bound-off st, 1 st in each garter ridge
along edge of sole, 1 st in each cast-on st, and
1 st in each garter ridge along remaining edge
of sole. Count sts; when working next round,
increase or decrease as necessary to obtain 98
sts. Join to work in the round; after several
rounds have been worked, place safety pin in
work to indicate beginning of round.
K 6 rounds. Break CC2.

Using MC, k 1 round. K first 12 sts of next
round, then place 16 sts just worked (12 sts
of current round and 4 sts of previous round)
on st holder. These sts are centered over toe,
and will form tongue of shoe. K to end. Upper
will be worked back and forth over remaining
82 sts.

Work 5 rows in stockinette st, ending with a
WS row.

Bind off 13 sts at beginning of next 2 rows.
56 sts.
Next Row [RS]: SKP, k to end.
Next Row [WS]: SPP, p to end.
Repeat these 2 rows 6 times more. 42 sts.
Continue in stockinette st until MC section
of upper measures 3.5 in/9 cm, ending with
a WS row.

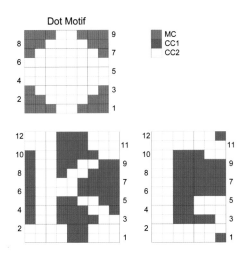

Dot Motif

MC
CC1
CC2

PLACE DOT MOTIF
Right shoe
Next Row [RS]: K8, place marker, work Row 1 of
dot motif over next 8 sts, place marker,
k to end.

Left shoe
Next Row [RS]: K26, place marker, work Row 1
of dot motif over next 8 sts, place marker,
k to end.

Both shoes
Work in stockinette st, working through all
rows of dot motif and then removing markers.
Continue until MC section of upper measures
5 in, ending with a RS row.
K 5 rows. Bind off all sts.

TONGUE
Place held sts on needle and join MC. Work
in stockinette st until tongue measures
10.5 in/27 cm. Bind of all sts.

CORD
Using 2 strands CC2 held together, cast on 3 sts.
(Using 2 strands will make cord dense and
strong.)

Work I-cord as follows: K 1 row. Instead of turning the work around to work back on the WS, slide all sts to the other end of the needle, switch the needle back to your left hand, bring the yarn around the back of the work, and start knitting the sts again. After the first 2 sts, give the yarn a sharp tug.

Repeat this row to form I-cord. After a few rows, the work will begin to form a tube. Continue until work measures approx. 28 in/71 cm, or desired length. Bind off.

FINISHING

Insert cardboard soles; be sure that cardboard soles are aligned correctly with contours of knitted soles. For each shoe, pin side edges of tongue to shaped edges of upper, matching top edges. Sew in place.

Stuff shoes as desired. Shoes shown were stuffed with pinecones (to give volume) and a few chestnuts (to provide weight); consider using similar materials found in your neighborhood. Be sure the shoes are not too heavy, or they will lose their shape. Sew tops of shoes closed, securing ends of cord in place at back of each shoe.

Using CC2, work two crochet chains, each approx. 30 in/76 cm long. Sew chains into shoes to simulate laces.

ROBIN JACOB, a.k.a. **KNITGIRL**, is a Vancouver, BC, mom and knitting maven who lives with her family and her beloved dog Yoshi. Taught by her grandmother, she has been knitting since childhood. KnitGirl enjoys walking the streets with her dog and children, looking for new art and places to put her own contributions.

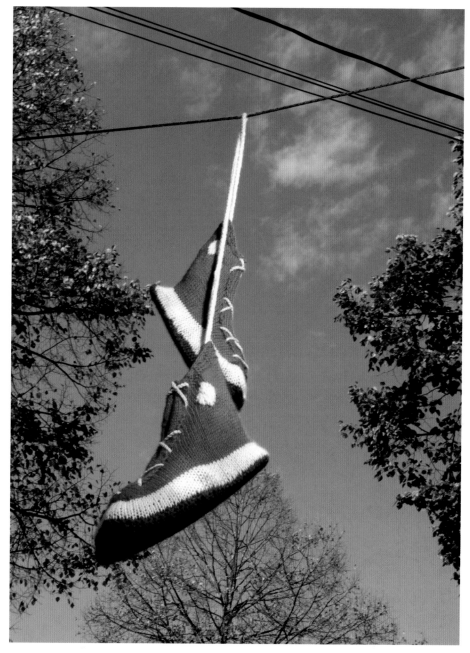

Bolo Balls

DEBORA OESE-LLOYD

The idea of bolo balls came to me suddenly as a way to tag a tree limb. The image that flashed was a set of children's encyclopedias that I had as a young girl, when I was infatuated with cowboy culture. The well-thumbed cowboy section had a picture of Argentinean cowboys using bolo balls instead of lassos to bring their "doggies" down.

When I Googled bolo balls to see if I had imagined the name, I found that they have an ancient and widespread history. The indigenous peoples of South America introduced the bolo to the Spanish gauchos. The Inuit, Chinese, and Japanese have also had their versions of weighted strings used as weapons to capture animals and people. Most surprising of all is that bolo balls are currently a popular sport item used to play variations of a game known as "Ladder Ball Toss" (because you throw them at a ladder-like target with scores marked on the rungs), "Hillbilly Golf," and "Bolo Ball Lawn Game."

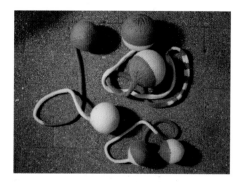

Below are instructions for three different sized balls: large plastic juggling balls, Maori-style Poi balls, and pink bouncing balls. I have given the instructions for straight-needle knitting, but you could also go seamless on double-pointed needles—just remember to put the ball in before you decrease each ball pocket. You can play with the placement of colors on the balls and the cords.

SIZES
S [M, L]
To fit balls with diameter of approx. 7.75[10, 12.5] in/19.5[25.5, 32] cm

FINISHED MEASUREMENTS
Length, measured after felting: 31[33.5, 57] in/79[85, 145] cm

MATERIALS
Cascade Yarns Cascade 220 [100 percent wool; 220 yd/201 m per 100 g skein]; 1 skein each color will make all bolo balls shown.
[MC] #8910 Citron
[CC] #8888 Lavender

1 set US #9/5.5 mm straight needles
1 set US #9/5.5 mm double-pointed needles (used for I-cord; only 2 needles are used)

GAUGE
16 sts and 24 rows = 4 in/10 cm in stockinette st
Note: Gauge is looser than usual for this yarn, which will aid in felting.

PATTERN NOTES
Terms and abbreviations used in this pattern can be found on page 226.

Directions are not given for color changes in this pattern. Use the colors as you like, changing when you get bored! The bolo balls shown have each color used in equal amounts, with the color scheme for the first half of each reversed for the second half. If you have made any of the other projects in this book, consider using leftover yarn for stripes in this project.

PATTERN

FIRST BALL POCKET
Increase section
Cast on 3[4, 5] sts, leaving a long tail; this tail will later be used to sew up pocket.
Row 1 [WS]: P all sts.
Row 2 [RS]: [Kfb] in each st to end. 6[8, 10] sts.
Rows 3–6: Work as for Rows 1–2. 24[32, 40] sts.
Rows 7–9: Work in stockinette st.
Row 10 [RS]: [K1, kfb] to end. 36[48, 60] sts.

MIDDLE SECTION
Work 11[15, 19] rows in stockinette st, ending with a WS row.

DECREASE SECTION
Row 1 [RS]: [K1, k2tog] to end. 24[32, 40] sts.
Rows 2–4: Work in stockinette st.
Row 5 [RS]: [K2tog] to end. 12[16, 20] sts.
Row 6 [WS]: P all sts.
Rows 7-8: Work as for Rows 5–6. 6[8, 10] sts.
Row 9 [RS]: Row 9 is different for each size. Work Row 9 onto a double-pointed needle, in preparation for working cord.
Size S: [K1, k2tog] twice. 4 sts.
Size M: K1, [k2tog] 3 times, k1. 5 sts.
Size L: [K1, k2tog] 3 times, k1. 7 sts.

CORD
Slip sts to a double-pointed needle. Work I-cord as follows: Instead of turning the work around to work back on the WS, slide all sts to the other end of the needle, switch the needle back to your left hand, bring the yarn around the back of the work, and start knitting the sts again. After the first 2 sts, give the yarn a sharp tug.

Repeat this row to form I-cord. After a few rows, the work will begin to form a tube. Continue until cord portion of piece measures approx. 36[40, 68] in/91.5[101.5, 173] cm, or desired length. Remember that cord will shrink considerably when felted.

SECOND BALL POCKET

Purl all sts onto straight needle; resume
 working back and forth.
Next Row [RS]: This row is worked
 differently for each size.
Size S: [K1, kfb] twice. 6 sts.
Size M: K1, [kfb] 3 times, k1. 8 sts.
Size L: [K1, kfb] 3 times, k1. 10 sts.
Work Rows 3–10 of increase section, and all
 rows of middle section and decrease section
 as for first ball pocket. Break yarn, leaving
 a long tail. Draw tail through remaining sts
 and pull tight.

FINISHING

Use yarn tails to sew up ball pockets,
inserting balls when they are halfway sewn.
Weave in remaining yarn tails.

Felting

Place one set of bolo balls in a pillow case
(or a laundry bag). You can felt more than
one set of bolo balls at a time, but they must
each be in their own bag. Tie up the pillow
case or laundry bag tightly. I used a hot
wash/cold rinse water temperature combina-
tion. Using a mild detergent, I put the balls
through a regular wash cycle twice. It is
always good to check on the felting process
about half way through the wash cycle,
because everyone's machine is different.
When fully felted, the I-cord should no longer
be hollow, and the knitted covers should be
tight against the balls. Allow bolo balls to
dry completely, then let them fly!

See Debora's bio on page 128.

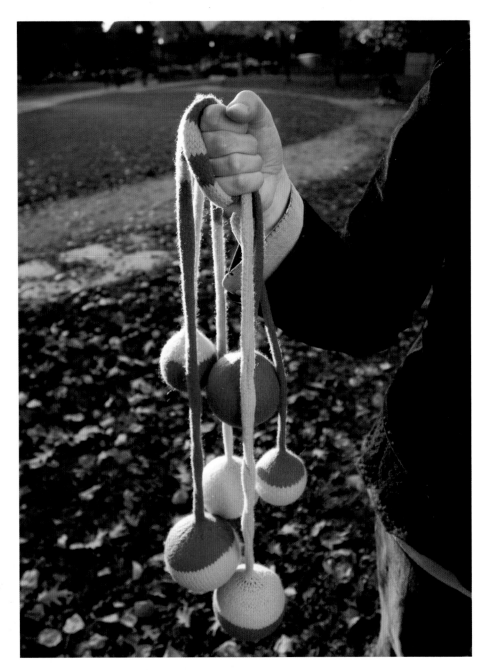

Elf Stockings

DANIELLE LOWRY

This pattern was inspired by seeing pairs of sneakers strung over power lines. It always struck me as bizarre and also a little mysterious. Tiny and dreamlike, these stockings evoke the same feelings, but with a touch of whimsy. Knit them in pairs and join them with a long crocheted chain. Wrap them around a tree branch, and people will wonder what tiny creature has lost their stockings.

I knit these in lace-weight mohair, but this is a great project for using up tiny amounts of any lace-weight yarn that is just too gorgeous to waste. If you're feeling particularly adventurous, try the optional beaded version. The sun glinting off the beads is sure to draw attention.

FINISHED MEASUREMENTS
Length (toe to heel): 11/8 in/3 cm

MATERIALS
elann.com Super Kydd [70 percent super kid mohair/30 percent nylon; 259 yd/237.5 m per 25 g ball]; shown in #06 Tango Red and #2105 Mist Green; less than 1 ball
1 set US #000/1.5 mm double-pointed needles—or the smallest size you can stand to work with!

Crochet hook, approx. size US #0/1.75 mm
Sewing needle or fine tapestry needle
Pipe cleaner or twist tie (optional)

For beaded stockings
Approximately 34 3 mm Swarovski crystal beads or size 10/0 glass seed beads for each pair of stockings
Fine beading needle
Sewing thread

GAUGE
This project is so tiny that gauge is irrelevant!

PATTERN NOTES
Terms and abbreviations used in this pattern can be found on page 226.

B: Place bead: Slide bead up yarn until it sits next to right needle. Bead will sit between the stitch just knit and the next stitch.

PATTERN
Foot
Cast on 4 sts, leaving a tail approx. 6 in/15 cm long.
K 1 row. P 1 row.
Next Row [RS]: [K1, kfb] twice. 6 sts.
Divide sts between needles and join to begin working in the round, being careful not to twist.

Rounds 1–3: K all sts.
Round 4: [Kfb, k1, kfb] twice. 10 sts.
Rounds 5–10: K all sts.
Round 11: [Kfb, k3, kfb] twice. 14 sts.
Rounds 12–14: K all sts.

Heel
Heel is worked back and forth over first 7 sts of round.
Row 1 [RS]: K6, W&T.
Row 2 [WS]: P5, W&T.
Row 3 [RS]: K4, W&T.
Row 4 [WS]: P3, W&T.
Row 5 [RS]: K3, W&T.
Row 6 [WS]: P4, W&T.
Row 7 [RS]: K5, W&T.
Row 8 [WS]: P6, W&T. You will now resume working in the round with RS facing.

Leg
Round 1: [K7, pick up and k 2 sts in space between heel sts and instep sts] twice. 18 sts.
Round 2: K all sts.
Round 3: [K1, k2tog, k3, k2tog, k1] twice. 14 sts.
Continue in stockinette st until leg measures 0.5 in/12 mm or desired length.

Flared cuff
Next Round: [Kfb, k1] to end.
K 1 round.
Repeat these 2 rounds twice more for plain cuff (total of 48 sts), or once more for beaded cuff (total of 32 sts).

Plain cuff
Bind-off Round: K2, slip both sts back to left needle, k2tog, [k1, slip 2 sts back to left needle, k2tog] until all sts have been bound off.

Beaded cuff
Break yarn, leaving a tail approximately 1 yd/90 cm long. Thread beading needle with sewing thread, and tie thread into a loop. Draw yarn tail through thread loop, then thread beads onto beading needle and draw them down over thread loop and onto yarn.

Bind-off Round: K1, B, k1, slip both sts back to left needle and knit them together, [k1, slip 2 sts back to left needle, k2tog, B, k1, slip 2 sts back to left needle, k2tog] until all sts have been bound off.

FINISHING

Sew up short seam at toe of sock; if desired, sew bead to tip of toe. Weave in ends.

Make a second sock in the same way.

Using two strands of yarn held together, crochet a chain approx. 6 in/15 cm long. Sew ends of chain to backs of sock cuffs. If desired, insert a length of pipe cleaner or folded twist tie into sock, and use it to shape sock (photo above shows stockings shaped in this way).

DANIELLE LOWRY (Ontario, Canada) is a mother of two young boys. She has been knitting since 2000 and has been knitting obsessively since 2005. She can knit and walk at the same time, and enjoys the stares she gets from passersby. She blogs (inconsistently) at **littlelambsydivy.blogspot.com**.

PATTERNS:
Soft focus

These projects will inspire viewers to look anew at the world around them, whether it's a bit of concert poster art, or an otherwise insignificant pay phone cord.

Knitted Poster Frame

KENDRA BIDDLE

The inspiration for this frame came from all of the elaborate gilded frames I've seen in museums and antique shops. I love the idea of bringing this homey indoor object, a picture frame, and taking it outdoors. This knitted picture frame can be stapled to a wall to frame a concert poster or another bit of graffiti art, inspiring viewers to take another look. Imagine going down the street and seeing all of these framed posters in different sizes and colors. It would be a true public art museum.

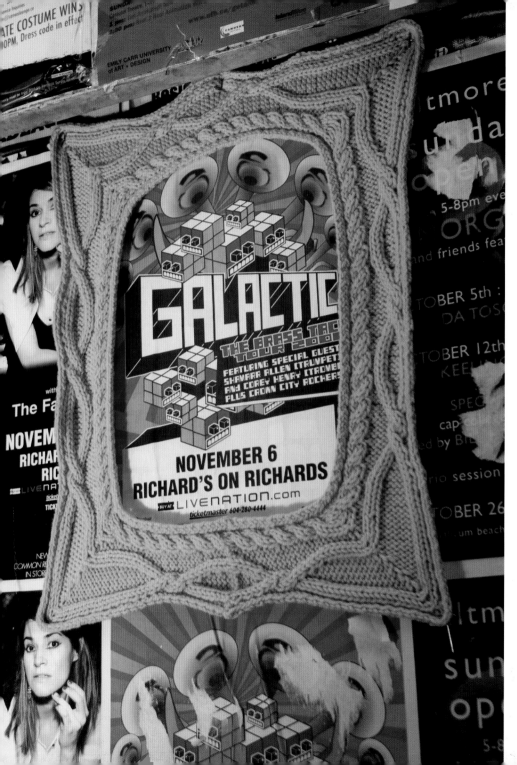

FINISHED MEASUREMENTS
Height: 17 in/43 cm
Width: 13.75 in/35 cm

MATERIALS
Cascade Yarns Cascade 220 [100 percent
 wool; 220 yd/201 m per 100 g skein];
 #9463B Gold; less than 1 skein

1 set US #8/5 mm straight needles, or size
 needed to obtain gauge
1 set US #10/6mm straight needles, or two
 sizes larger then smaller needles
Note: Larger needles are used only for casting
on and binding off.

Cable needle
Yarn needle

GAUGE
18 sts and 26 rows = 4 in/10 cm in
 stockinette st

PATTERN NOTES
The terms and abbreviations used in this
 pattern can be found on page 226.

C3F: Slip 2 sts to cable needle and hold to
 front of work; p1 from left needle, k2 from
 cable needle.
C3B: Slip 1 st to cable needle and hold to
 back of work; k2 from left needle, p1 from
 cable needle.
C4F: Slip 2 sts to cable needle and hold to
 front of work; k2 from left needle, k2 from
 cable needle.
C4B: Slip 2 sts to cable needle and hold to
 back of work; k2 from left needle, k2 from
 cable needle.

Note: Cable pattern is presented in both written and charted form.

Cable pattern (worked over 24 sts):

Row 1 [RS]: K1, k1 tbl, p2, k4, p2, k2, p6, k2, p2, k1 tbl, k1.

Row 2 [WS]: P1, p1 tbl, k2, p2, k6, p2, k2, p4, k2, p1 tbl, p1.

Row 3 [RS]: K1, k1 tbl, p2, C4B, p2, k2, p6, k2, p2, k1 tbl, k1.

Row 4 [WS]: Work as for Row 2.

Row 5 [RS]: K1, k1 tbl, p2, k4, p2, C3F, p4, C3B, p2tog, k1 tbl, k1. 23 sts.

Row 6 [WS]: P1, p1 tbl, k2, p2, k4, p2, k3, p4, k2, p1 tbl, p1.

Row 7 [RS]: K1, k1 tbl, p2, C4B, p3, C3F, p2, C3B, p2tog, k1 tbl, k1. 22 sts.

Row 8 [WS]: P1, p1 tbl, [k2, p2] twice, k4, p4, k2, p1 tbl, p1.

Row 9 [RS]: K1, k1 tbl, p2, k4, p4, C3F, C3B, p2tog, k1 tbl, k1. 21 sts.

Row 10 [WS]: P1, p1 tbl, k2, p4, k5, p4, k2, p1 tbl, p1.

Row 11 [RS]: K1, k1 tbl, p2, C4B, p5, C4F, p2, k1 tbl, k1.

Rows 12, 14, 16 [WS]: Work as for Row 10.

Row 13 [RS]: K1, k1 tbl, p2, k4, p5, k4, p2, k1 tbl, k1.

Row 15 [RS]: Work as for Row 11.

Row 17 [RS]: K1, k1 tbl, p2, k4, p4, C3B, C3F, pfb, k1 tbl, k1. 22 sts.

Row 18 [WS]: Work as for Row 8.

Row 19 [RS]: K1, k1 tbl, p2, C4F, p3, C3B, p2, C3F, pfb, k1 tbl, k1. 23 sts.

Row 20 [WS]: Work as for Row 6.

Row 21 [RS]: K1, k1 tbl, p2, k4, p2, C3B, p4, C3F, pb, k1 tbl, k1. 24 sts.

Rows 22, 24 [WS]: Work as for Row 2.

Row 23 [RS]: Work as for Row 3.

Repeat Rows 1–24 for cable pattern.

PATTERN

Begin lower section

Using larger needles, cast on 24 sts.

Switch to smaller needles and work Rows 1–24 of cable pattern, then work Row 1 once more.

Mitered corner

Mitered corner is shaped by working short rows. While working corner, work all sts as set by Rows 1 and 2 of pattern. Do not work cable twists.

Row 1 [WS]: Work 20 sts in pattern, W&T.

Even-numbered Rows 2–36 [RS]: Work in pattern to end.

Row 3 [WS]: Work 18 sts in pattern, W&T.

Row 5 [WS]: Work 16 sts in pattern, W&T.

Row 7 [WS]: Work 14 sts in pattern, W&T.

Row 9 [WS]: Work 12 sts in pattern, W&T.

Row 11 [WS]: Work 10 sts in pattern, W&T.

Row 13 [WS]: Work 8 sts in pattern, W&T.

Row 15 [WS]: Work 6 sts in pattern, W&T.

Row 17 [WS]: Work 4 sts in pattern, W&T.

For Rows 19–37, when you come to a stitch which has been wrapped on a previous short row, work the wrap together with the wrapped stitch. If the stitch is a knit stitch, do this by inserting the right needle into both the wrap and the stitch, and knitting

Cable Pattern

K on RS, P on WS
P on RS, K on WS
b K tbl on RS, P tbl on WS
/ P2tog
V Pfb

C3F
C3B
C4F
C4B

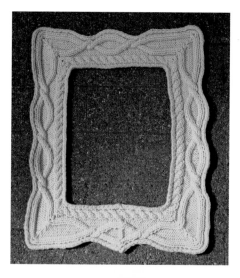

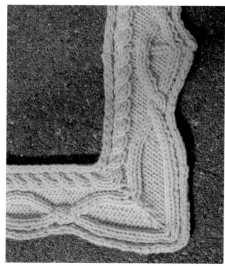

them together. If the stitch is a purl stitch, use the tip of left needle to pick up the wrap and place it on left needle, then purl the wrap and stitch together.

Row 19 [WS]: Work 5 sts in pattern, W&T.
Row 21 [WS]: Work 7 sts in pattern, W&T.
Row 23 [WS]: Work 9 sts in pattern, W&T.
Row 25 [WS]: Work 11 sts in pattern, W&T.
Row 27 [WS]: Work 13 sts in pattern, W&T.
Row 29 [WS]: Work 15 sts in pattern, W&T.
Row 31 [WS]: Work 17 sts in pattern, W&T.
Row 33 [WS]: Work 19 sts in pattern, W&T.
Row 35 [WS]: Work 21 sts in pattern, W&T.
Row 37 [WS]: Work all sts in pattern. Mitered corner is complete.

Long section
Work Rows 3–24 of cable pattern. Work Rows 1–24 twice, then work Row 1 once more.

Work mitered corner.

Upper section
Work Rows 3–24 of cable pattern. Work Rows 1–24 once, then work Row 1 once more. Work mitered corner, then repeat long section.

Finish lower section
Work Rows 3–24 of cable pattern. Bind off all sts loosely using larger needles.

FINISHING
Sew cast on edge and bound off edges together. Wet block piece following directions on page 66, ensuring that corners are square.

Mount the frame outdoors, using a staple gun. This ensures that the frame will be up for some time and not easily removed. Frame everything that is stapled down, and a few things that aren't!

KENDRA BIDDLE (Auburn, Maine, USA), is a photographer and textile artist. She began learning crafting from her mother and grandmother when she was young, but has been knitting seriously for only about ten years—ever since her mother refused to knit scarves for her any longer. Kendra's interest in textiles has been growing ever since, and she has been exploring ways to integrate textiles and photography. Her senior thesis culminated in a graffiti knitting photo exhibition. She graduated from Syracuse University with a BFA in Art Photography.

Crocheted Scallop Tags

STEPHANIE LAU

These crocheted scallops are fast, easy, surprising, versatile, and beautiful: everything you could want in a piece of yarn graffiti. This design works well on fences, abandoned shopping carts, railings, and—the designer's favorite—phone booth telephone cords. Depending on the yarn used, it can be as delicate or as outrageous as you like. Thick, colorful wool is a great choice because it works up fast, is highly visible, and is relatively inexpensive.

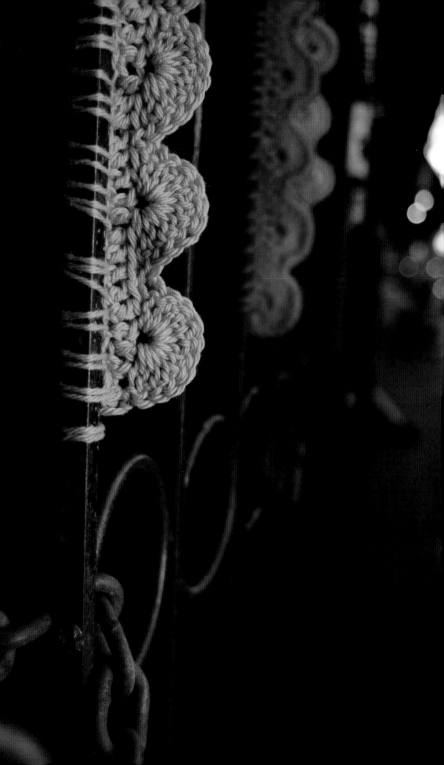

MATERIALS

Use any yarn you like! Yarn for tags shown:
Cascade Yarns Cascade 220 [100 percent wool;
220 yd/201 m per 100 g skein]; #8895
Christmas Red and #9421 Blue Hawaii

Crochet hook to suit size of yarn chosen;
for tags shown, a US #10/J / 6 mm hook
was used

Yarn needle

GAUGE

In the tags shown, each scallop is approx.
1.75 in/4.5 cm wide.

PATTERN NOTES

Terms and abbreviations used in this pattern
can be found on page 226.

PATTERN

Leaving a yarn tail several yd/m long, ch a
multiple of 6 sts + 3. (Each 6 sts will form
the base for 1 scallop.)
Row 1: Dc in 3rd ch from hook and in each ch
to end. You will have a multiple of 6 dc + 1.
Row 2: Ch 1, sc in first dc, [skip next 2 dc,
work 10 dc in next dc, skip next 2 dc, sc in
next dc] to end. Fasten off and weave in
end. Do not weave in long yarn tail at
beginning of piece.

FINISHING

To apply the tag, use the long yarn tail to
lash the straight edge of the tag along the
target object, sewing 1 to 2 sts through each
st of the base chain.

STEPHANIE LAU (Montreal, Quebec): All my
life I have been a maker. The journey from the
initial conception of an idea to the moment
when that concept becomes a physical reality
is what drives me as a human being. I am a
weaver, a spinner, a dyer, a rabble-rouser, a
beader, a lover of animals, good friends, tall
men, and tequila. I am a graduate of the
Capilano College Textile Arts Program.

Your International Crew

THE SOCIAL OPPORTUNITIES offered by knit graffiti are not limited to your neighborhood. By documenting and sharing projects online, yarn bombers can contribute to an international movement of knit and crochet graffiti. This chapter is full of tips on how to meet other crews, find street-art inspiration, and resources you can go to when you need to learn a new craft technique.

Connect with others

There are some great places online where you can meet others with similar interests:

Craigslist (**craigslist.org**), an online classified site for most of the major cities in the world, has an artists' section where you can post about your yarn bombing crew. Don't forget to check out the free stuff section to look for yarn to build your stash.

Facebook (**facebook.com**) allows you to send a note to your friends and acquaintances about starting a group. Once you collect a few friends, you can form a group under the name of your yarn graffiti crew and open it up for friends-of-friends to join.

MySpace (**myspace.com**) has many yarn bombing related folks who you can contact and befriend online. Knitta has a page, as does Erika Barcott's *Treesweater*.

Ravelry (**ravelry.com**) is a great social networking site for all needle workers to meet up and chat. This online community launched

in 2007 and has over 200,000 members. A community for knitters and crocheters, Ravelry has a variety of important features that let you connect with other artists. You can set up a profile, post photographs of projects, make a wish list of projects you'd like to create, purchase patterns, send email to other members, and keep track of your stash. You can find other knitters and crocheters by location, and even start a group for your crew and invite others to join. Ravelry also has user groups with discussion forums on particular topics. Our favorites are the CLF (Crochet Liberation Front), Knit Graffiti, and Guerilla Knitting Groups. There is also a Yarn Bombing group on Ravelry that you can join!

Meet-up (**meet-up.com**) was designed for people who want to meet up and discuss their hobbies. You can create a knit or crochet graffiti meet-up group for your area, and you will be notified when others join it. You can host meetings in person and plan to meet up to bomb.

Guerrilla knitting and crochet online

Whether you bomb on your own or with a crew, there are many ways to connect with others online.

As your crew develops, you'll probably want to build a blog or website to show off the collection of tags you've made. In addition to showing off your work, a blog is also a great way to connect with other yarn bombers and to let them know that you are actively recruiting.

It can take as little as ten minutes to start a blog, which you can use to tell the world about your tags. Some of the most popular blogging platforms on the web, such as **wordpress.com**, **typepad.com**, **tumbler.com** or **blogger.com**, will let you sign up for a free blog account. Each of these sites contains tutorials and user tips to help you get started.

Once you've started a blog, don't forget to update often with photographs and stories about tagging. Just as you can search for others on the Internet, make sure that they can find you by correctly labeling your posts. Tag your posts with words such as "knit graffiti," "yarn

⭐ When meeting in person for the first time with your Internet acquaintances, be cautious. Make sure that someone always knows where you've gone. Meet strangers in a public place that you are familiar with, and take a cell phone—even a friend or two—along.

SPECIAL NOTE TO KIDS AND TEENS: It's great to meet new friends online, but it is not safe to meet with strangers, even if you think you've gotten to know them over the Internet. Always make sure that your parent or guardian knows about your online friends, and never give out personal information such as your telephone number, school, or address.

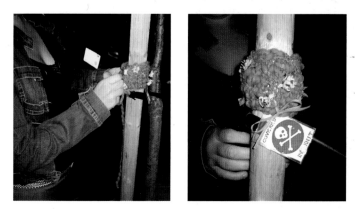

Covered in Knit by Boho Knitter Chic.
Photo: Rebecca Cantebury

In addition to showing off your work, a blog is also a great way to connect with other yarn bombers and to let them know that you are actively recruiting.

bombing," and "crochet graffiti." When you find other blogs you like, be sure to offer comments to show your appreciation of their posts—not only will this provide a compliment to the blog author, but also it's a great way to start a conversation with a potential ally.

Some knit and crochet graffiti artists like to put up details about each crew member. Some bloggers like to have a bio page, invite others to join in on their projects by sending photographs, or publish their manifesto.

Other people's work [inspires me]; I especially love Masquerade's work. Or I look for a normal scarf or other knitting work and use that pattern [for my yarn graffiti]. Yarn colors inspire me too. —KNIT SEA

It's the coolest thing in the world if there are more groups. I love it that most of them seem to give us a nod, which makes me feel even more warm and fuzzy inside. —MAGDA SAYEG, KNITTA

You know, all of the pictures you'll find on our website that are pictures of us are actually pictures of some matriarch in our lives. Either a mother or a grandmother or somebody else. —EDIE OF THE LADIES FANCYWORK SOCIETY

Here are some blogs that maintain yarn graffiti content:

- ArtYarn (England): **artyarn.blogspot.com**
- The Baltimore DIY Squad (USA): **baltimorediy.blogspot.com**
- Flower Power Knits (Sweden): **flowerpowerknits.blogspot.com**
- GarnKonst (Sweden): **garnkonst.blogspot.com**
- Incogknito (UK): **oldbakerygallery.com/incogknito/index.html**
- Jafabrit's Art (USA): **jafabrit.blogspot.com**
- Knit Happens (USA): **knithappenskc.blogspot.com**
- knit sea (Finland): **knitsea.blogspot.com**
- Knitted Landscape (The Netherlands): **knittedlandscape.com**
- The Ladies Fancywork Society (USA and The Netherlands): **ladiesfancyworksociety.com**
- Masquerade (Sweden): **maskerade.blogsome.com**
- Micro-Fiber Militia (USA): **microfibermilitia.blogspot.com**
- Mis-Cre-Knits (UK): **misscreknits.blogspot.com**
- Outdoor Knit (Australia): **outdoorknit.blogspot.com**
- Stickkontakt (Sweden): **stickkontakt.blogspot.com**

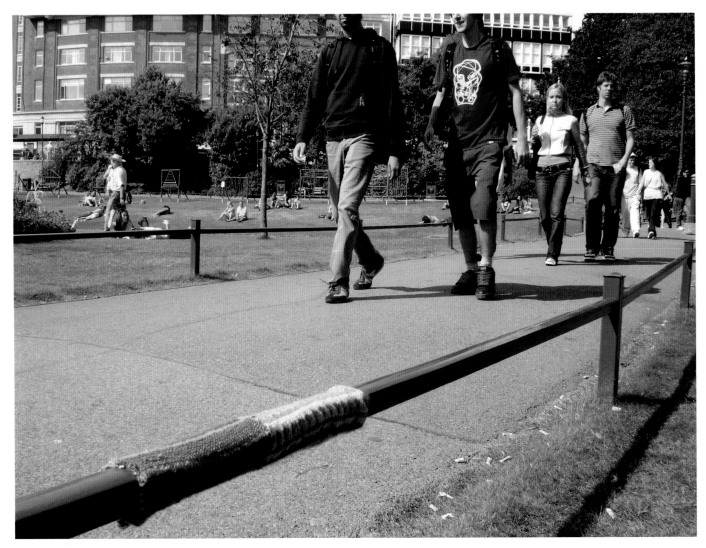

Photos: Work by Elvis Robertson of Lovely Textiles, UK.

Showing appreciation for an artist's work
will ensure that a wider community sees it.

The online photo repository Flickr (**flickr .com**) is a great place to meet other graffitiers. Post photographs of your pieces and flag them with tags such as "knit graffiti," "yarn bombing," and "crochet graffiti." On the message boards for these crews, graffitiers post hot topics and chat among themselves. It's also a great place to get inspired and to show your potential crew members why knit graffiti is cool. Check out the following groups, and make sure that you contribute photos of your tags to them: "Urban Knitting," "Guerilla Knitting," and "Knitting Graffiti." Be sure to bookmark tags by other artist that you admire by clicking the "Add to faves" button or leave a comment. Showing appreciation for an artist's work will ensure that a wider community sees it.

Inspiration: Graffiti

*I really like going to the Graffiti Research Lab website (**graffitiresearchlab.com**). That's where I've gotten some ideas and inspiration on how to push things more. I also like the Wooster collective (**woostercollective.com**) which is a blog and graffiti-art center in New York, and Craftzine (**craftzine.com**). I love going on there and seeing the really wacky stuff they've found online and thinking about pushing it in different directions that I'd never think I could possibly go.*
—MICRO-FIBER MILITIA

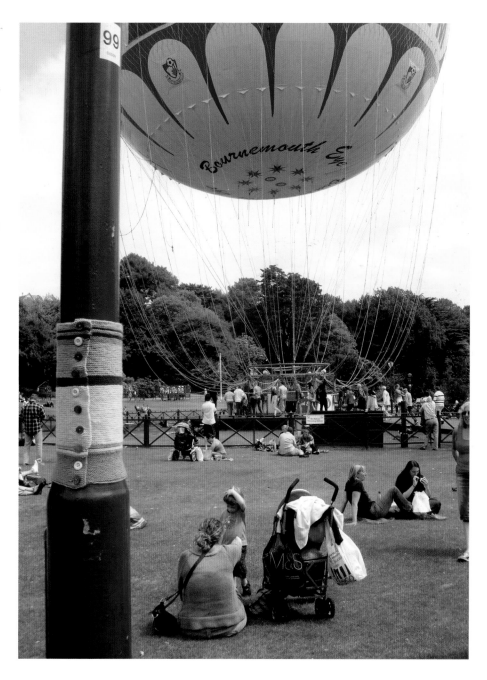

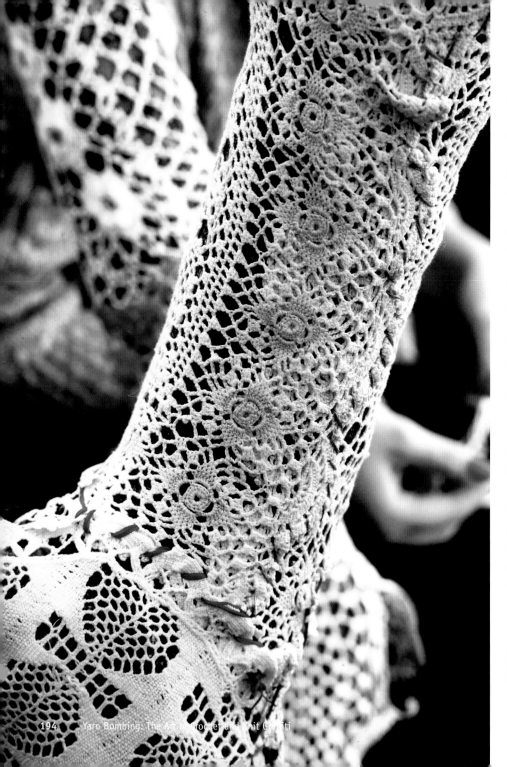

Here is a list of street art related websites that inspire us:

Streetsy is an amazing site that features street art. **streetsy.com**

Art Crimes is a website about spray graffiti that is organized by subject matter. **artcrimes .com**.

FFFFound is a great image bookmarking site where contributors add anything they find visually interesting. **ffffound.com**

Banksy is the UK's best known street artist. His work never ceases to amaze us. **banksy .co.uk**

Spain has a rich history of street art, and much of it can be viewed at Barcelona Street Art. **barcelonastreetart.net**

Sticker legend Shepard Fairey is always up to new tricks. **obeygiant.com/articles**

Online Craft Communities

The Internet is home to a wide variety of craft communities—some of them more subversive than others. We use the following sites to develop our technique and learn about what other crafters are up to:

The CRAFTSANITY podcast series by

THIS SPREAD: Work by Pene Durston and the Magnolia Collective inspired by Janet Morton's *Early Frost*, 2004, Fitzroy, Australia. Photo: Shula Hampson

Jennifer Ackerman-Haywood, which has aired close to 100 episodes, features informative interviews with many of today's craft superstars. Episode No. 10 was with Knitta. **craftsanity.com**

SUPERNATURALE is an online magazine that features good tutorials, interesting articles, and forums on which to discuss everything crafty. **supernaturale.com**

A multi-author website, WHIPUP features daily tutorials of crafty projects that are always stylish and informative. This site's slogan is "Handicraft in a Hectic World." **whipup.net**

CRAFTSTER is the site where craft and hipsters meet. This extensive forum has photographs of every craft you can think of, styled in a variety of materials. **craftster.org**

CROCHETVILLE's online forum is exclusive to crochet. Users can participate in show and tell, join a crochet-a-long in which they simultaneously crochet the same piece as others and report on their progress, or simply introduce themselves to others who take up the hook. **crochetville.org/forum**

If you want to make your own tofu or incorporate LED lights into your knitting, CRAFT is the place to learn how to do it. The magazine features a stellar blog which has daily hits of the most unusual art and craft objects on the web. **craftzine.com**

STITCH 'N BITCH is a listing of stitch 'n bitch groups worldwide. Find one in your immediate area and sniff out the renegade knitters. **stitchnbitch.org/snb_groups.htm**

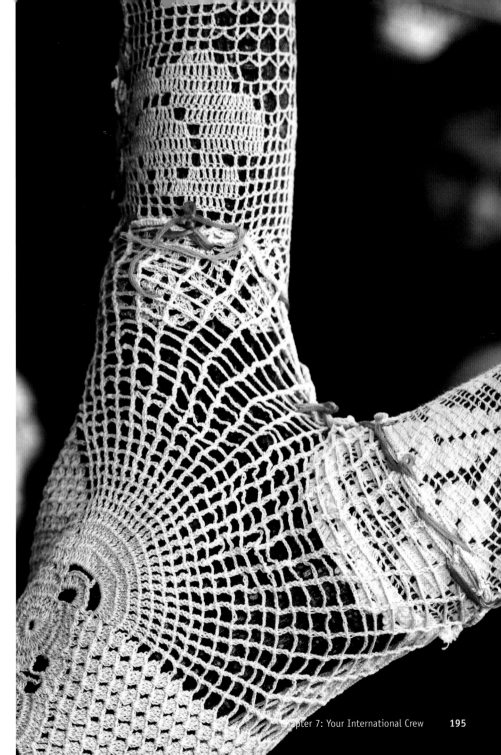

Tutorials and crafty help

HOW TO KNIT OR CROCHET: While we recommend learning to knit or crochet from another person, the Internet also provides a few useful tutorials. YouTube features videos on how to knit or crochet. Our favorites include those by Knit Witch (**knitwitch.com**) and Crochet Mania (**crochet-mania.blogspot.com**).

HOW TO EMBROIDER: Sublime Stitching, an embroidery company with designs such as the Jolly Roger, zombies, and martini glasses, has several online tutorials for beginners. (**sublimestitching.com /howto.htm**.) The founder, Jenny Hart, also has an excellent embroidery book called *Sublime Stitching: Hundreds of Hip Embroidery Patterns and How-To* (Chronicle Books, 2006).

HOW TO SCREEN PRINT: Silkscreen techniques can be produced using very expensive equipment or just a few materials. A good book to start with is *Print Liberation: The Screen Printing Primer* (North Lights Books, 2008) by Nick Paparone, Jamie Dillon, and Luren Jenison.

HOW TO STAMP OR PRINT ON FABRIC: Lena Corwin's excellent book, *Printing by Hand: A Modern Guide to Printing with Handmade Stamps, Stencils, and Silk Screens* (STC Craft/A Melanie Falick Book, 2008) outlines everything you need to know to create small-scale prints on fabric or paper.

SOFTWARE TO AID THE REVOLUTION: The MicroRevolt Project offers the free software KnitPro, which translates images into knit, crochet, cross stitch, or needlepoint patterns. The creators of KnitPro encourage users to make knitted versions of the well-known logos of fashion labels that are considered sweatshop offenders. (**microrevolt .org/knitPro**)

Tag the world

I would like to have knitters in every country in the world knit the same piece and then have all of them place it on the same day.
—JAN FROM KNITTED LANDSCAPE

Whenever I go anywhere I take a suitcase or purse with pieces in it. That's how we covered more of the world then we ever expected to.
—MAGDA SAYEG, KNITTA

What time of day we tag depends on the attitude of the city in which we find ourselves. When we are in Manchester, we will tag mainly at night when the streets are quiet, due to a more uptight attitude… When Sarah was in Berlin, she could just tag any old time of the day and felt much more comfortable about doing something that, anywhere else, would seem strange. —ARTYARN

If you visit the websites of yarn bombers, you'll find that there are others out there who would love to have you contribute to their cause. The Ravelry forums are full of knit and crochet graffiti artists proposing ideas for bombing around the world and suggesting group projects. A couple of crews even have invitations to join on their websites.

What could your crew do if you had contributors from around the world? If you have a web presence and a great idea, there is no limit to what you can accomplish.

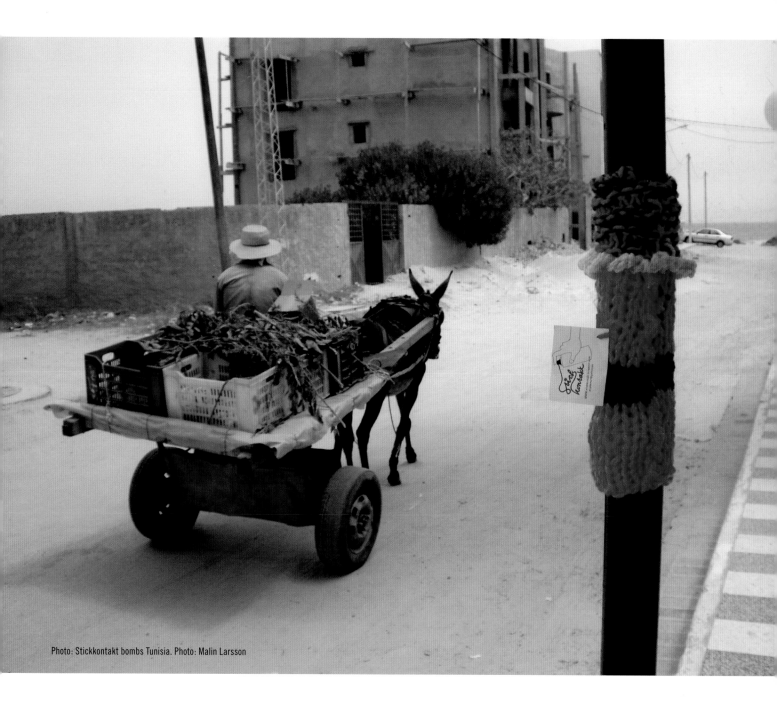

Photo: Stickkontakt bombs Tunisia. Photo: Malin Larsson

AN INTERVIEW WITH
Stickkontakt

Brunaluna, Rut Dubbelknut, and Pinkelink are the code names of the Swedish yarn bombing trio Stickkontakt. Together with their "sidekicks," they produce a stunning range of yarn graffiti tags that we love for their wit, creativity, and striking use of color.

Q: How did you get into textile graffiti?
A: One of us (Brunaluna), read about Knitta, and she got inspired by them. Brunaluna inspired the rest of us by showing us Knitta's website. We were all raised in families where art and handicraft have had a key position, and our parents and grandparents have given us a lot of inspiration. We are three in our crew, but Stickkontakt has sidekicks, and they knit with us whenever they feel like it.

Q: Where do you create your tags? What sort of materials do you work with?
A: We create our tags here and there, and we are almost always carrying something to work on with us. So, whenever we get a chance we work on a piece. Right now we are talking about how we can make people open their eyes and do something for the environment. Our crew will try to recycle different fabrics, such as plastic bags or clothes we don't wear anymore, and then knit with them. The fact that most yarn is ecologically harmful is definitely a problem to us.

Q: Tell us how you go about the act of yarn bombing. Do you knit or crochet or do both? What are your favorite objects to tag? Do you have a signature style? How do you attach your tags?
A: We all both knit and crochet, and we often combine them. None of us has a favorite artifact to tag, but we do get bored of tagging the same objects over and over, so we try to find new challenges all the time. We attach our pieces by sewing, and then we hang our tag on the piece. The tag ensures that people can find our blog.

Photos:
Stickkontakt

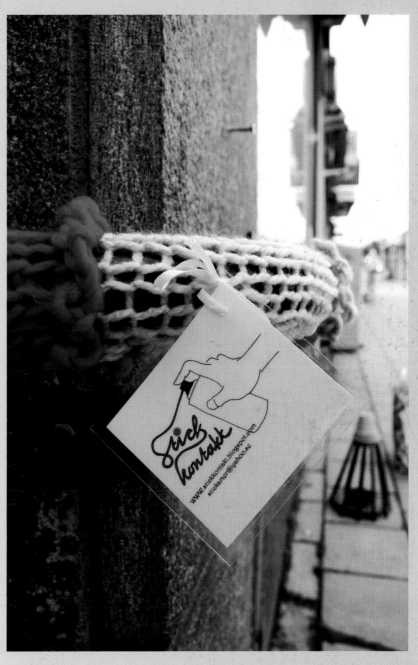

Q: What time of day do you tag? How often do you tag?
A: When we started, we snuck out during nighttime, but now we really don't care. It's more fun during daytime, because then we get to meet people and see their reaction. We are all into other things in life, such as motherhood, studies, work, and so on, and that's why we sometimes knit and tag like crazy, and sometimes we chill. It depends on what's going on in our lives. But knitting has become a lifestyle, so we always have something going on.

Q: How do you get your inspiration for tags?
A: We all get inspired by other handicrafters, by music, our loved ones, politics, colors, and different qualities. In other words, both things that make us happy-clappy and things that make us pissed off inspire us.

Q: What parts of the world have you tagged? What is your craziest yarn graffiti fantasy?
A: We are not trying to conquer the world, but we always try to tag something when we travel. We have tagged in Tunisia, New York, Barcelona, Öland, Gotland, and so on.

We really don't have any crazy fantasies. If there is anything we want to do, we do it. Simple as that.

Q: Does your family know you do this? Do your co-workers know?
A: Friends and family know. So do co-workers. It's too hard to keep it a secret.

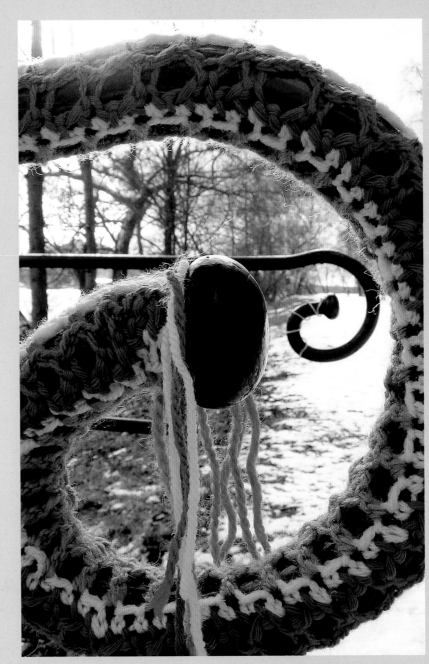

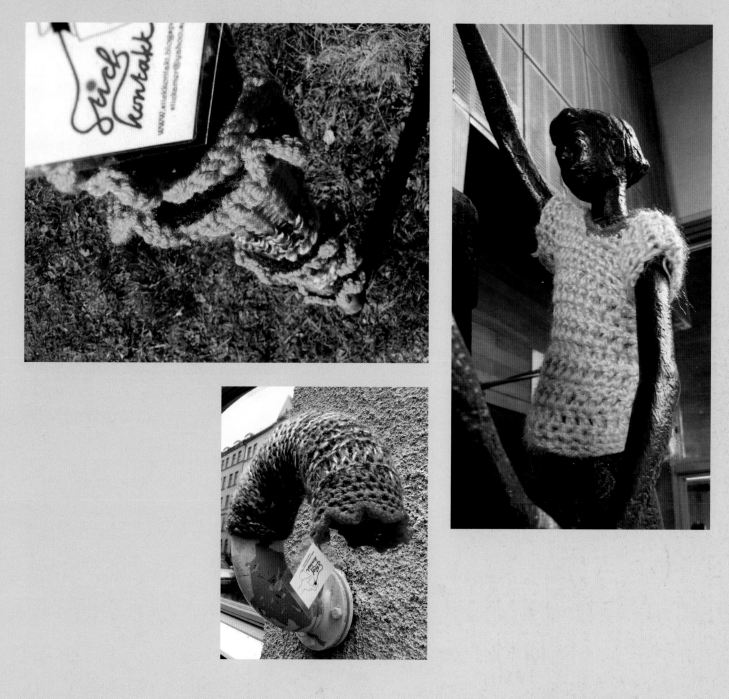

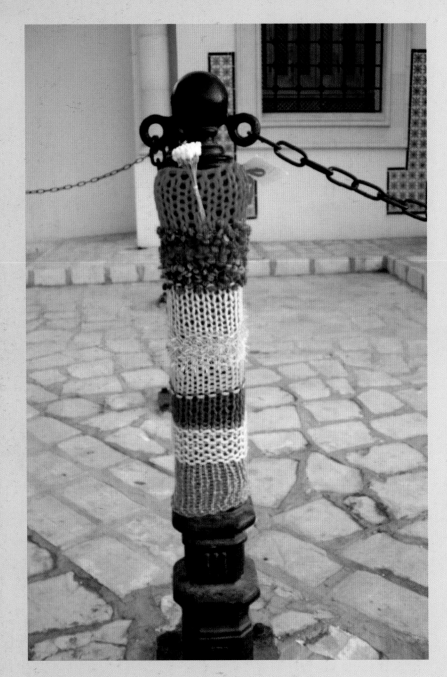

Q: What do you say when people ask you what you are knitting?
A: We tell people the way it is. It's kind of fun to see their reactions. Some get it at once, and others just look at us like we are crazy.

Q: Have you ever been caught in the act of yarn bombing? What did you do?
A: If you mean caught by the police, no. If you mean caught in the act by people passing by, yes. A lot of people stop and want to talk to us. They ask questions, take photos, or just tell us to keep up the good work.

Q: Do you document your work? Do you photograph it or keep a blog?
A: We document everything we do, and we have a blog so we can show our masterpieces to the rest of the world.

Q: Have you gotten feedback from your community?
A: We get feedback all the time. Many newspapers and magazines have written about us and what we do. We have been on TV, and a famous Japanese fashion magazine wrote a big article about us, and that's like, very hardcore. But the feedback we get on the street means the most to us. Nothing compares to the feeling we get when people stop, smile, and tells us how nice it looks.

CHAPTER 8
Flights of Imagination

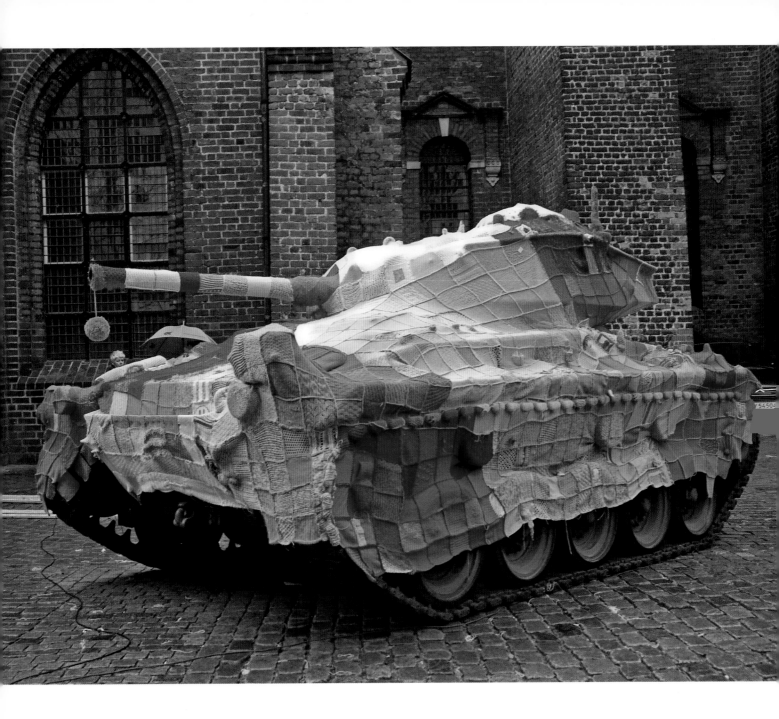

REALITY SHOULDN'T GET IN THE WAY of fantasies for gigantic projects. If you can create a gauge swatch, you can figure out how to knit or crochet a giant cozy for your favorite monument. If you've got a truckload of yarn at your disposal, or enough time on your hands to daydream, large-scale works are a lot of fun to contemplate.

I have sleepless nights thinking about how far I can go with this. There are so many cool things I could do. When you let yourself embrace an idea like this, more ideas just start coming at you. If you concentrate, you can keep the fire burning. I will do this for as long as I can.
—MAGDA SAYEG, FOUNDER OF KNITTA

The knitted *Pink M.24 Chaffee* by Marianne Jørgensen. Photo: Barbara Katzin

Stupendous feats

Take inspiration from knitting artists who have let their imaginations run wild and created works that defy expectations of what a piece of textile art should be:

THE PINK M.24 CHAFFEE

In 2006, Danish artist Marianna Jørgensen developed the concept of a crocheted army tank cozy. A pink blanket made of 4,000 squares contributed by needle workers throughout Europe and the USA was stitched together to cover a combat tank (called the M24 Chaffee) dating from World War II. Jørgensen named the cozy the *Pink M.24 Chaffee*, and it was created to protest Denmark's involvement in the Iraq War.

Each contributor provided a six-inch (fifteen-centimeter) crocheted square made with his or her own yarn, so the blanket was created in various shades of pink. Found through word of mouth, knitting clubs,

and the Internet, the contributors were of varying age groups, sexes, and nationalities. This project opened for the public the possibility of, as Jørgenson explained it, "knitting their opinions." The process of covering the tank occurred at Nikolaj Place, the Copenhagen Contemporary Art Center in Denmark.

Jørgenson said of the project: "The main impression of the knitted tank is that it consists of hundreds of patches knitted by many different people in different ways: single-colored, stripes with bows or hearts, loosely knitted, closely knitted, various knitted patterns…that represent a common acknowledgement of a resistance to the war in Iraq."

[Unlike] a war, knitting signals home, care, closeness, and time for reflection. Ever since Denmark became involved in the war in Iraq, I have made different variations of pink tanks, and I intend to keep doing that until the war ends. For me, the tank is a symbol of stepping over other peoples' borders. When it is covered in pink,

*it becomes completely unarmed, and it loses
its authority. Pink becomes a contrast in
both material and color when combined
with the tank.*

THE HARE

On the 5,000-foot (1524-meter) high Colletto
Fava hillside in northern Italy rests a mammoth,
pink bunny. *Hase* (the hare or rabbit), erected
by Viennese artist collective Gelitin in 2005, is
so large that it can be viewed by Google Earth.
From ear to toe, the behemoth sculpture
measures 200 feet (sixty-one meters) long.

Stuffed with straw, the bunny's pink exterior
was knitted in pink wool. Gelitin expects that
spectators will not only walk around the bunny,
but also climb up onto it. A full-grown adult is
exactly the right size to form a belly button on
the giant sculpture. On one side of the hare
spill knitted guts and intestines.

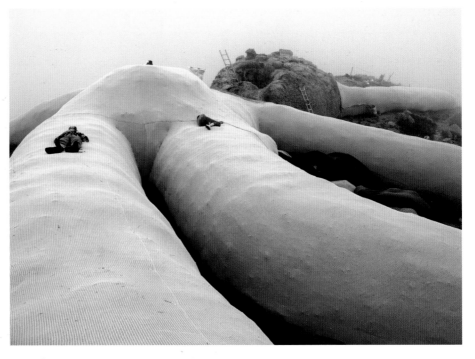

Hase/Rabbit/Coniglio, Gelitin 2005, straw, wood, fabric.
Design sketches, map and photos: Gelitin

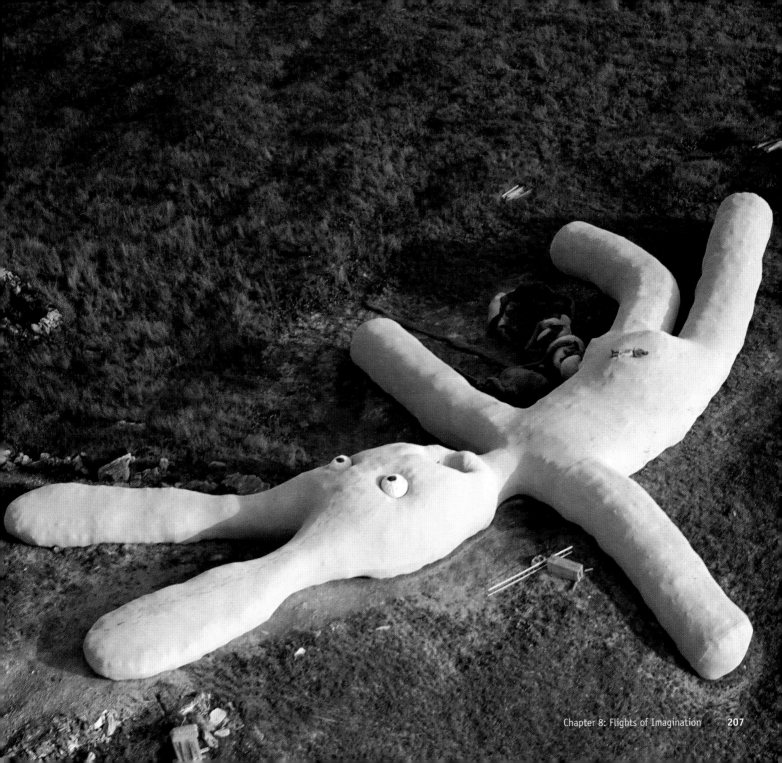

An aerial view of Gelitin's *Hase*. Visitors take a nap on the giant rabbit. Photo: Gelitin

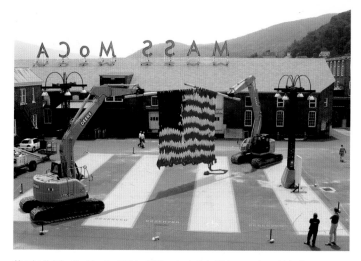

Massive Knitting Machine, David Cole, 2005, orchestrated with lamp posts and John Deere cranes.
Photo: Judi Rotenberg Gallery

From the artists' statement:

The things one finds wandering in a landscape: familiar things and utterly unknown, like a flower one has never seen before, or, as Columbus discovered, an inexplicable continent; and then, behind a hill, as if knitted by giant grandmothers, lies this vast rabbit, to make you feel as small as a daisy.

The toilet-paper-pink creature lies on its back: a rabbit-mountain like Gulliver in Lilliput. Happy you feel as you climb up along its ears, almost falling into its cavernous mouth, to the belly-summit and look out over the pink woolen landscape of the rabbit's body, a country dropped from the sky; ears and limbs sneaking into the distance; from its side flowing heart, liver, and intestines."

Gelitin plans for the bunny to remain in place until 2025.

Take inspiration from knitting artists who have let their imaginations run wild.

THE KNITTING MACHINE

The courtyard of the Massachusetts Museum of Contemporary Art hosted an event with some unusual large scale knitting in July 2005. Using aluminum light poles manipulated by two John Deere backhoes, Rhode Island artist David Cole orchestrated the knitting of a giant American flag. He stood on a boom suspended about thirty feet (nine meters) in the air, and, using a long fishing gaff, cast yards of eighteen inch-wide (forty-six centimeter) strips of red and white felt over the massive twenty-five foot (7.6 meter) long needles. The end result produced a twenty-foot (six meter) long by thirty-five-foot (10.6 meter) wide American flag. The final piece consisted of 800 stitches executed in the air.

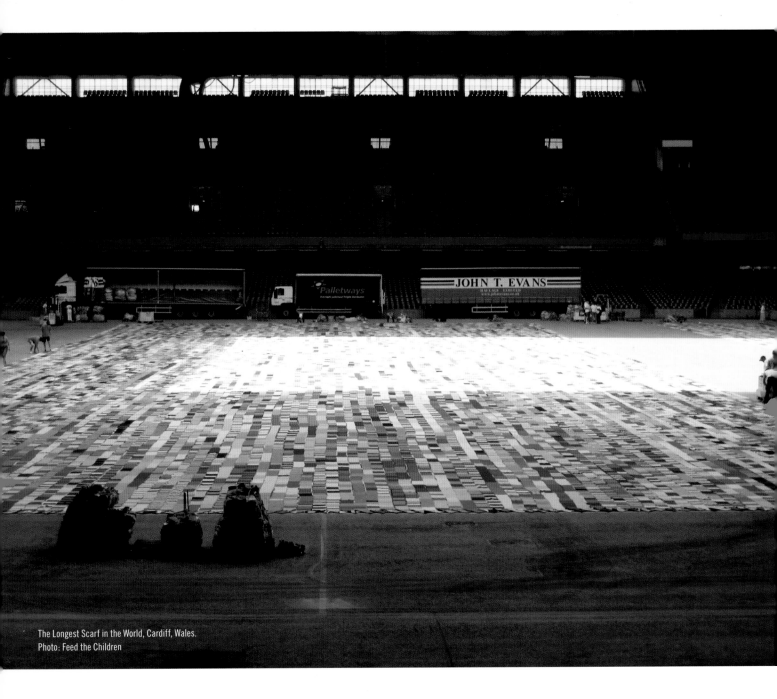

The Longest Scarf in the World, Cardiff, Wales.
Photo: Feed the Children

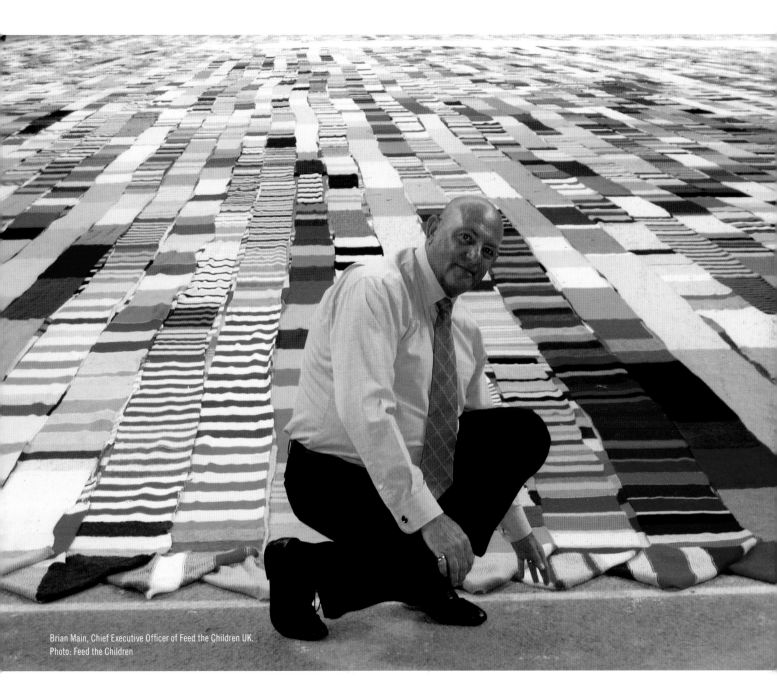

Brian Main, Chief Executive Officer of Feed the Children UK.
Photo: Feed the Children

◇◇◇◇◇◇◇◇◇◇◇◇◇◇◇◇◇◇◇◇◇◇◇◇◇◇◇◇◇◇◇◇◇◇◇◇◇

"For me, it is as much a poetic gesture as a political one."

—ROBIN LOVE

◇◇◇◇◇◇◇◇◇◇◇◇◇◇◇◇◇◇◇◇◇◇◇◇◇◇◇◇◇◇◇◇◇◇◇◇◇

THE LONGEST SCARF IN THE WORLD

The record for the world's longest scarf is held by the British charity Feed the Children. The scarf began as a fundraising event, initially in aid of a children's hospice in Wales. Knitters were sponsored by how many feet of work they could produce. When the massive scarf was completed three years later, it was more than thirty-three miles (fifty-three kilometers) long and held the work of over 2,000 knitters. It was displayed in the Millennium Stadium, Cardiff.

What do you do with the world's largest scarf? The organization found another team of volunteers to cut the scarf into shorter lengths and sewed them together to make blankets, to be sent to African countries such as Uganda, Angola, and Liberia.

THE KNITTED MILE

As a part of an exhibition called Gestures of Resistance, fiber artist Robyn Love created a project called the *Knitted Mile*. Worked entirely in hand-knit garter stitch, a yellow strip was created to mimic the highway divider along a road in Dallas, Texas. Ninety volunteers created the *Knitted Mile*; the finished strip was four inches wide and over 2,000 feet (609.6 meters) long.

Love has described the intent of the project as beautiful and subversive: "The gesture of placing a mile of knitting upon the roadways of Dallas is intended to be an intervention, an interruption of the everyday environment created for cars and trucks (and all that they imply) with this lovingly made, handmade element. For me, it is as much a poetic gesture as a political one."

Think bigger

Now think of your own large-scale piece of knit or crochet work. What could you create that would exceed your expectations? How would you amaze yourself and others? Would the sheer size of your piece be enough to impress, or would it be more satisfying to include a large number of

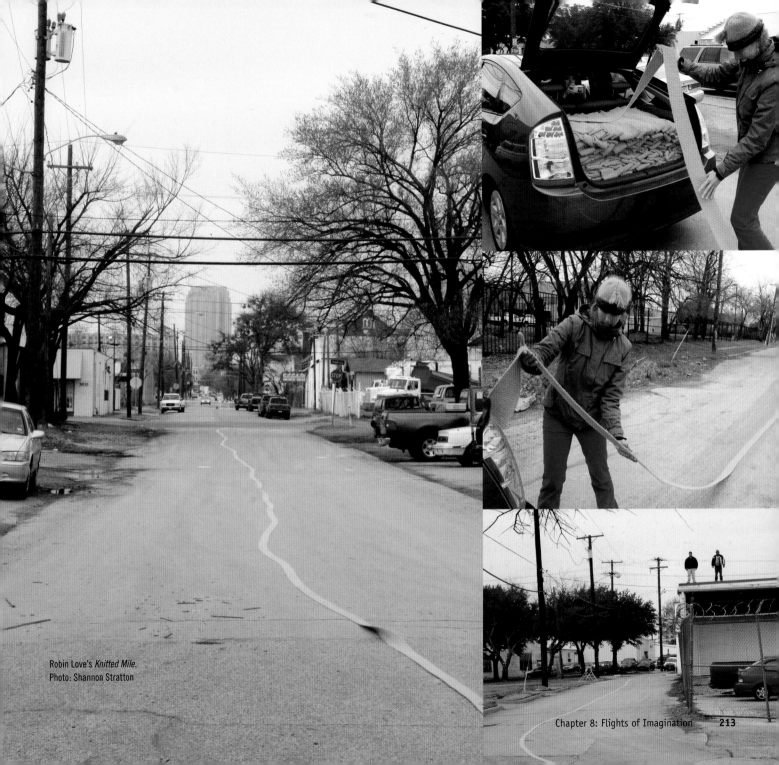

Robin Love's *Knitted Mile*.
Photo: Shannon Stratton

Measurements for monuments around the world:

MONUMENT	LOCATION	WIDTH	HEIGHT OR LENGTH	SPECIAL CONSIDERATIONS
Big Ben	England	Diameter of dials: 23 ft (7 m)	Clock Tower: 320 ft (97 m)	A cravat placed below the clock face would be jaunty!
Brooklyn Bridge	USA	5,989 ft (1,825 m)	Towers are 277 ft (84 m) high	We'd love to see bunny ears on the Brooklyn Bridge.
Burj Dubai	United Arab Emirates	-	2,684 ft (818 m)	Be prepared to pick up stitches.
CN Tower	Canada	-	1,815 ft, 5 inches (553.33 m)	One long leg warmer could do the trick.
Empire State Building	USA	1.8 acre (79,288 sq. ft)	1,453 ft, 8 in (443.2 m) to the top of the lightning rod	Large needles recommended.
Golden Gate Bridge	USA	90 ft (27 m)	1.7 miles/8,981 ft (2,737 m)	Imagine it with pom-pom trim.
Great Pyramid of Giza	Egypt	755.75 ft (230 m) on each side of the base	1455.2 ft (38.8 m)	Test your sculptural crochet skills.
Great Wall	China	The maximum width of the wall is 30 ft (9.1 m)	2,500 miles (4,020 km)	Fuzzy yarn may snag on the rock face; smooth yarns are recommended.
Leaning Tower of Pisa	Italy	The width of the walls at the base is about 6–7 ft (1.8–2.1 m) at the top	The height of the tower is 183.27 ft (55.86 m) from the ground on the lowest side and 186.02 ft (56.70 m) on the highest side	The tower has 296 or 294 steps; the seventh floor has two fewer steps on the north-facing staircase. The tower leans at an angle of 3.97 degrees.
Mt. Rushmore	USA	1,278.45 acres (517.37 sq. km)	5,725 ft (1,745 m)	None of the US presidents are wearing scarves or hats.
Niagara Falls	Canada and the USA	The rim of Horseshoe Falls (on the Canadian side) measures 2,200 ft (670 m) across	188 ft (57 m) high	A crocheted fishing net would be helpful for catching intrepid adventurers who want to travel over the falls.
St. Peter's Basilica, the dome	Italy	193 ft (58.9 m) in diameter	136.57 meters 448.06 feet	A hat may work for this structure.
Space Needle	USA	Diameter of the halo: 138 ft (42 m)	605 ft (184 m)	On a hot day, the Space Needle expands about 1 in (2.5 cm); thankfully, knitted fabric is stretchy.

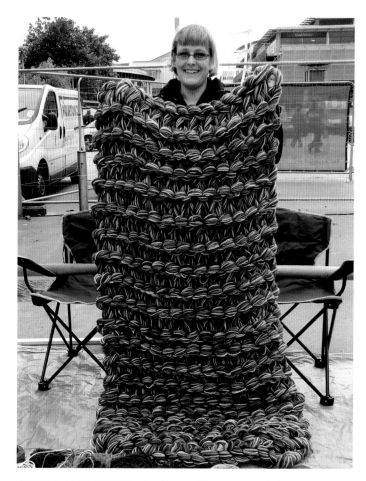

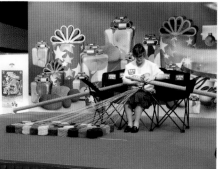

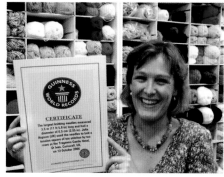

Julia Hopson of Knit Wits Wool Shop in Penzance, UK, is the Guinness World Record holder for the largest knitting needles on earth. Photos: Matt Hopson

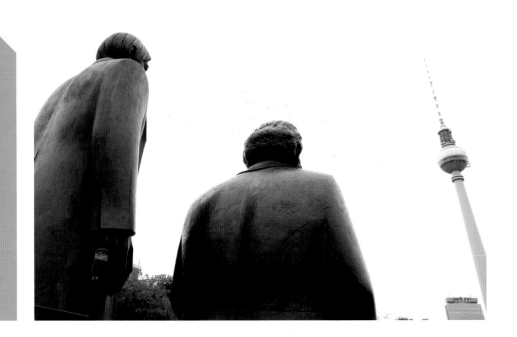

volunteers who could lend a helping hand? If you were to inherit a mountain of yarn, what would be your ideal project?

Imagine creating:
- a leg warmer for the Eiffel Tower
- a blanket for the Great Wall of China
- a cozy for a Buckingham Palace Guard's hat
- a shawl for the Statue of Liberty

If you are really adventurous and have some time on your hands, you could create some of the projects in this book on a monumental scale. For example, the Crochet Scallop Tags (page 184) could trim the Eiffel Tower in Paris. The first and second floors of the Tower have railings that are 928 ft (283 m) long and 538 ft (164 m) long, respectively. If you were to make scallops of the same size as those in the pattern on page 184 to trim these railings, you'd need two strips of crocheted scallops, one with 6,363 scallops and one with 3,689 scallops. You would use up

almost 115 skeins of Cascade 220 yarn, and your base chains would be 38,181 sts and 22,137 sts long, respectively! It might be worth considering a chunkier yarn…

The Picasso public sculpture in Daley Plaza [in Chicago] is renowned and controversial. I love that kids slide down this one little part of it, and skateboarders go on it. I'd love to cover it because of its edges and weird shapes. —MICRO-FIBER MILITIA

Go big, go fast, or go home

If recruiting large armies of volunteers is not your style, you may want to pick up some tricks from the speediest knitters and crocheters in the world.

According to a contest held by the Craft Yarn Council of America, the fastest knitting speed was recorded as 255 stitches in three minutes.

The record-breaking piece used stockinette stitch across a row of sixty stitches. This record, set in 2004 by Hazel Tindall from Shetland, UK, was created using 4 mm (US #6/UK #8) needles and double knitting (DK) weight yarn. In 2008, Tindall retained her record at this competition by knitting 212 garter stitches in three minutes. Miriam Tegels of the Netherlands holds the Guinness world record (2008) for 118 stitches in one minute.

The fastest crochet speed is held by Lisa Gentry who became the Guinness world record fastest crocheter in 2005 by crocheting at a mind-boggling rate of 170 stitches per minute.

If you can't knit or crochet quickly, you can always go big by using supersized tools. Julia Hopson of Knit Wits Wool Shop in the UK created a giant tension square with needles that were 6.5 centimeters in diameter and 3.5 meters long. Created with the help of Matt Hopson and James Morris Marsham, these needles were scaled ten times the size of a standard 6.5 millimeter and thirty-five centimeter long knitting needle. And the world's longest piece of crochet was created back in 1986 by Ria van der Honing of The Netherlands, who completed a thirty-eight mile (sixty-one kilometer) long crochet chain.

THIS SPREAD: ArtYarn hits Berlin and leaves a tag around the Marx-Engels statue. Photos: Sarah Hardacre

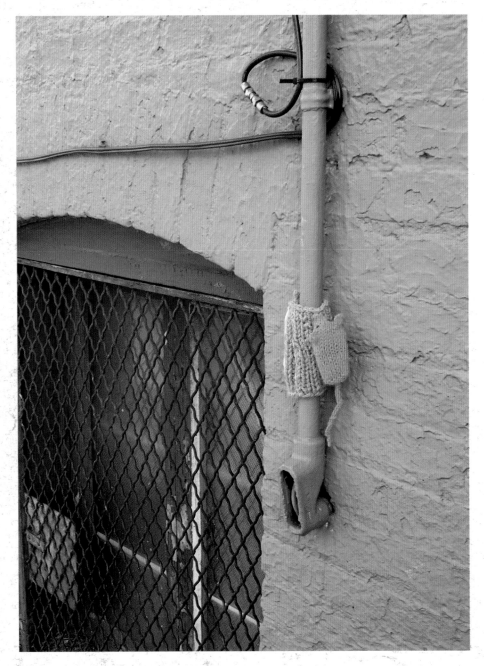

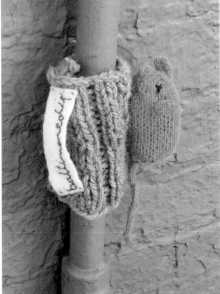

My craziest yarn graffiti fantasy involves knitting the little mouse cat toy from the second Stitch 'n Bitch book. I'd love to fill an alley with little fuzzy mice! I'd also like to cover some of Baltimore's abandoned row homes in knit roses. —ALIZA OF BALTIMOREDIY

If you were to inherit a mountain of yarn, what would be your ideal project?

Photos: Aliza Sollins

AN INTERVIEW WITH
Magda Sayeg of Knitta

The founder of Knitta may no longer use her street name of PolyCotN, but she's still creating tags and leaving them around the world.

Q: Should we call you PolyCotN?

A: Two years ago, I would have said absolutely, [but] as I've done more exhibits and installations, there seems to be less reason to hide my identity. It was fun, at first, when we had code names...Now it's just too hard to hide.

Q: Are you still working with Knitta as a group?

A: This group [has ranged in number] from six to eleven people. Now we are down to a comfortable three or four people. Because I'm the person who founded it, I'm the person who does these things. There is always an issue with trips, where they budget for one person, sometimes two, to attend international exhibitions, but they can never budget for eleven. People in the group have now moved in their own directions, and so the last couple of installations have been solo projects for me.

The group has grown, too; it has gone through growing pains. There are people in the group who now live far apart. When it started there were four or five of us and we always went out and tagged together.

Q: Do you guys do any street tagging now?

A: Oh yeah, whenever we go anywhere. My brother is the one who tagged the Great Wall of China. He was visiting a friend who lived near there and happened to have a pink fuzzy piece of material with him.

Q: I heard a podcast in which you said you taught your brother how to knit.

A: I taught both of my brothers how to knit. My one brother is in the group—his name is Mascuknitty. My older brother, who is a doctor, can knit and knit and knit! Sometimes he has twenty feet knitted, and he says it's because I never taught him how to bind off.

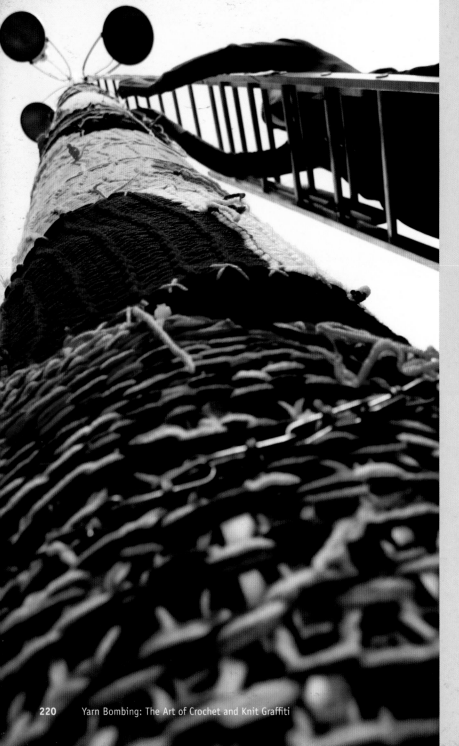

Q: Were most of the people in Knitta your family members?

A: It definitely started out like that. My mother-in-law, who is now seventy-five, is an incredible knitter. So, [being in Knitta] has tickled her. For the first six months she didn't really grasp the concept. And then she saw, "Wow this is taking me to Seattle and California and New York and Paris!" Now she understands the magic a little bit more. But at first, all her lady friends were asking her, "Why do you do this? Don't you know that you are more talented than this?"

Q: Was Knitta's installation at Bumbershoot in 2006 one of the first times you started to use your real name?

A: Bumbershoot was the pivotal moment of taking our masks down. It was one of those unavoidable situations. Newspapers wanted to interview us and people want to take pictures of us. Honestly, we are kind of cute; we looked like a girl band.

Q: Perfect for Bumbershoot! Did you do the installation before the fair started?

A: Bumbershoot was one of the more impressive projects we've done. We were flown up there a month and a half before the festival began, and were taken all over the city by people who knew it well. We took a whole suitcase of tags, and within three days we had covered the whole city. Local writers were creating curiosity about us. Blogs were written about us, asking if anybody had seen that fuzzy thing on the corner of whatever and whatever and who had done this? They created this hype, so when we got there for the big festival,

Magda Sayeg tags a light pole. Photo: Ben Sayeg

kids came up to us and said, "I jumped the fence just so I could meet you all."

That was the time we did our first workshop. I'm the loudest of the group; everyone else is kind of shy. There we were in a room with forty people who wanted to learn how to knit and ask us questions. I put the mike on and thought, Okay, I guess this is my job. I do the workshops now. I love doing the workshops. It's so fun.

Q: What do you get people to do in the workshops?
A: The easiest thing of all—which is the antenna cozy. People absolutely love it. It takes about half an hour and it's only four to seven stitches wide, and can be twenty to thirty inches long. All you do is crochet it closed and flip it onto a car antenna.

Q: For the larger installation works, are you hand knitting all of those or getting machine help?
A: I'm still doing it by hand, but when we were in Paris, they gave us one of the coolest knitting machines. We were philosophically against [using the machine]. I don't know if you've ever used a rotating knitting machine, but that thing is so much fun. There we were in Paris, and we sat there with this machine, three nights in the row, just cranking it out, adding wool. Paris is the best city for circular tube pieces. They have bollards everywhere, these posts that stick up [from the streets] about waist high, and they're all over the city. So all we had to do was flip the knitted pieces onto the bollards, and we put pom-poms on them. On a city block, every

Magda Sayeg tags outside Domy Books in Houston, Texas.
Photo: Daniel Fergus

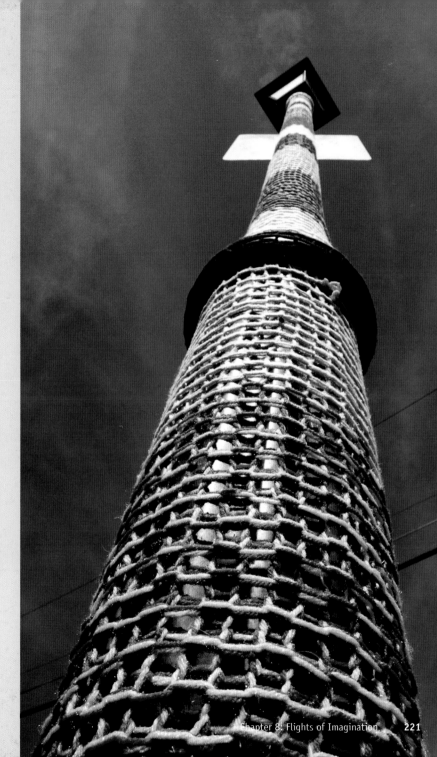

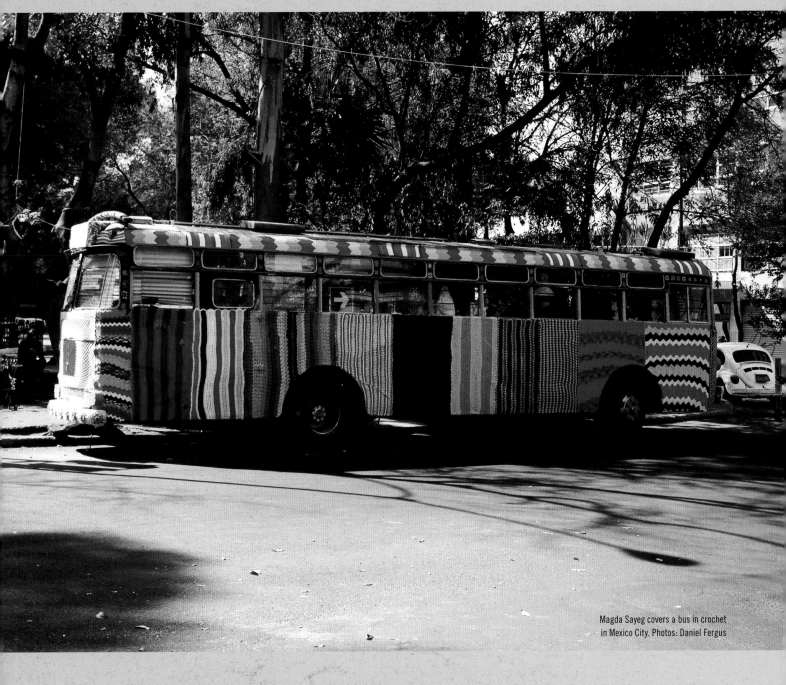

Magda Sayeg covers a bus in crochet in Mexico City. Photos: Daniel Fergus

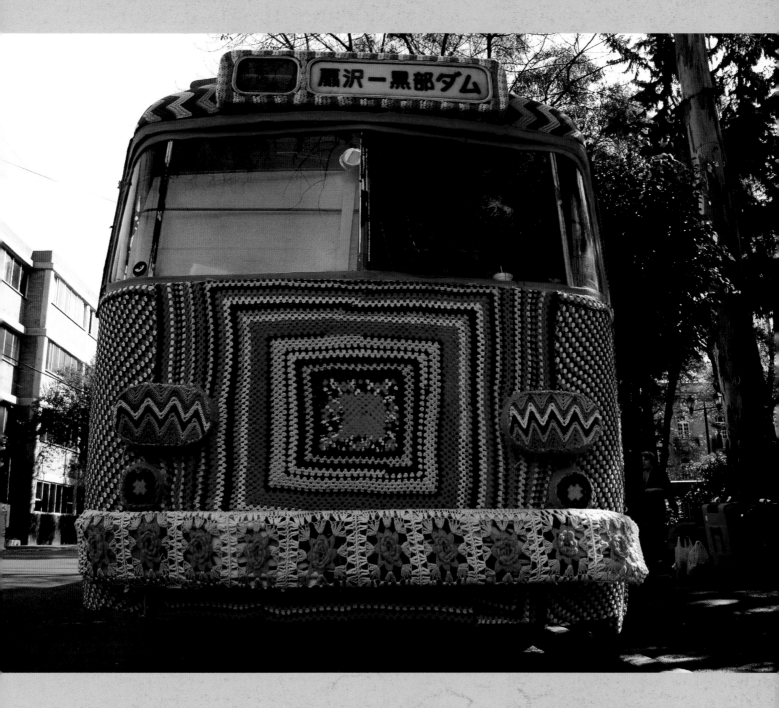

扇沢ー黒部ダム

single bollard would be covered with knitting. If we didn't have a machine, we wouldn't have been able to create that look. So it was worth the knitting machine. It was worth breaking the rules.

Q: What are your thoughts on wanting everything knit by hand?
A: Most of the emails I've received have said things like, "I deliver mail, and I've gone down the same street every day for five years, and you've made that stop sign pole beautiful with purple yarn." It's stuff like that that warms me up, makes me want to do it. And so, if I can make [those pieces] by hand, I will.

Q: In what countries do you think you have the warmest reception? Is it about the same, globally?
A: Internationally, it has been incredible. For some reason, Sweden loves us, and I love them back. And I love Paris; we had a lot of media attention there—I felt like a rock star at that moment!

Q: We have a copy of the book _KnitKnit_ [by Sabrina Gschwandtner (Stewart, Tabori and Chang, 2007)] where you were profiled, and we noticed that there was a mention of people giving you knitting that had belonged to loved ones who had passed away. Does that happen often? That must be pretty emotional.
A: Talk about touching. There was this older woman who had her dead mother's unfinished project in the attic and decided that our project moved her enough for her to send it to us. That amazed me.

But I was also amazed the first time I called for volunteers in Seattle. We had no money and nothing to offer them. We could only mention their names at the opening installation. We were facing this totally insurmountable project of wrapping a fifty-foot wide column that held up the monorail. There was no way we could do this, even if we had twenty people in our group.

I did a call-out to our mailing list and asked, "Who wants to help? Email me back, and I'll give you dimensions." Well, about fifteen people emailed me back from all over the country. I gave them the dimensions, and three weeks later—that's where I got silly and goose bumpy and cried a little—they would send me these incredible pieces. This one woman from Seattle sent me a thirty-foot-long piece. I unraveled it; it went from the front door to the back door. People would send these little notes that said, "Thanks for letting me be a part of this." That amazed me.

That's how I know there is some magic here. This captures people. I'm so happy that this captures them in such a positive, moving, touching way. So many people want to do Knitta elsewhere, which is hard for me to control. The best scenario is for me to encourage people to do their own thing, in their own worlds: Make it happen, let them tag it and claim it as their own.

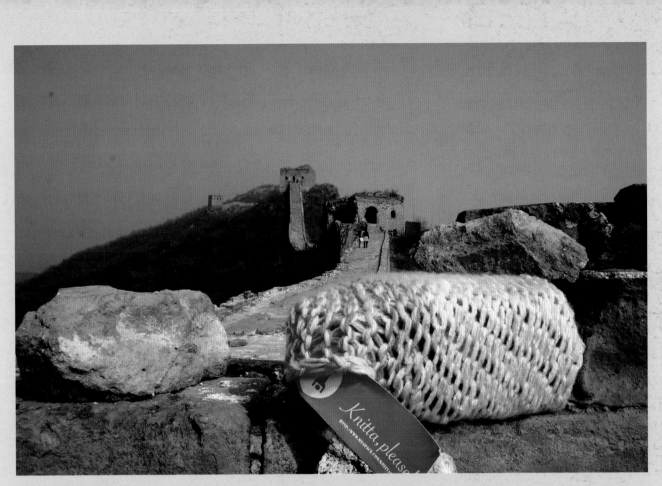

Knitta bombs the Great Wall of China.
Photo: Ben Sayeg

Glossary of Terms and Abbreviations

General terms

st[s]: Stitch[es]
RS: Right side of work
WS: Wrong side of work
MC: Main Color
CC: Contrast Color

Knitting terms

K: Knit
P: Purl

Garter stitch: If working back and forth, knit all rows. If working in the round, alternate knit rounds and purl rounds.

Grafting: Grafting is the technique for invisibly joining two sets of live stitches. Directions for grafting can be found at: **knitty.com/ISSUEsummer04 /FEATtheresasum04.html**

k2tog: Knit 2 together. Knit next 2 stitches together as if they are one stitch; 1 stitch decreased (forms a right-leaning decrease).

k3tog: Knit 3 together. Knit next 3 stitches together as if they are one stitch; 2 stitches decreased (forms a right-leaning decrease).

kfb: Knit into front and back of stitch. Knit next stitch, but do not drop it from left needle; bring right needle around back of stitch and knit again into the back loop of the stitch. 1 stitch increased.

m1: Make 1 stitch. Insert left needle, from front to back, under strand of yarn which runs between last stitch on left needle and first stitch on right needle; knit this stitch through back loop. 1 stitch increased.

m1p: Make 1 purl stitch. Insert left needle, from back to front, under strand of yarn which runs between the last stitch on left needle and the first stitch on right needle; purl this stitch through its front loop.

m1r: Make 1 right-slanting knit stitch: Insert left needle, from back to front, under strand of yarn which runs between last stitch on left needle and first stitch on right needle; knit into front of this stitch. 1 stitch increased.

p2tog: Purl 2 together. Purl next 2 stitches together as if they are one stitch; 1 stitch decreased (forms a right-leaning decrease).

pfb: Purl into front and back of stitch. Purl next stitch, but do not drop it from left needle; bring right needle around back of stitch and purl again into the back loop of the stitch. 1 stitch increased.

skp: Slip 1 knitwise, k1, pass slipped st over st just knit. 1 stitch decreased (forms a left-leaning decrease).

sl: Slip. Slip stitch to other needle, either knitwise (inserting needle as if to knit) or purlwise (inserting needle as if to purl) as directed.

sp2p: Slip 1 purlwise, p2tog, pass slipped st over st just worked. 2 stitches decreased.

spp: Slip 1 purlwise, p1, pass slipped st over st just purled. 1 stitch decreased (forms a right-leaning decrease on RS of work, when worked on WS).

ssk: Slip slip knit. Slip the next 2 stitches knitwise, one at a time, to the right needle; insert the left needle into the fronts of these 2 stitches and knit them together. 1 stitch decreased (forms a left-leaning decrease).

Stockinette stitch: If working back and forth, knit all RS rows, and purl all WS rows. If working in the round, knit all rounds.

tbl: Through back loop. Knit or purl into the back loop of the stitch, as directed.

W&T: Wrap and turn. Bring yarn to front of work between needles, slip next st to right-hand needle, bring yarn around this st to back of work, slip st back to left-hand needle, turn work to begin working back in the other direction.

yo: Yarn over. Wrap yarn over right needle, from front to back.

Crochet terms

Note: This book uses North American crochet terminology.

ch: Chain
sc: Single crochet
dc: Double crochet
hdc: Half-double crochet

ch-sp: Chain space; the space formed by a chain stitch in a crochet stitch pattern

dc2tog: Yarn over, insert hook in next st, pull up a loop, yarn over and draw through first 2 loops on hook; yarn over, insert hook in following st, pull up a loop, yarn over and draw through first 2 loops on hook, yarn over and draw through remaining 3 loops on hook.

Fasten off: Break yarn, draw yarn tail through last stitch and pull tight.

Pull up a loop: After inserting hook into stitch as directed, wrap yarn around hook and pull this loop through stitch to front of work.

sc2tog: Single crochet 2 together. Insert hook into next stitch and pull up a loop, insert hook into following stitch and pull up a loop (3 loops on hook); yo and draw through all 3 loops on hook.

sl st: Slip stitch. Insert hook in next st and pull up a loop, draw this loop through loop on hook.

tch: Turning chain. This is the initial chain stitch(es) worked at beginning of row to provide the correct height for the stitches in that row. Unless otherwise indicated, it does not count as a stitch in that row.

yo: Yarn over. Wrap yarn once around hook.

Knitted Landscape hits the coast of Ireland.
Photo: Evelien Verkerk

Index

Note: Patterns are in **bold**

About the authors

MANDY MOORE is the technical editrix of popular online knitting magazine **knitty.com**, and of various other knitting and crochet books and publications. She blogs about her life at **yarnageddon.com** and blogs with Leanne at **yarnbombing.com**. She lives in Vancouver, BC.

LEANNE PRAIN co-founded a stitch and bitch called Knitting and Beer in order to expand her skills while knitting at the pub. A professional graphic designer, Leanne holds degrees in creative writing, art history, and publishing. She lives and knits in Vancouver, BC.